THIS SIDE
UP

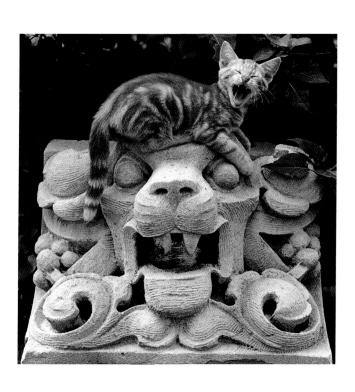

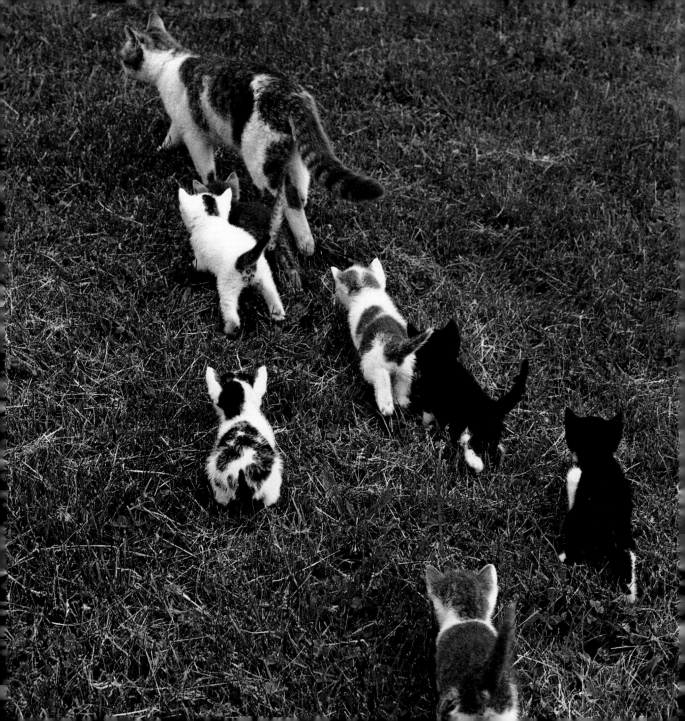

THE BIG BOOK OF

CATS

EDITED BY J.C. SUARÈS

SCRIPTUM EDITIONS

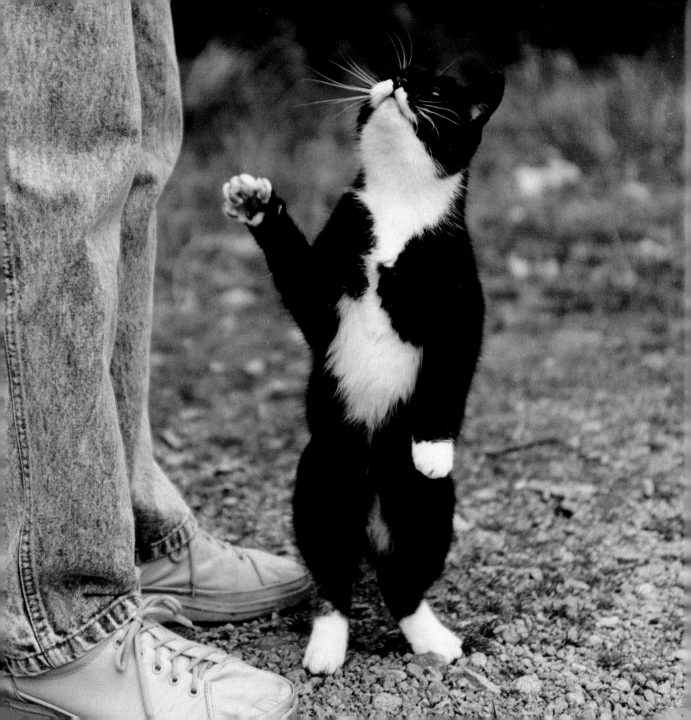

F O R E W O R D

THIS IS MY TWENTIETH BOOK ABOUT CATS. I've either edited, designed, written, or illustrated one almost every year since *The Illustrated Cat*, which came out in the seventies. You'd think that I could probably answer any question about cats after all this time, but they remain a mystery. Sure, I can tell the difference between a Persian and a Siamese and a Himalayan, and I know that calicos are always female. But how does purring work? Do cats dream? Does it really help to have an "s" sound in their name? (Sam vs. Myron?) And why do they play with their dead victims? One thing is sure, however: I've got a list of my favorite cats of all time. It includes real cats and fictitious ones.

No. 1: Morris the Cat My all-time

hero. The large, orange TV spokesman for 9-lives cat food, called Lucky before his rise to fame, was "discovered" at the Human Society of Hingdale, Illinois. With his macho looks and cool demeanor, he was so good at selling 9-Lives that he was made an honorary director of the parent company, Star Kist Foods, Inc., and given power to reject new cat-food flavors. When he passed away in 1978, it made the evening news.

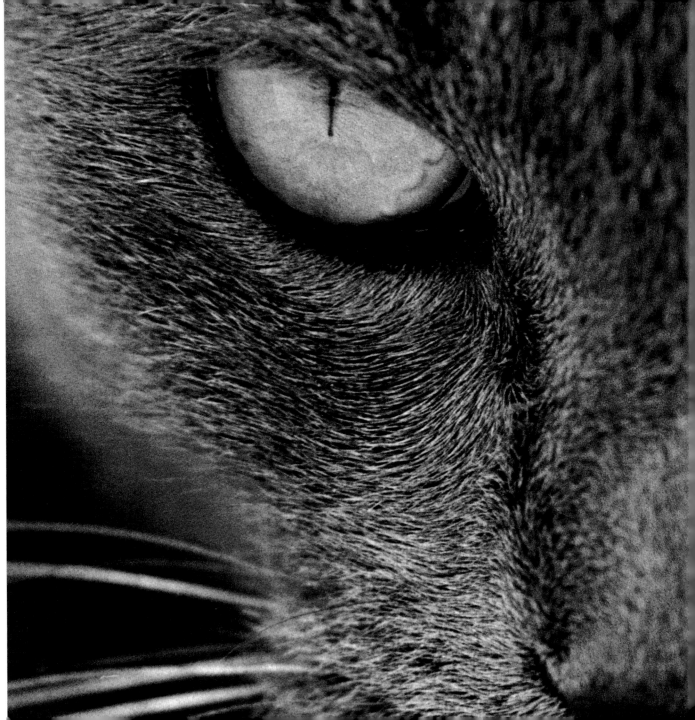

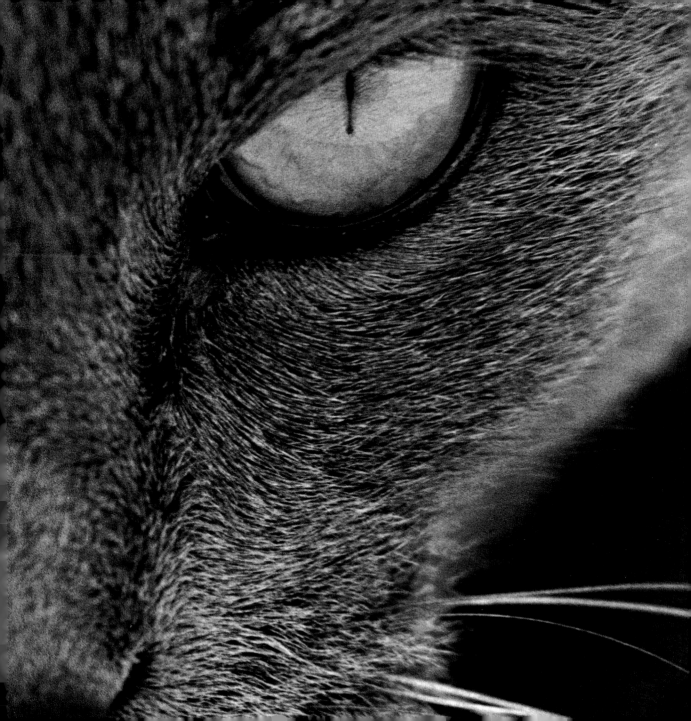

As I was going to St. Ives,

I met a man with seven wives.

Each wife had seven sacks,

each sack had seven cats,

each cat had seven kits:

kits, cats, sacks and wives,

how many were going to St. Ives?

ANONYMOUS

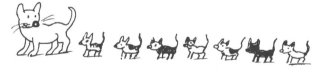

CLAUDIA GORMAN
A Mother's Love
Pleasant Valley, New York, 1994

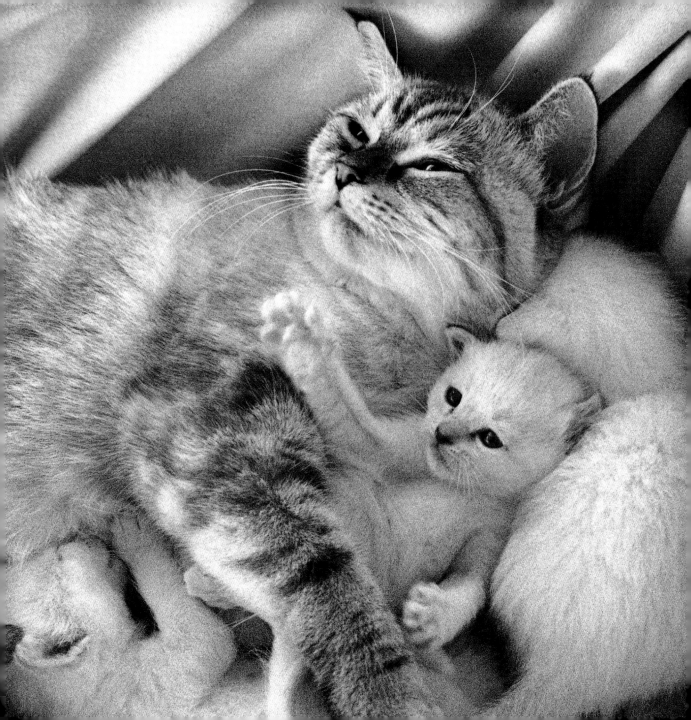

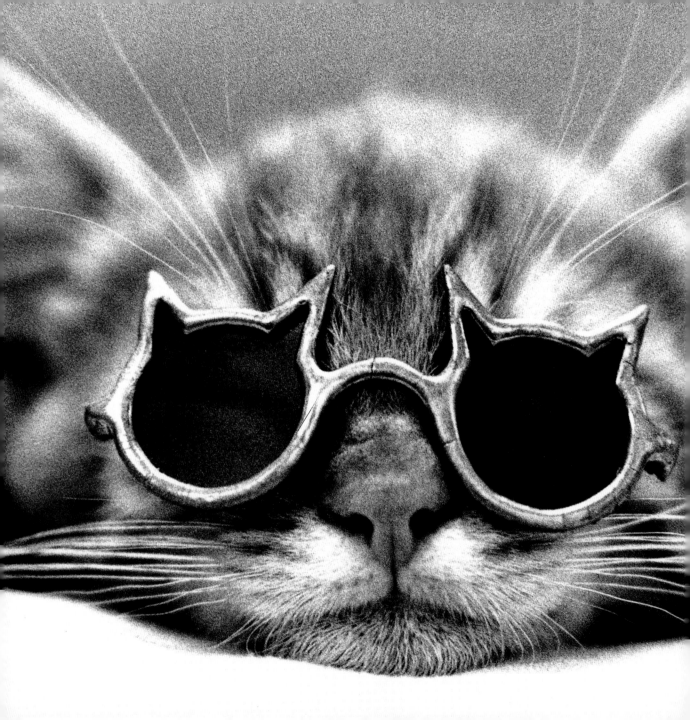

DAVID McENERY
CAT IN SHADES, 1993

This is the male kitten of a friend's cat's litter.
He was the most outgoing of all of them, a real showcat.

STUDIO LEMAIRE
A TOAST, 1994

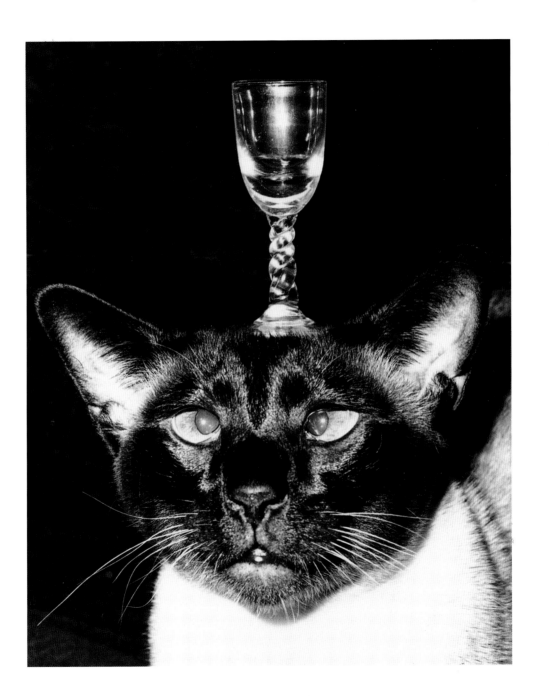

The Cat only grinned when it saw Alice. It looked good-natured, she thought:
still it had very long claws and a good many teeth, so she felt that it ought to be
treated with respect. "Cheshire Puss," she began, rather timidly, as she did not at all
know whether it would like the name: however, it only grinned a little wider.
"Come, it's pleased so far," thought Alice, and she went on. "Would you tell me,
please, which way I ought to go from here?"
"That depends a good deal on where you want to go," said the Cat.
"I don't much care where——" said Alice.
"Then it doesn't matter which way you go," said the Cat.
"——so long as I get somewhere," Alice added as an explanation.
"Oh, you're sure to do that," said the Cat, "if only you walk long enough."
Alice felt that this could not be denied, so she tried another question.
"What sort of people live around here?"
"In that direction," the Cat said, waving its right paw round, "lives a Hatter and in
that direction," waving the other paw, "lives a March Hare. Visit either you like:
they're both mad."
"But I don't want to go among mad people," Alice remarked.
"Oh, you can't help that," said the Cat. "We're all mad here. I'm mad. You're mad."
"How do you know I'm mad?" said Alice.
"You must be," said the Cat, "or you wouldn't be here."

LEWIS CARROLL
Alice's Adventures in Wonderland

WALTER CHANDOHA
CHESHIRE CAT, 1972

*I'm fascinated by the idea of a grinning cat. This was Smiley, one of our cats,
and his expression is as close to the Cheshire cat as I've come.*

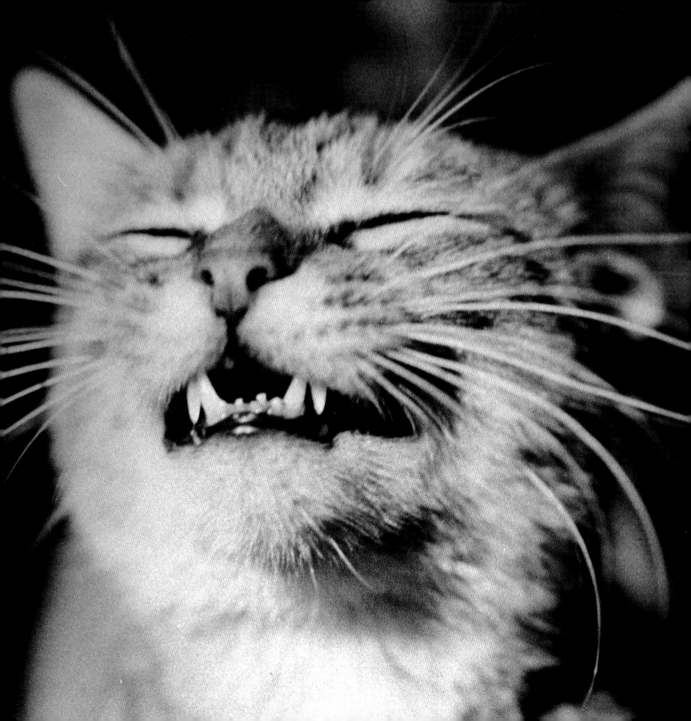

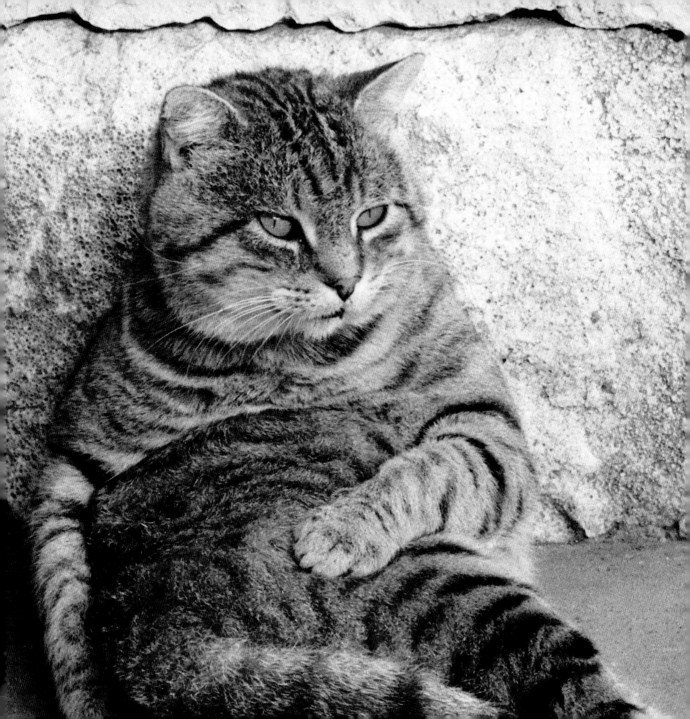

MARILAIDE GHIGLIANO
OUTSKIRTS OF ROME, ITALY, 1991

"I got rained out photographing the ruins
at Ostia Antica and stepped into a pizzeria
and ordered a pie. When it arrived, a stray
cat showed up to beg for some pizza. Later,
when he had eaten more than I and was
taking it easy, I snapped his picture."

A Cat, hearing that there were some sick Birds in the neighborhood, got himself up as a doctor and set off to pay a house call. When he arrived at their home he called out to ask how the occupants were getting on. "Very well, thank you," came the reply, "if only you would go away."

AESOP
The Cat and the Birds

JAN RIETZ
CAT ON BIRDHOUSE, 1987

This was taken when my cat Millie was already ten years old. Even though Millie is a feminine name, he was a very male cat. He was a nice cat too, and an optimist—he was sure that the birds would fly right into his mouth as they headed for the birdhouse.

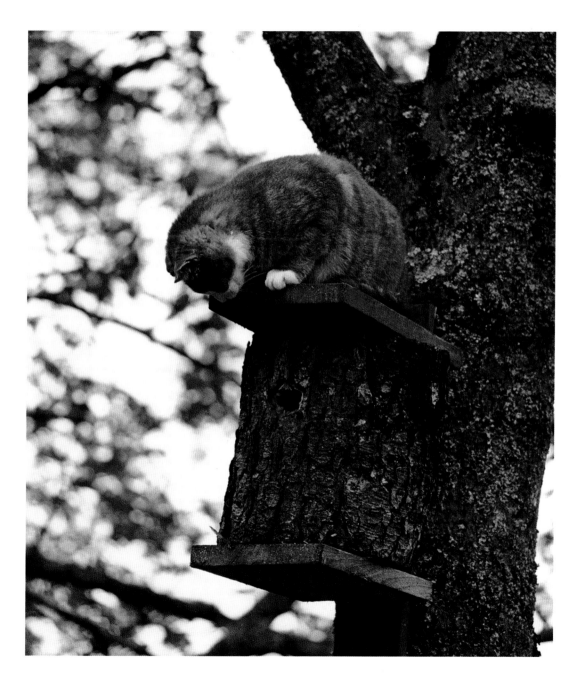

do you think that i would change

my present freedom to range

for a castle or moated grange

wotthehell wotthehell

cage me and i d go frantic

my life is so romantic

capricious and corybantic

and i m toujours gai toujours gai

...

DON MARQUIS
the song of mehitabel

GUY LE QUERREC
VILLE JUIF, 1975

Taken in a suburb near Paris.

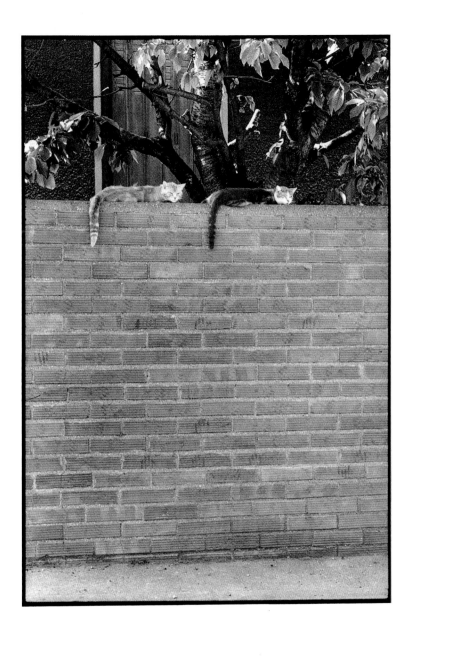

A kitten is so flexible that she is almost double; the hind parts are equivalent to another kitten with which the forepart plays. She does not discover that her tail belongs to her until you tread on it.

HENRY DAVID THOREAU

WALTER CHANDOHA
Washing Up
Long Island, New York, 1960

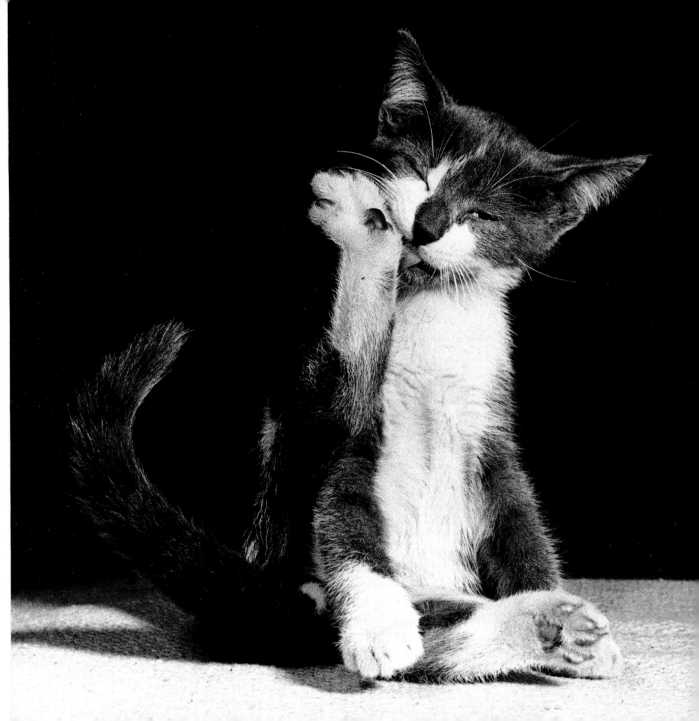

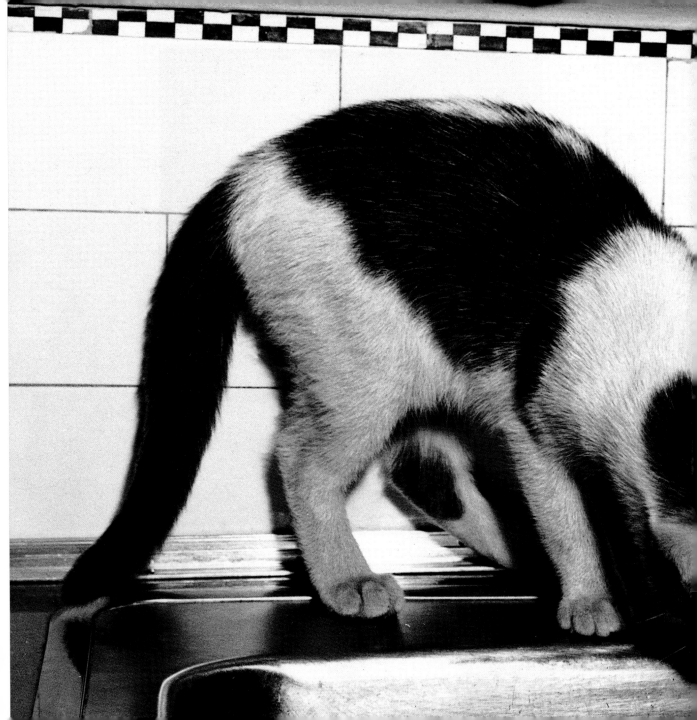

STYLE POLICE

Balmain, my Burmese cat, thinks she's the head of the style police. She won't go near a person in a bad outfit, even if they're my honored guest. She sits in the alcove outside the living room, staring at them and making them feel incredibly insecure. My partner Chris used to wear Harris tweed jackets, and we all told him they looked ludicrous. But he wouldn't listen. So Balmain took the matter into her own hands. When Chris left his jacket on a chair one afternoon, Balmain methodically shredded it to rags. Issue resolved.

STEVEN MOY, SHOE DESIGNER, LONDON

RIGHT:
DAVID McENERY
MAXWELL HIDING,
BEAULIEU, FRANCE, 1996

"Maxwell, a very dignified English cat, does not like visitors. Whenever there's a gathering, he hides in the old cottage on our grounds and just peeks out at us from the screen door as if to say, 'Go home, all of you.'"

OVERLEAF:
DONNA RUSKIN
BLACK AND WHITE KITTEN,
LAKE COMO, ITALY, 1994

"This kitten, whom I found crouched atop a wall in a town north of Lake Como, was very skittish. I'm amazed he stayed around as long as he did."

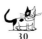

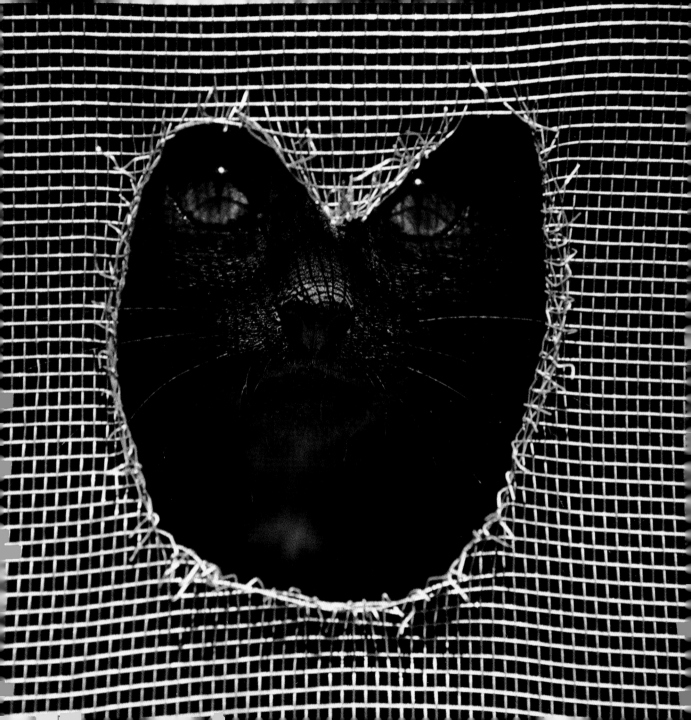

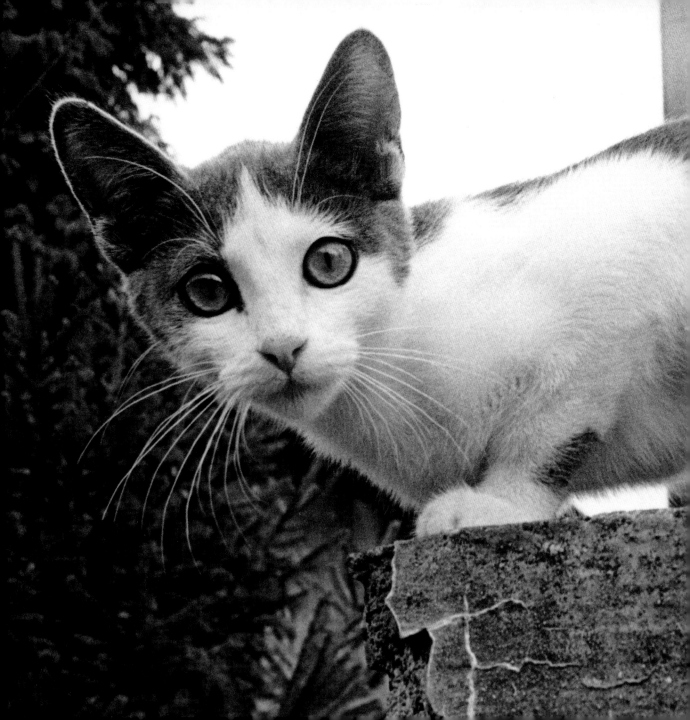

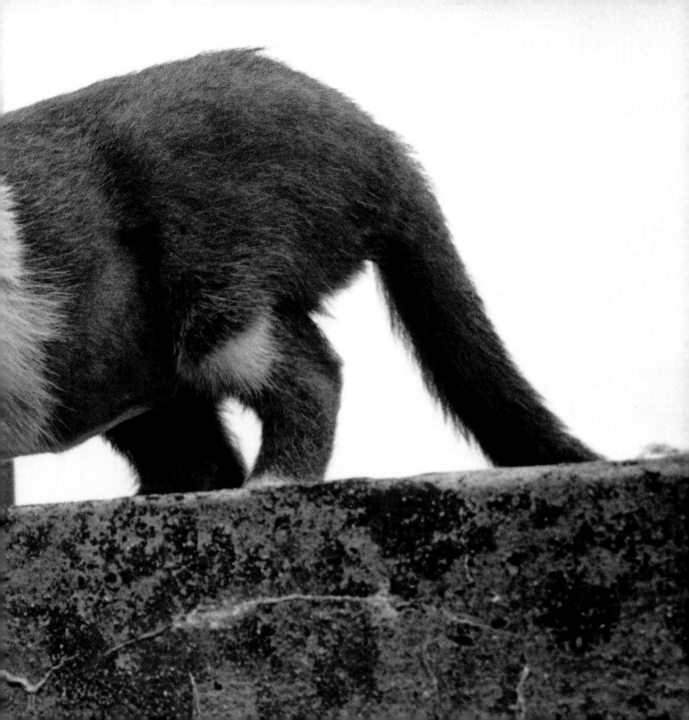

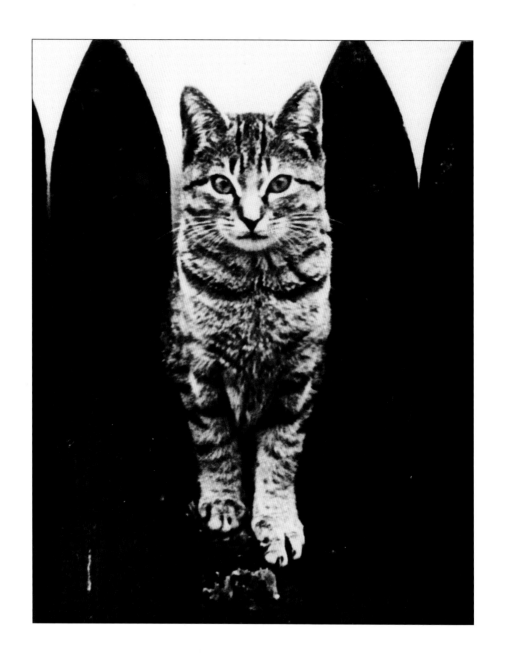

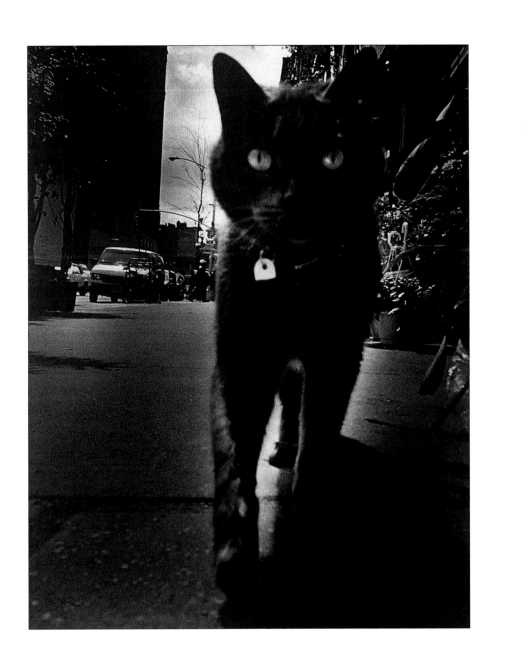

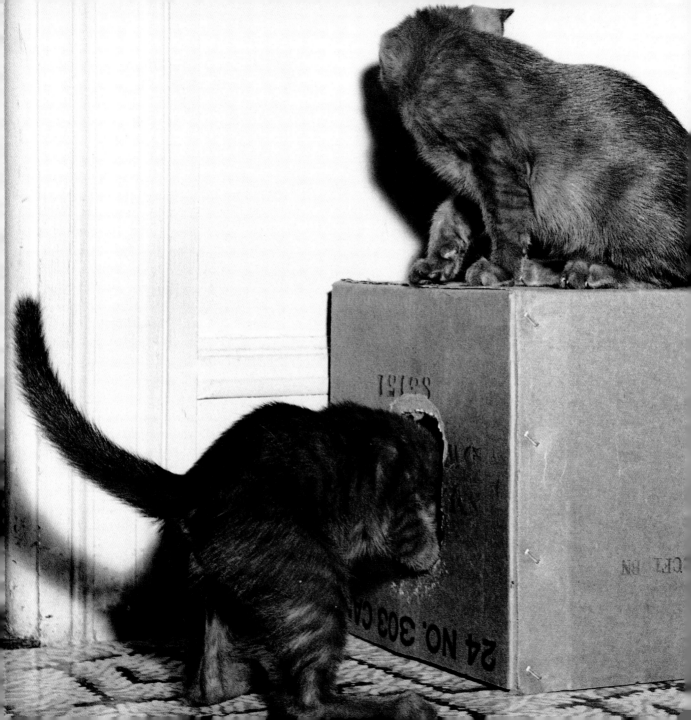

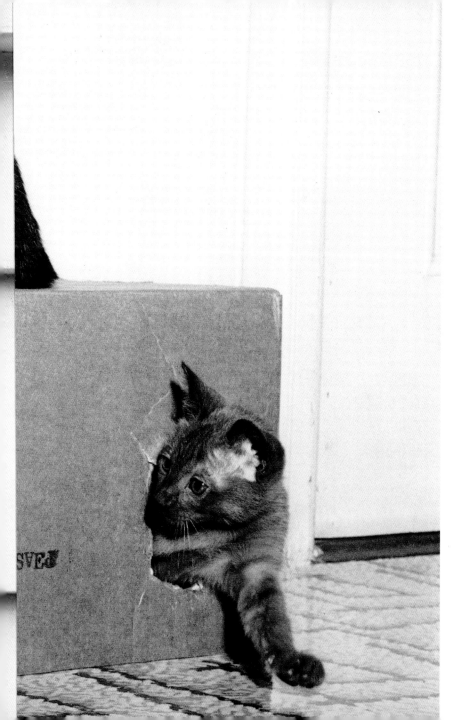

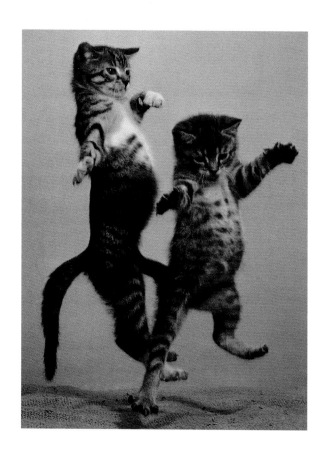

YLLA
Kittens in the Air
New York City, 1951

right:
PHOTOGRAPHER UNKNOWN
Hang On
Philadelphia, c. 1942

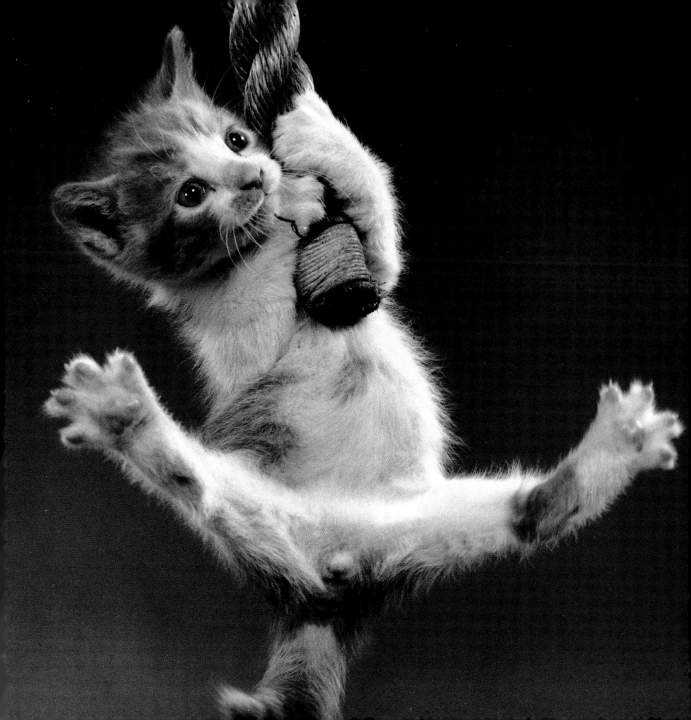

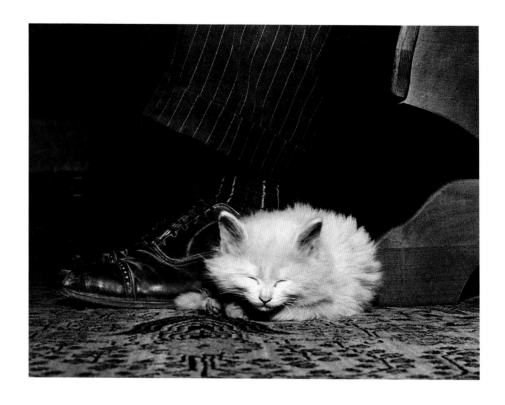

WALTER CARLOCK
Untitled
Ramsey, New Jersey, 1940

Opposite:
WALTER CHANDOHA
Paula Chandoha and Our Kitten Smiling
Long Island, New York, 1956
"The kitten was called Smiling for obvious reasons.
He was about eight weeks old here, the little mayor
of our city of daughters and cats."

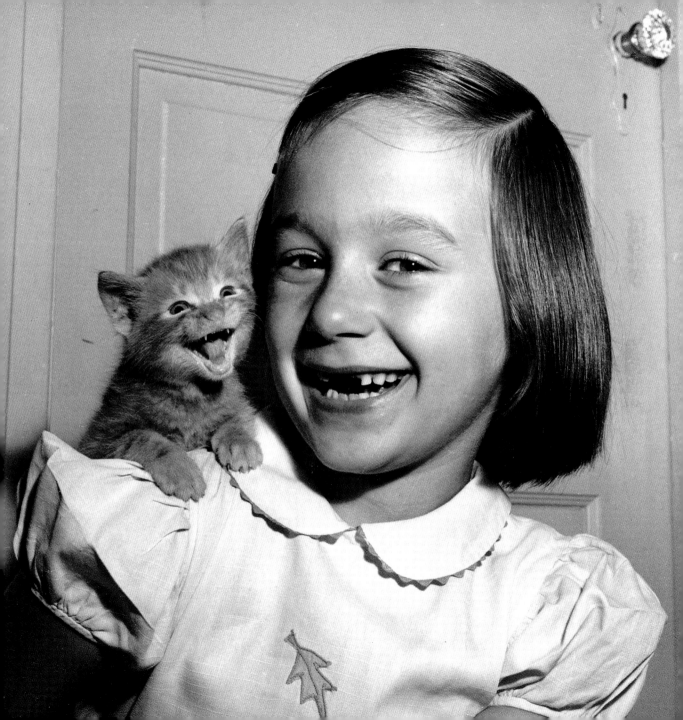

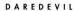

DAREDEVIL

Kook, my Siamese kitten, has prevented me from getting any sleep for the last three weeks. He has discovered that he has claws. At around midnight, just when I am trying to finally fall asleep, he gets wild. He likes to free-climb the curtains all the way up to the rods and then try to kill the curtain rings. I hear them rattling under his busy paws, and then I know I'm in for it. The next thing that happens is that he comes flying through the air, having propelled himself off a curtain rod, and lands on my bed—usually right on top of me, with all four paws extended. He also likes to leap onto my shirt and then rappel down my pant leg. Serves me right, I suppose, for those long hours I leave him alone when I go teach my slow fellow-humans how to climb.

CARL STERLING, CLIMBING INSTRUCTOR, BOSTON

RIGHT:
DAVID McENERY
HER SURROGATE, BEAULIEU, FRANCE, 1996
"Claude, our neighbor, had adopted a small Siamese kitten whose mother had been hit by a car. I was visiting Claude one afternoon when I noticed the kitten had taken a fancy to the cat statue in the window. 'Perhaps,' said Claude, 'it replaces her mother.'"

OVERLEAF:
KARL BADEN
RADAR CAT, RHODE ISLAND, 1993
"At a cat show, one of the problems is finding a way to integrate foreground and background. But this cat obviously didn't care a whit about the background."

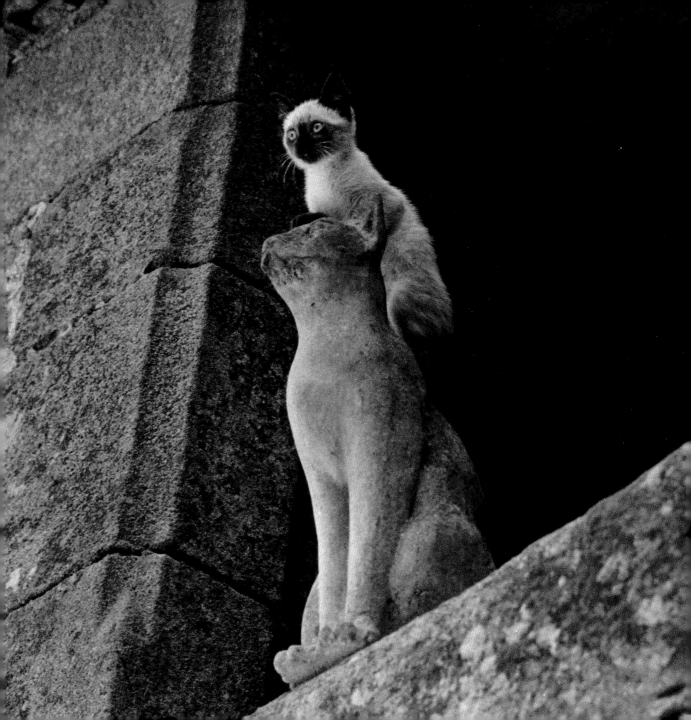

WALTER CHANDOHA
Let Us In
Huntington, Long Island, 1962

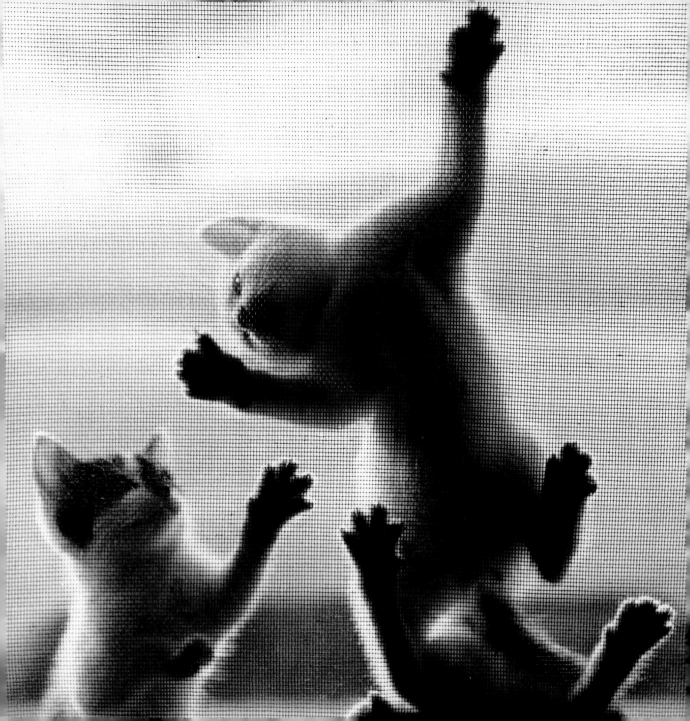

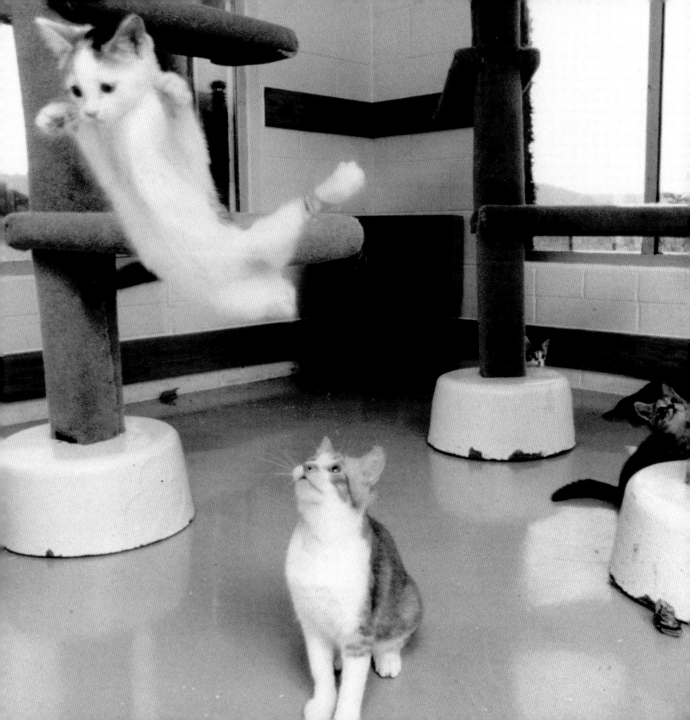

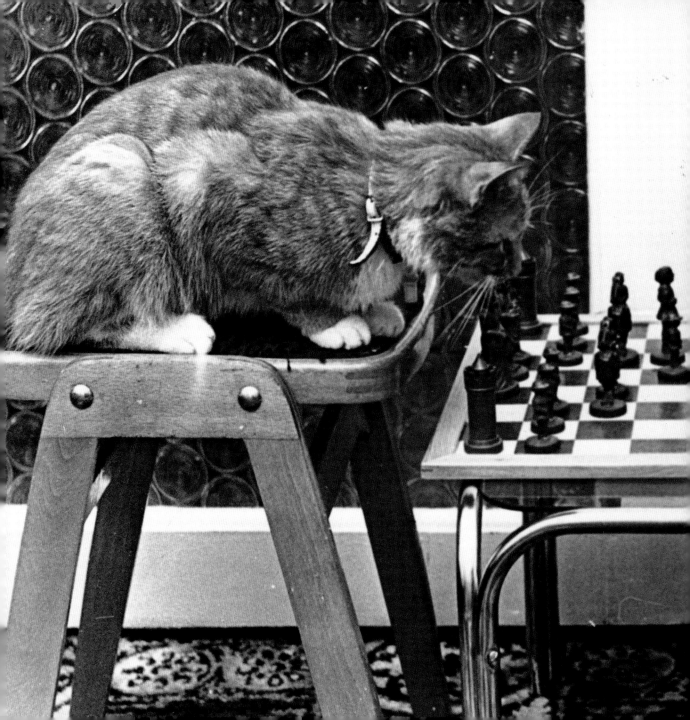

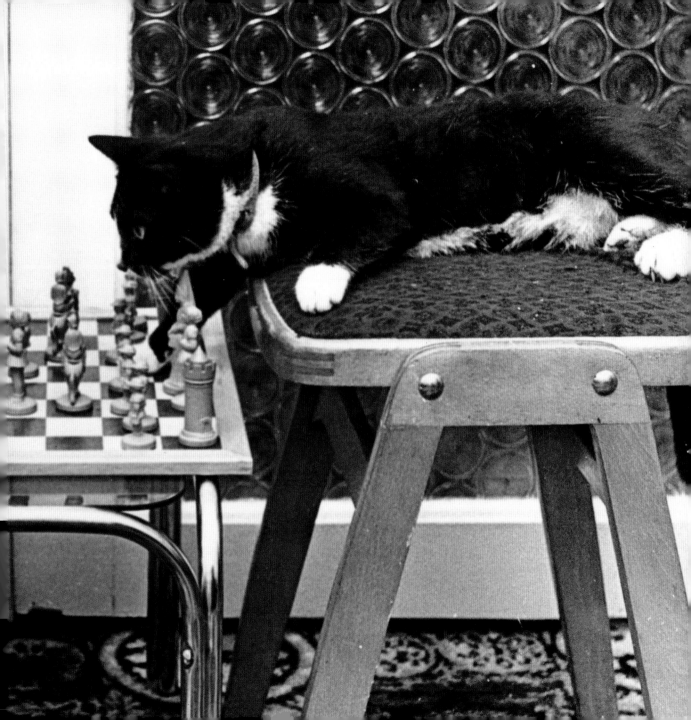

For having done duty and received blessing he begins to consider himself.

For this he performs in ten degrees.

For first he looks upon his fore-paws to see if they are clean.

For secondly he kicks up behind to clear away there.

For thirdly he works it upon stretch with the fore-paws extended.

For fourthly he sharpens his paws by wood.

For fifthly he washes himself.

For sixthly he rolls upon wash.

For seventhly he fleas himself, that he may not be interrupted upon the beat.

For eighthly he rubs himself against a post.

For ninthly he looks up for his instructions.

For tenthly he goes in quest for food.

CHRISTOPHER SMART
Jubilate Agno

WALTER CHANDOHA
OH, THAT FEELS GOOD, 1955

When we lived on Long Island I got my first cat, Loco—a very resourceful fellow.
He liked to sharpen his claws on the bark, as cats do. Then, always wanting to get more
for his money, he'd turn around to scratch his back.

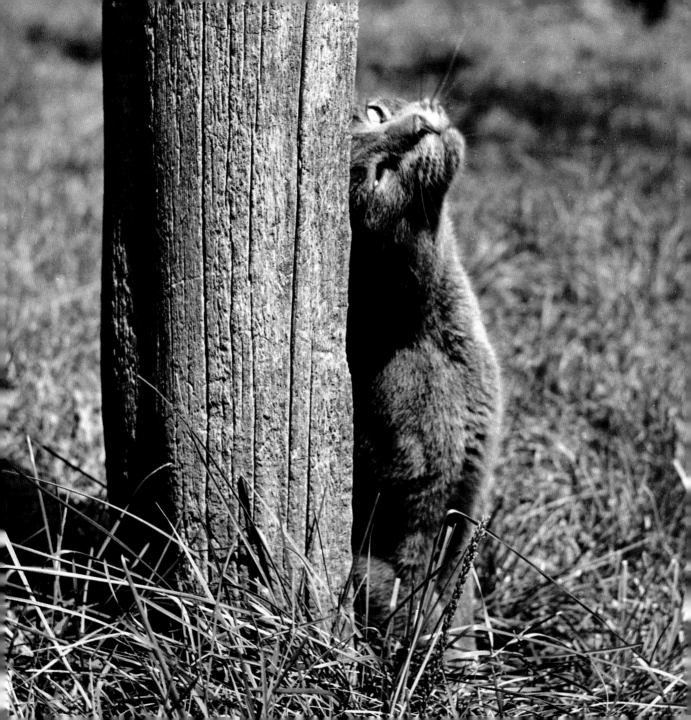

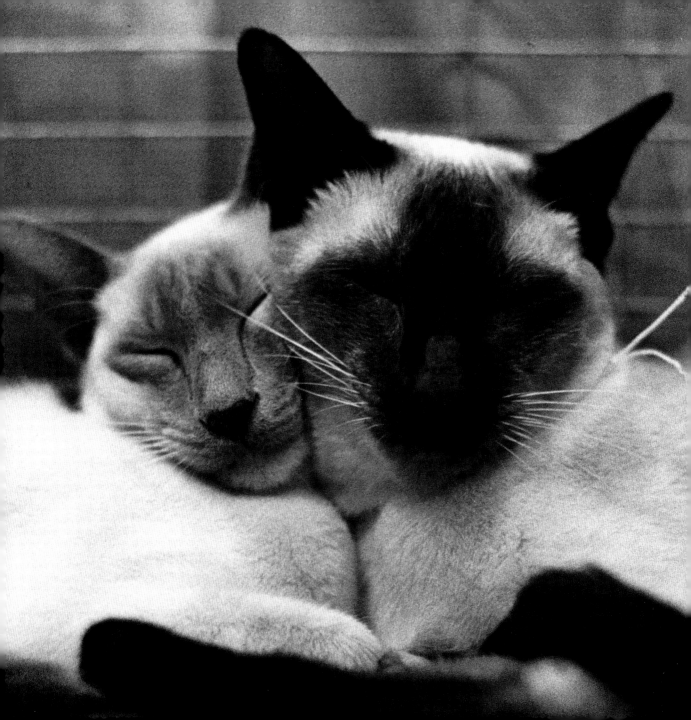

THOMAS WESTER

Consolation at the Cat Show

Nybro, Sweden, 1984

The trouble with a

kitten is that

eventually it becomes a cat

OGDEN NASH

LAURA STRAUS
Pippi
City Island, New York, 1999

overleaf:
THOMAS WESTER
Distraction
Vagnhärad, Sweden, 1992

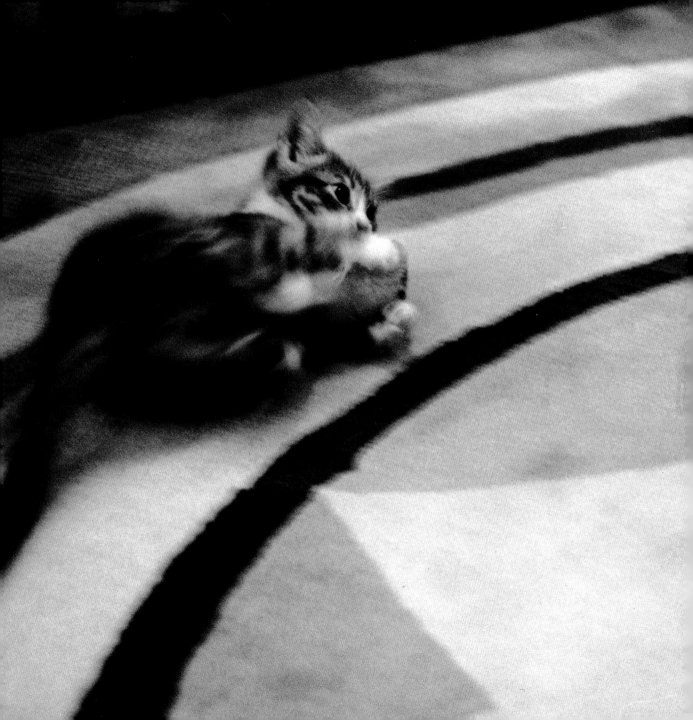

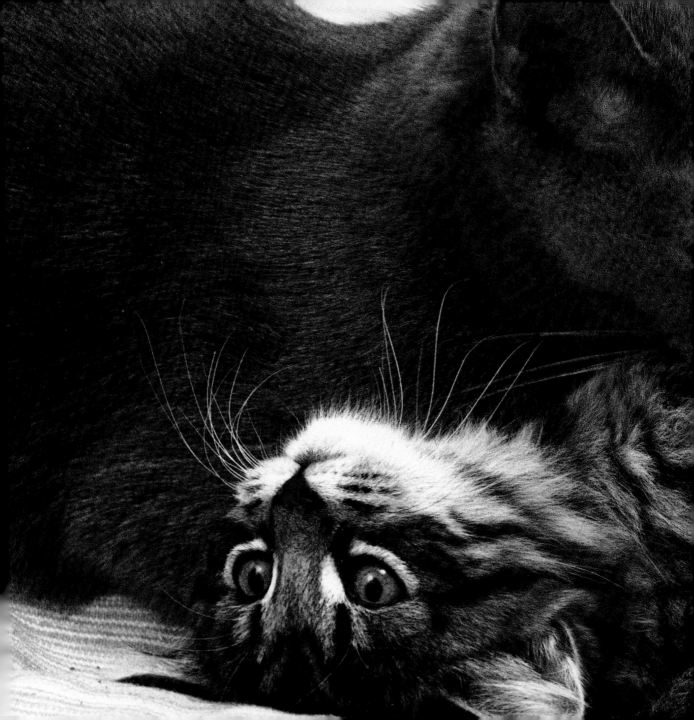

ANDREA MOHIN
Spike and His Pal
Washington, D.C., 1991
"We had just moved to this house and this was
Spike's first introduction to the backyard. You could say that
the cement cat solidified his introduction to the outdoors."

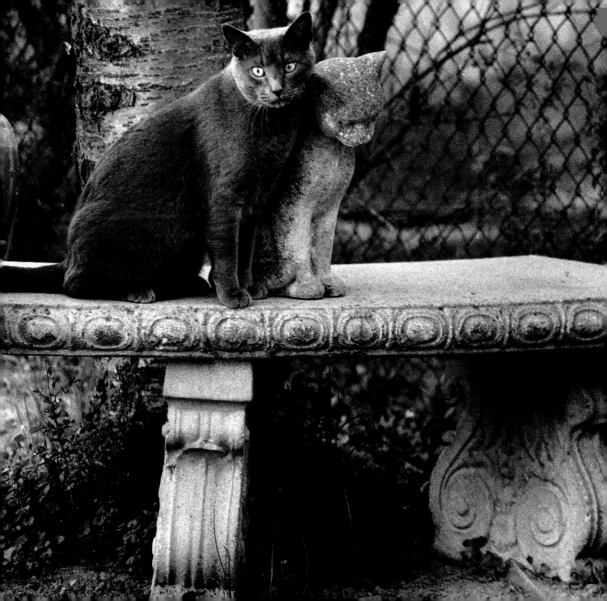

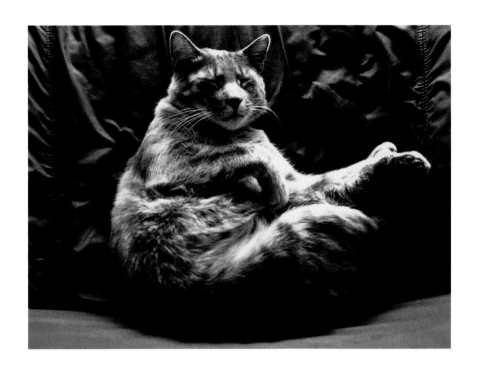

ABOVE:

MICHAEL NICHOLS

UNTITLED, BERKELEY, CALIFORNIA, 1980s

"Pearl was a male cat that we captured as a feral kitten and tried to
make into a housecat. In the five years we had him, he never really
became domesticated, but just roamed wild into our loft. For the
past two years I've been photographing tigers, and I really
don't see much difference between tigers and cats."

RIGHT:

DAVID McENERY

BOSS CAT, LOS ANGELES, CALIFORNIA, 1994

"Our son's cat, Jack, weighs sixteen pounds and eats everything in sight.
This is the way he likes to sit on the couch. He is a true couch potato."

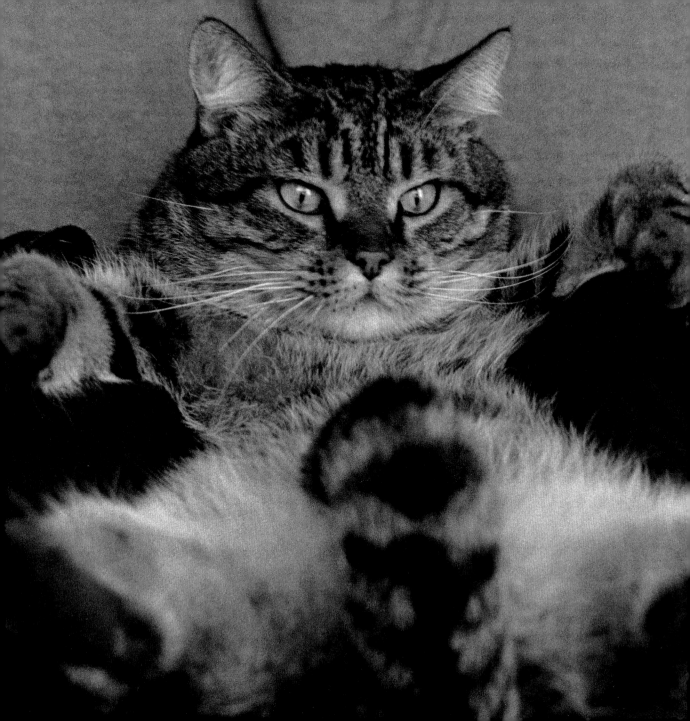

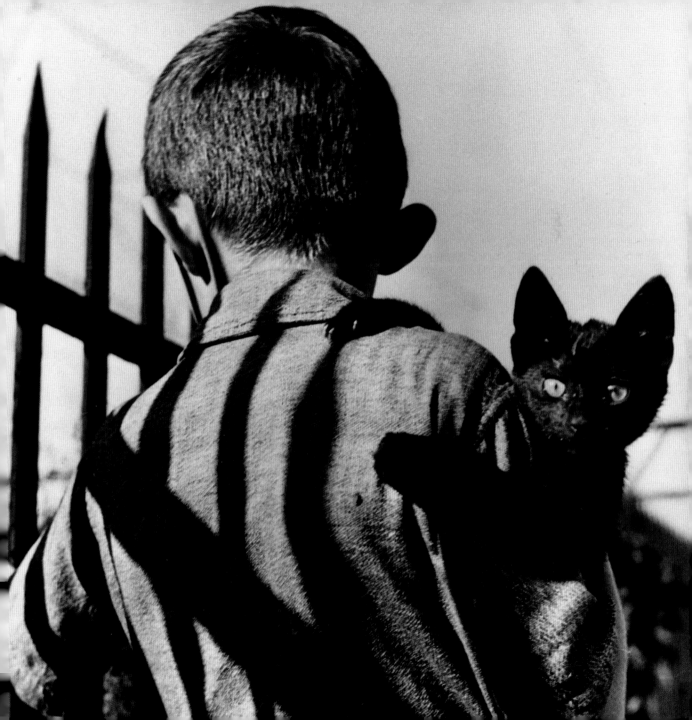

Sympathy Cat

WALTER CHANDOHA
Chiara and Ginger
Annandale, New Jersey, 1966

The year after my mother died, I would stay home alone on the weekends just trying to deal with it. I had this one cat named Nori-San who was black with a white triangle on his chest. He had green eyes and a sweet little voice. Normally he was pretty friendly—nothing remarkable. But during this time he became extremely loving. He'd come and nuzzle me or lick my ear, or he'd try to distract me with his antics. He'd keep at it until I cheered up. Once I got over my blue period, he reverted back to his old self, stealing my jewelry and hiding it under the sofa. One morning at 4 a.m. I realized I'd lost my watch and when Nori-San ran by, he had the watch in his mouth. I followed him into the living room and under the couch he had this little stash. There was everything I thought I'd lost. And he was perfectly willing to give it back. He was a very special cat.

MISSY ROGERS, CLOTHING DESIGNER

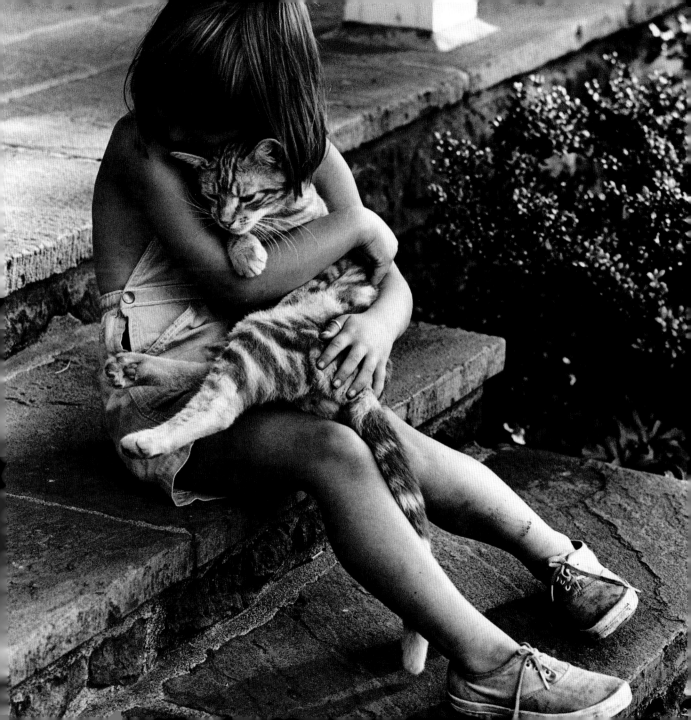

DAVID MCENERY
LOST NOTE, 1992

That's Lovejoy, our own kitten. He's a very curious cat.
You just leave him alone and let him go.

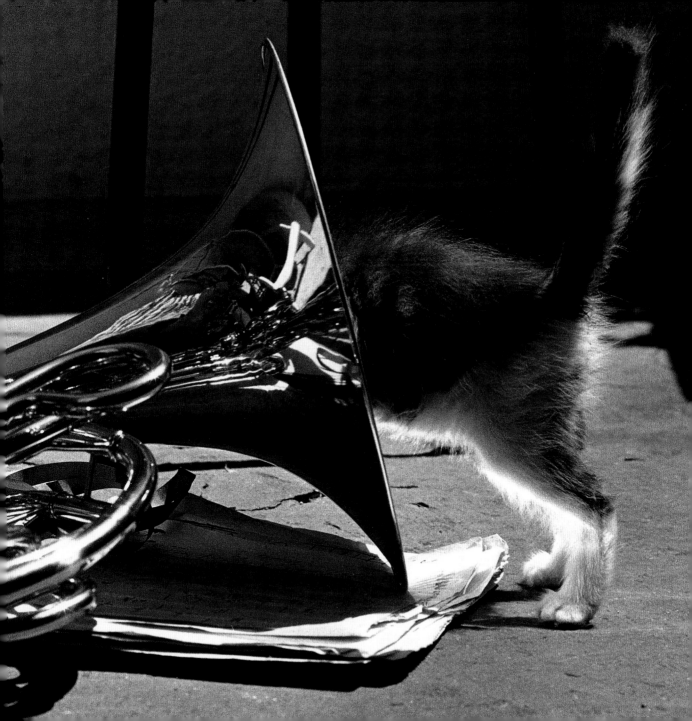

Domesticity

I rescued two kittens living in the barn on my mother's farm and brought them back to New York. My place was a loft, one big room. For exercise they'd have daily indoor steeplechases. Their course was always the same. They'd start on my bed, race across the floor and over my desk, knocking anything they could to the floor, then leap six feet onto the dish rack, with extra points if something fell and made a huge clatter, then into the sink to splash dishwater everywhere. Then they'd leap back to the floor, circle the columns at full tilt and make a mad dash back to the finish line, which was at the top of the silk curtains. The girl kitten, a real toughie, always won.

CAROLANNE PATTERSON

ARTIST

MANHATTAN

PHOTOGRAPHER UNKNOWN
Who's the Fairest One of All?
U.S., c. 1945

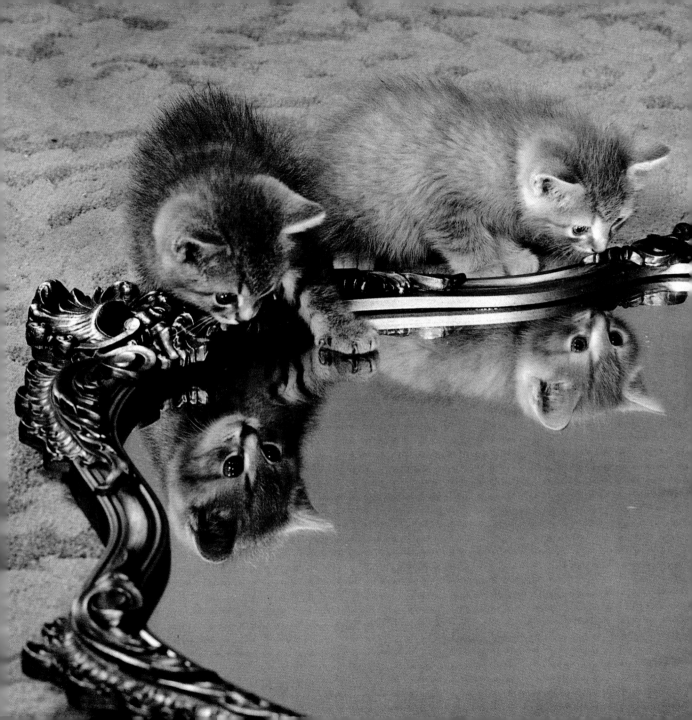

WALTER CHANDOHA
GREENWICH VILLAGE, NEW YORK, 1954

My friend Mabel Schezleri was the cat columnist for the old World Telegram.
Her nom de plume was Henrietta Hitchcock. One day we were just fooling around and her cat
got onto the kitchen table and sat in the bowl.

OVERLEAF: WALTER CHANDOHA
HERE'S LOOKING AT YOU, NEW YORK, 1956

This was taken in a New York apartment. The kitten, a Siamese,
just rushed up to the mirror and started staring.

74

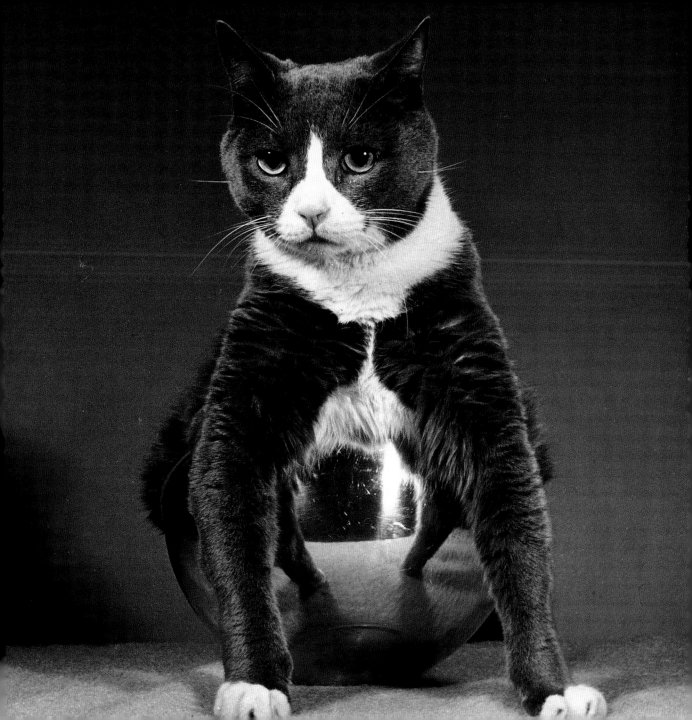

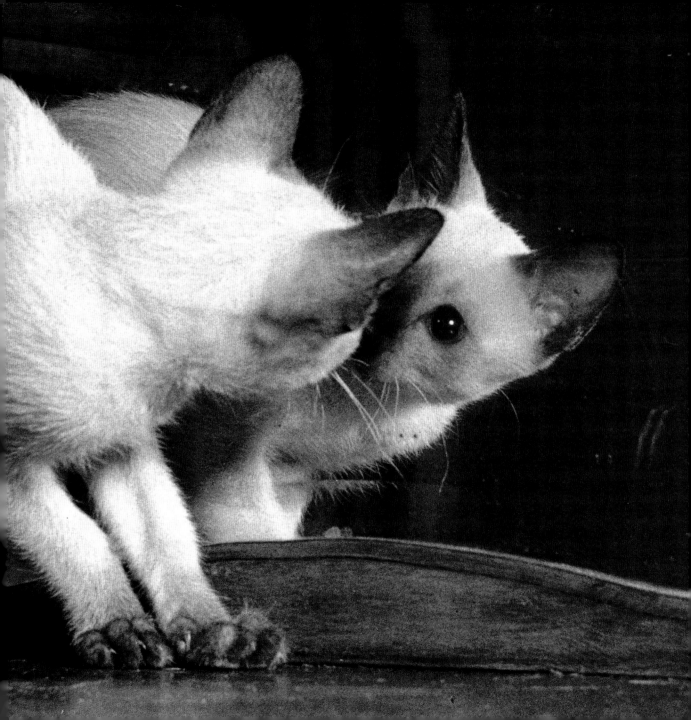

Kitty Gimmicks

Kittens are like old comedians. They always use the same shticks. There's the scaredy-kitten stance, the vampy butt-in-the-air move, the you're-so-boring-I-could-die glare, the monster-under-the-sheets attack, and of course the I'm-so-little-how-could-you-possibly-get-mad look. The gimmicks work, so why change them?

<div align="center">

VARDA MILLER

ASPIRING COMIC

CHICAGO

</div>

<div align="center">

JAYNE HINDS BIDAUT
"Kitten," from the "Animalerie" Series
Paris, 1987

</div>

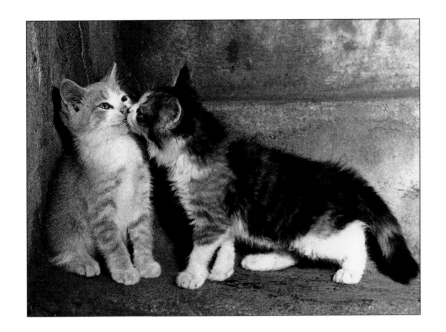

WALTER CHANDOHA
Farm Kittens
Landisville, New Jersey, 1954

Opposite:
WALTER CHANDOHA
Kissing Cousins
Huntington, Long Island, 1959

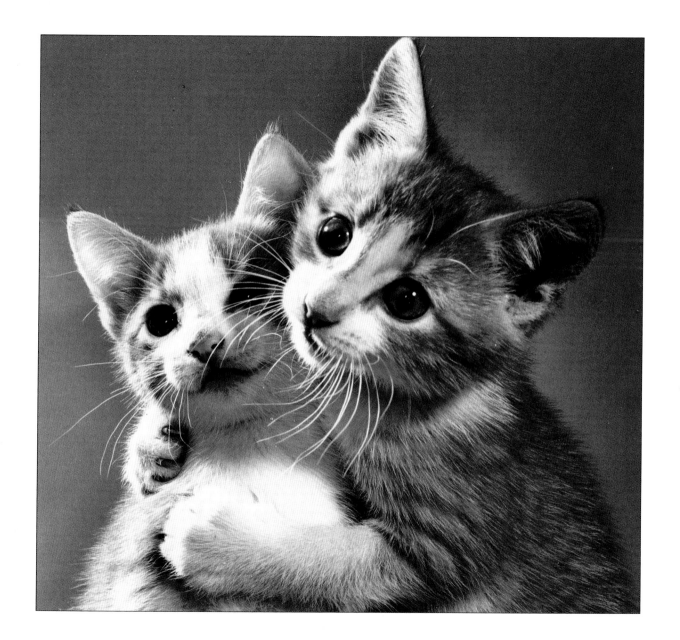

Maurice

WALTER CHANDOHA
Minguina and Kitten
Huntington, Long Island, 1952

Maurice's mother climbed into my lap to have him and three other kittens. Maurice slept with me every night from that day until he was well into his second year. One day, I had to go to Puerto Rico for a long weekend to work on a film. When I got back, he seemed totally disheveled and bleary-eyed. Unused to sleeping by himself, he had paced around the whole time.

As he got older he grew quite large, to about twenty pounds. And he was clumsy. Whenever he'd see me, he'd flip over on his back and the whole room would shake.

Needless to say, he slept with me for the rest of his life.

J.C. SUARÈS

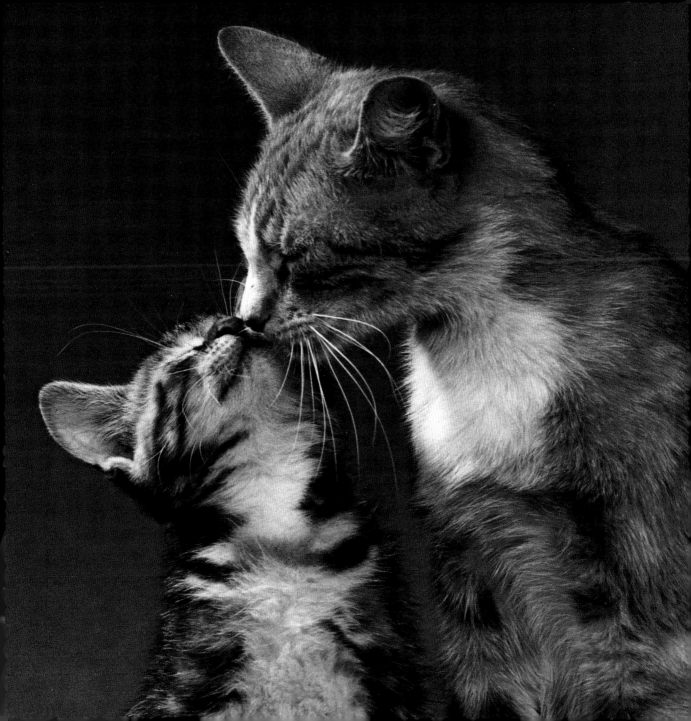

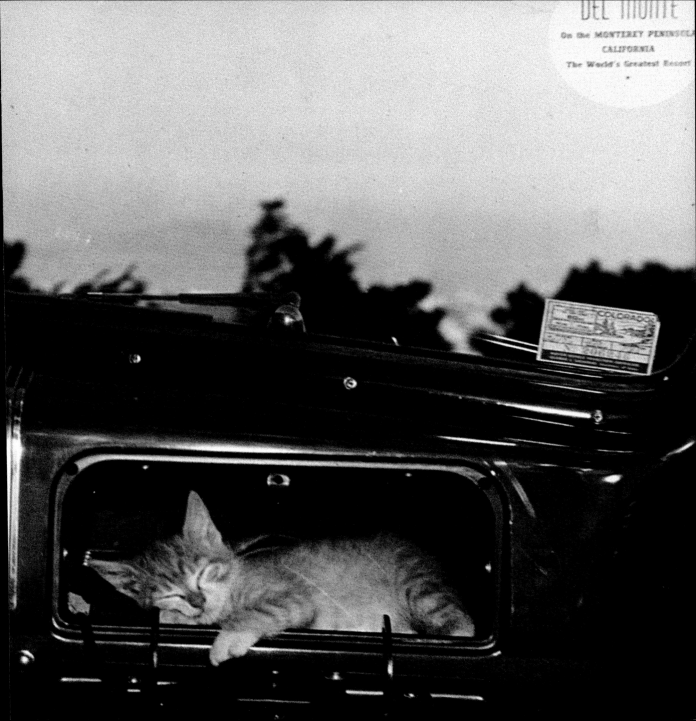

No matter how much cats fight, there

always seem to be plenty of kittens.

ABRAHAM LINCOLN

preceding pages:
PHOTOGRAPHER UNKNOWN
Dashboard Kitty
Denver, Colorado, 1946

right:
THOMAS WESTER
My Fantastic Chance
Vagnhärad, Sweden, 1992

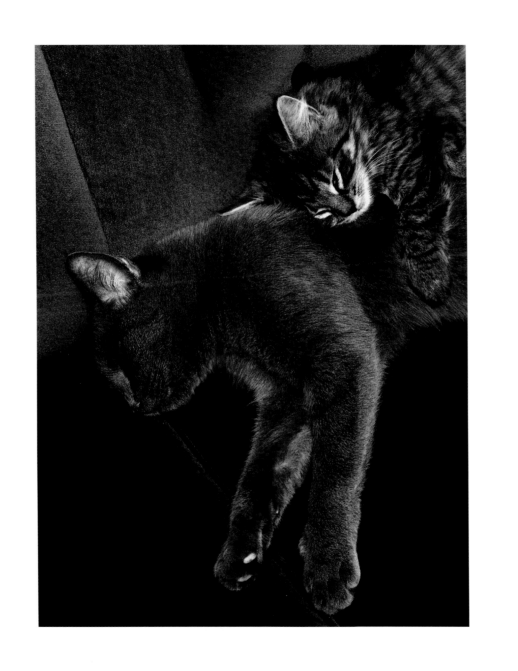

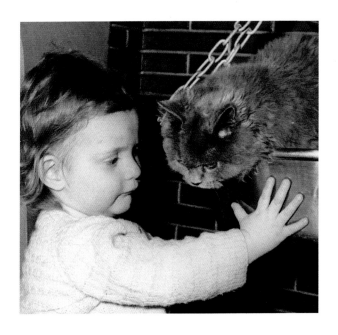

At the annual show presented by the Cat Circle of
Paris, this Blue Persian makes his first appearance.
The cat's young mistress, however, thinks more of him
as a playmate than as a prospective champion.

(Original caption, circa 1963)

Little Gordon Peters, two years old, carrying his Blue
Persian kitten, Minnow, into the Royal Horticultural Hall.

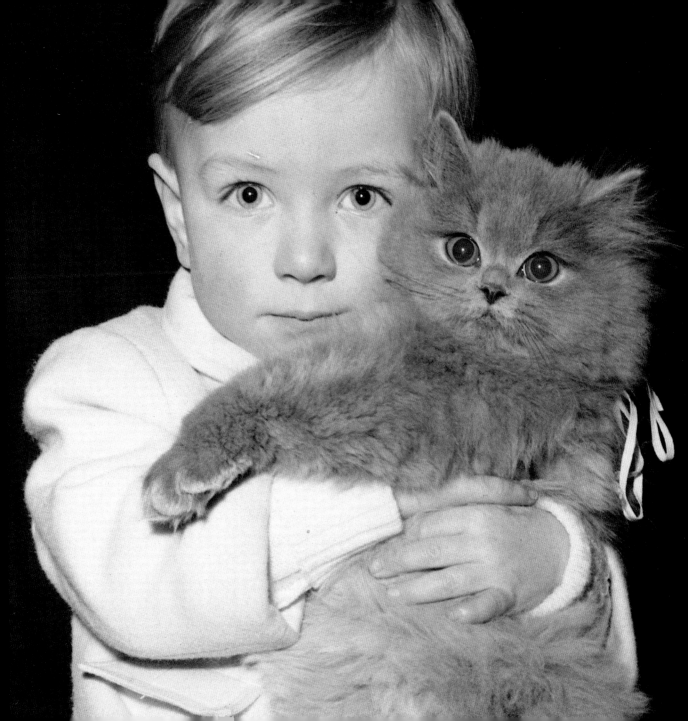

PHOTOGRAPHER UNKNOWN
Desiree Sampson and Her Cat Billy
London, 1950

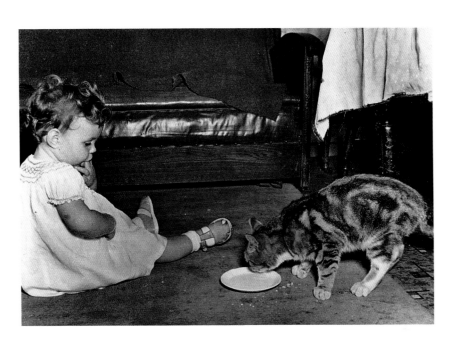

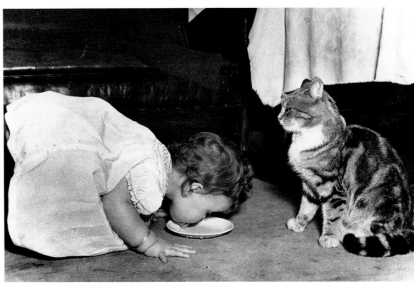

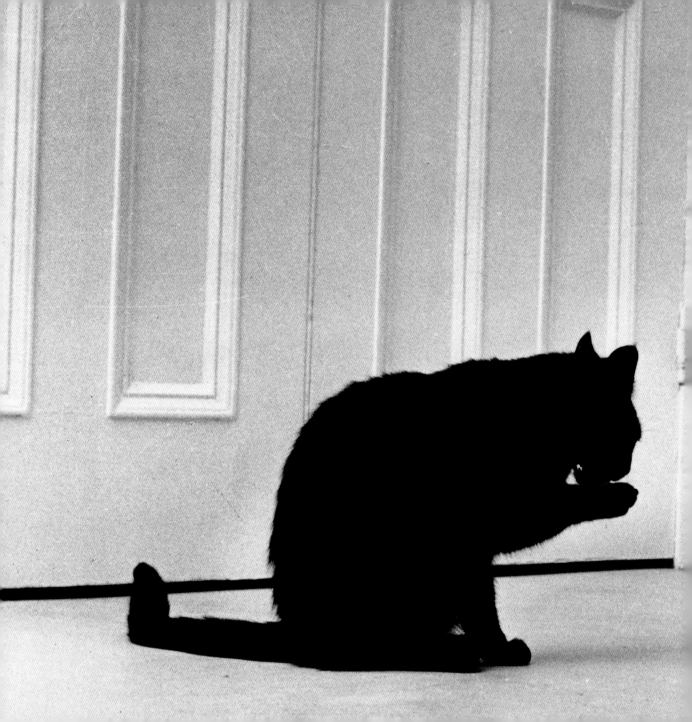

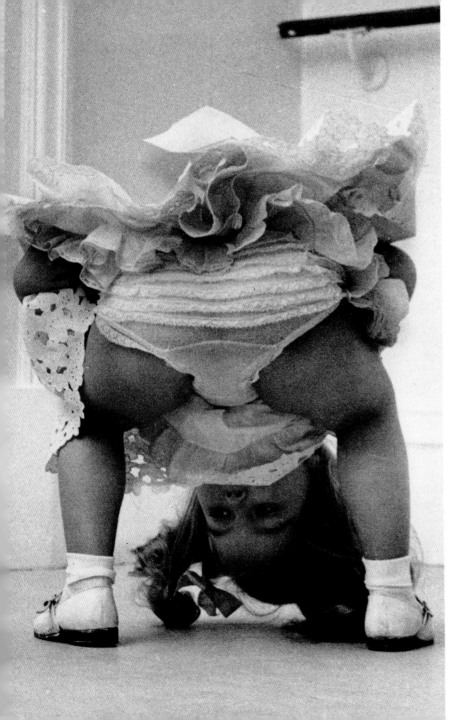

LEFT:

**JOHN DRYSDALE
PEEK-A-BOO,
LONDON, ENGLAND, 1990**

"The pianist for a London toddlers' dancing class used to bring her cat, which always distracted the kids. The cat, on the other hand, never seemed too interested. One afternoon, while it was grooming itself — typically oblivious to the goings-on — one little girl decided an inverted view of the cat was far more interesting than an arabesque. True to form, the cat ignored the entire spectacle."

93

How to Bond with a Dog

THOMAS WESTER
Natural Enemies
Stockholm, Sweden, 1984

One of my own cats, a champagne tabby named Stain, fell in love with my dog over the course of a month when they were both in the house a lot. It was the rainy season in Arizona, and the animals preferred the confines of the house to the stormy outside. Stain had never given the dog much attention. But suddenly, he seemed overcome by an incredible desire to spend every minute, waking or not, at her side. She is a gentle, playful German Shepherd, more curious than aggressive. At first she'd lie on the floor, her side against the front door in her customary way, and Stain would come marching up, his tail held kitten-high, and head right for her face. He'd brush himself against her two or three times until finally she gave him a lick. Thus encouraged, he'd come back for more, beginning to purr and playfully box her nose with a paw, until finally she began to wag her tail. When he sensed she'd accepted him, he steadied himself and jumped clear onto her back, wedging himself between dog and door. If she got up to find privacy, he'd rush between her legs, slowing her down, lying on his back and poking up at her. After a week, she relented. From then on she expected him to be at her side, and he was. At mealtimes, on walks, even when I took her for a jog—Stain would follow close behind, never letting her out of his adoring sight.

JANE MARTIN

Overleaf:
THOMAS WESTER
Natural Enemies Continued
Stockholm, Sweden, 1984

94

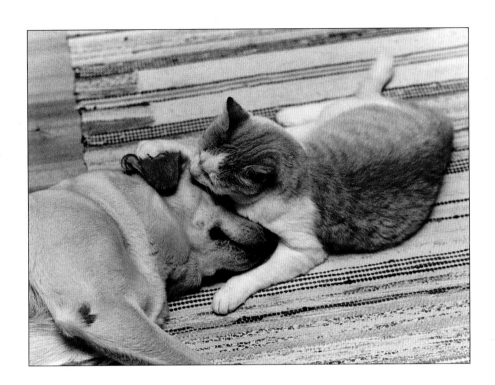

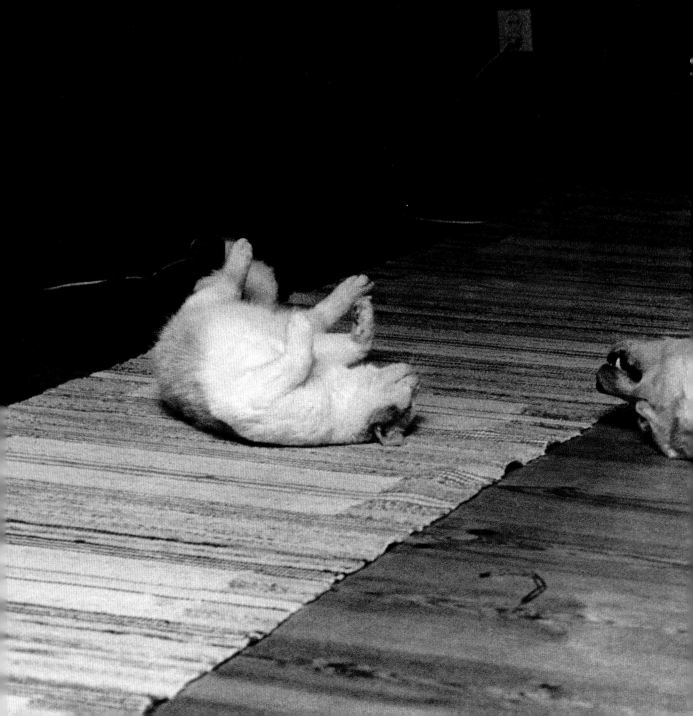

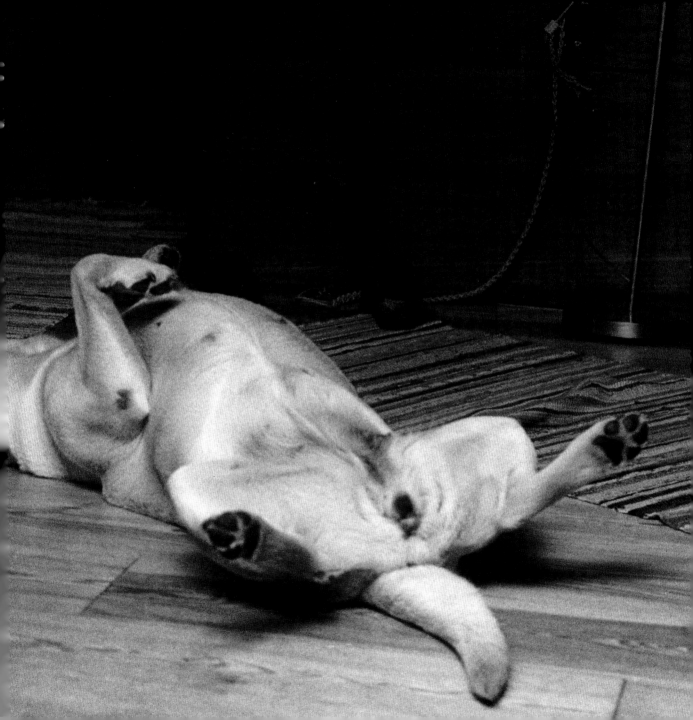

I'M FINE, REALLY

Batty, my cat, is enormous, but she moves pretty fast. The only thing is that she sometimes gets stuck in places. My friend came over with her dog, and Batty hates dogs. First she puffed herself up to twice her size, which made her look absolutely obese. But she thought she looked really tough. Then, when the dog didn't get scared, she charged. The dog didn't move. So at the last minute Batty veered away and dashed behind the armchair. Somehow she got herself wedged in there, though I didn't know it. I just thought she was hiding. Hours later, my friend and the dog had gone, and I heard a plaintive little meow coming from behind the chair. There was Batty, stuck in the funniest position, all four paws off the ground and her belly stuck between the back of the chair and the wall. She had kept her cool until the dog was gone rather than admit she needed help.

DEANNA CHUI, LAWYER, BROOKLYN

RIGHT:
ANONYMOUS
WHITE CAT, U.S., 1950s
At home on the moving edge of a rolling
wooden ball, this white cat keeps its cool.

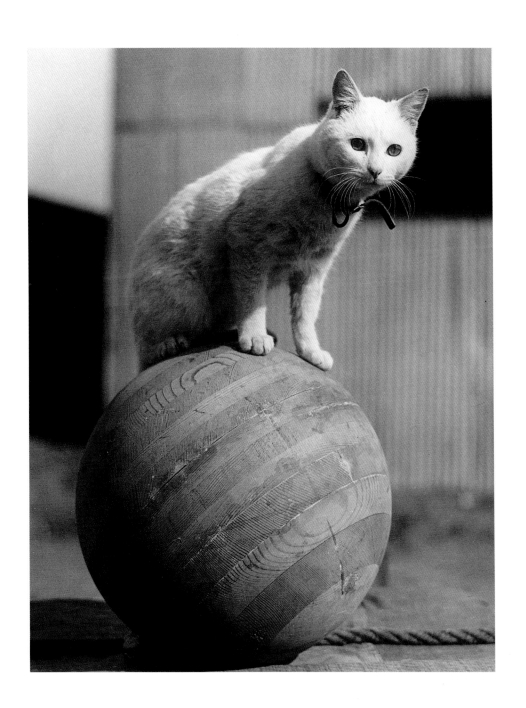

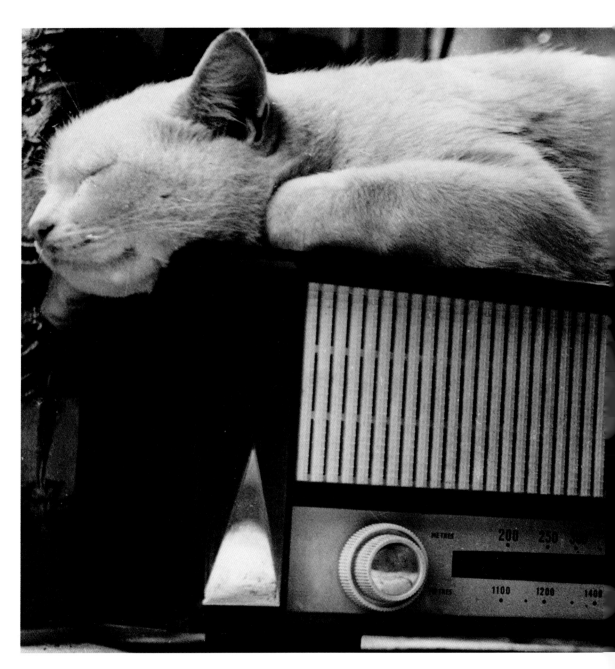

**UPI PHOTOGRAPHER
O SOUL O MEOW,
BIRMINGHAM, ENGLAND, 1961**

"The Birmingham man who owned this
cat declared him '50 percent Siamese
and a 100 percent musical snob.'"

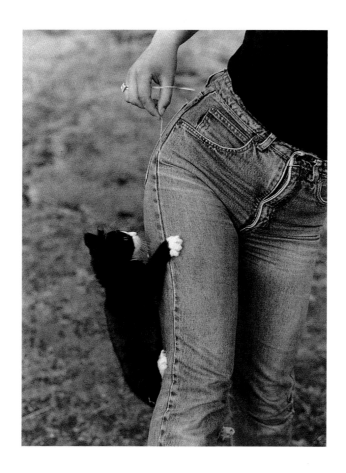

THOMAS WESTER
Kitten Climbing Blue Jeans
Utlängan, Blekinge Archipelago, Sweden, 1983

right:
Kitten on Telephone Pole
Skärblaka, Sweden, 1984

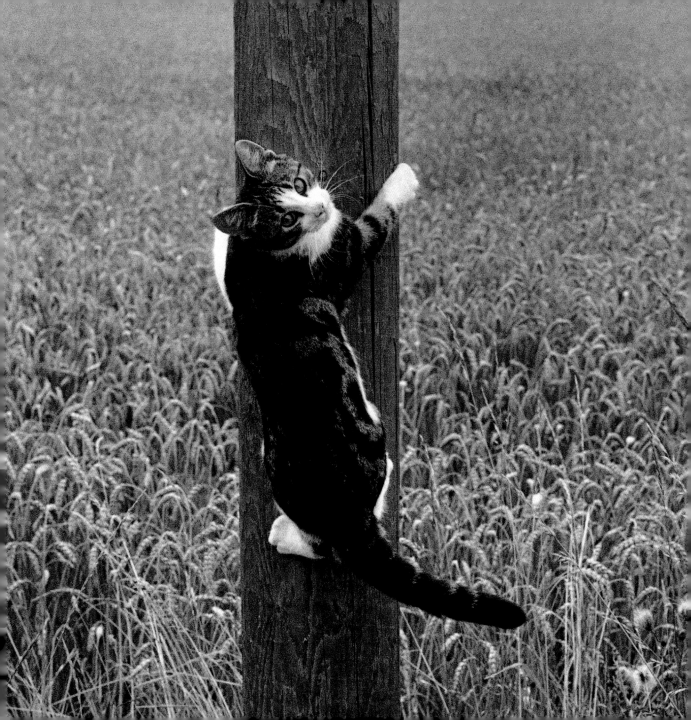

DAVID McENERY
Daisy at the Sweater
Los Angeles, California, 1994

overleaf:
TERRY DeROY GRUBER
Chapin Nursery School
Upper East Side, New York City, 1979

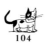

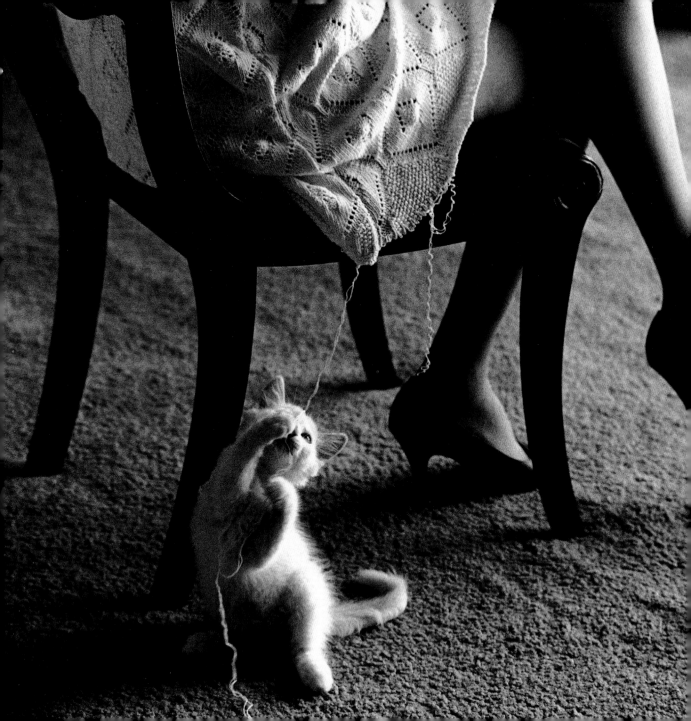

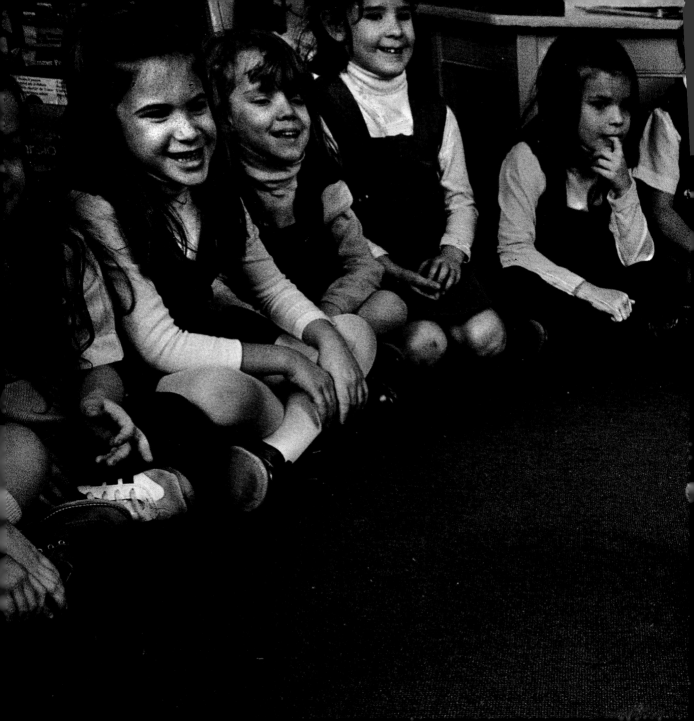

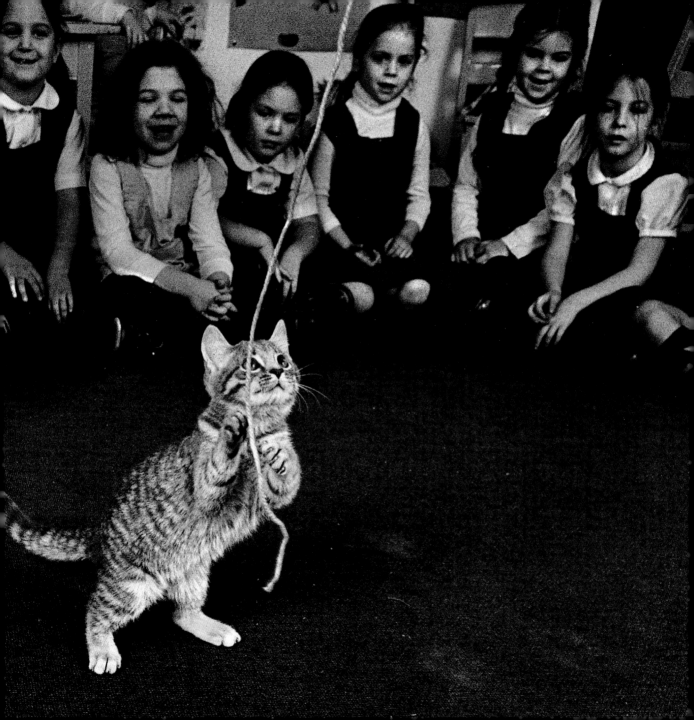

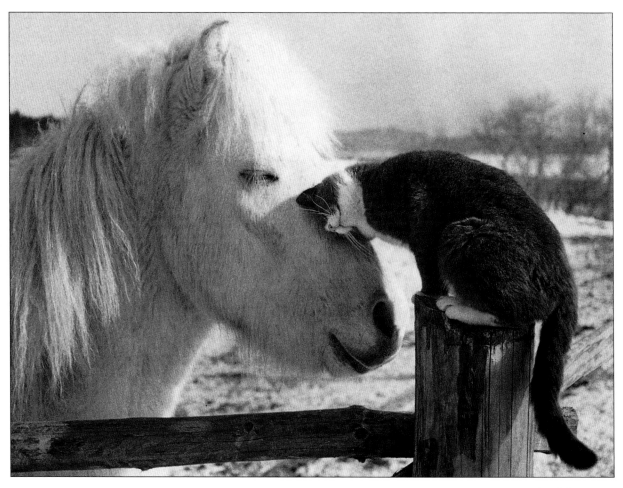

PER WICHMANN
In the Field (series)
Sweden, 1989

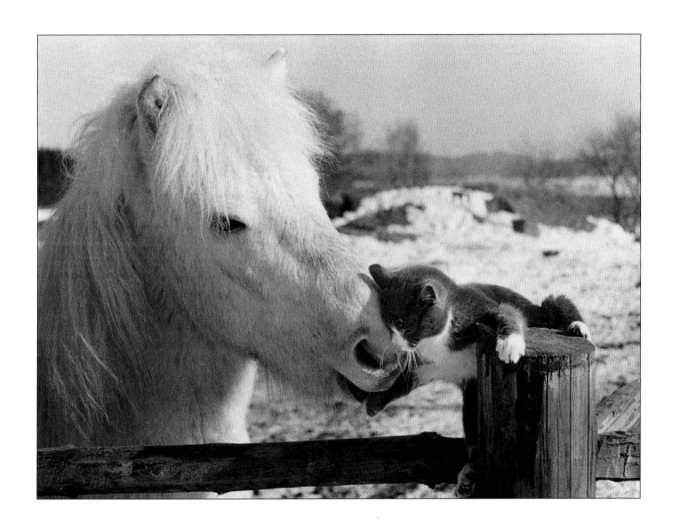

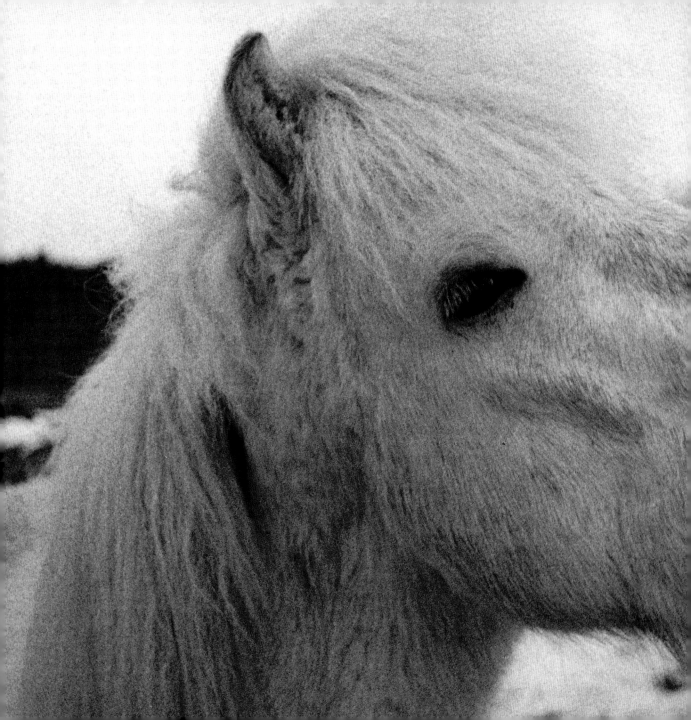

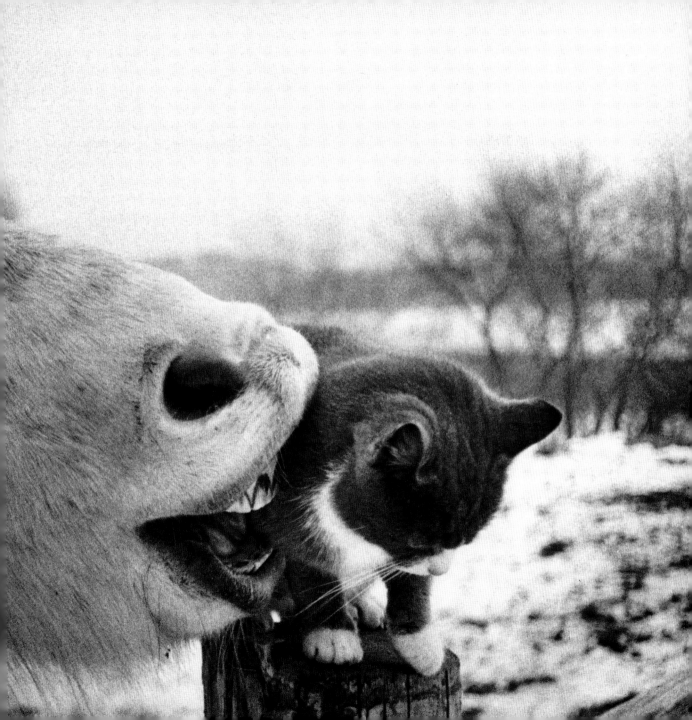

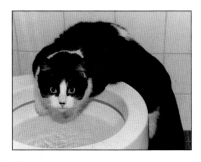

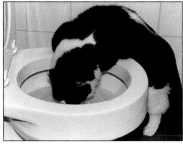

ABOVE:
ROBIN SCHWARTZ
BROOKLYN, NY, 1996

"Fat cat Walter loves to watch the water swirl in the toilet bowl.

RIGHT:
ROBIN SCHWARTZ
BROOKLYN, NY, 1996

Walter gets a big hug from his owner, Angela.

OVERLEAF:
JOHN DRYSDALE
HASLEMERE, ENGLAND, 1979

Marvin began life as a sickly kitten who was fed from an eyedropper. He grew up on a gourmet diet of venison, salmon from Scotland, steak, chicken, and vitamins with ice cream. Marvin refused all cat food and preferred a ride in the family's vintage chauffeur-driven car to chasing mice in the garden. Marvin always traveled on his own velvet cushion.

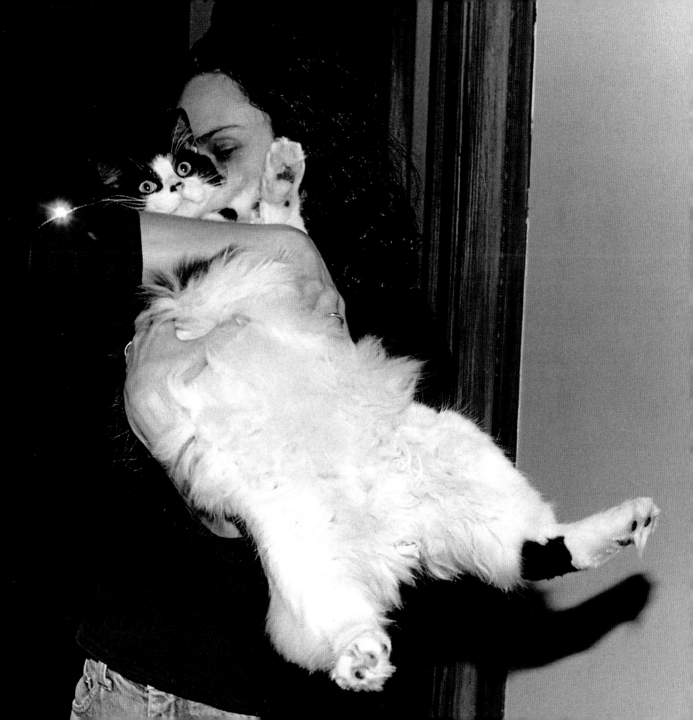

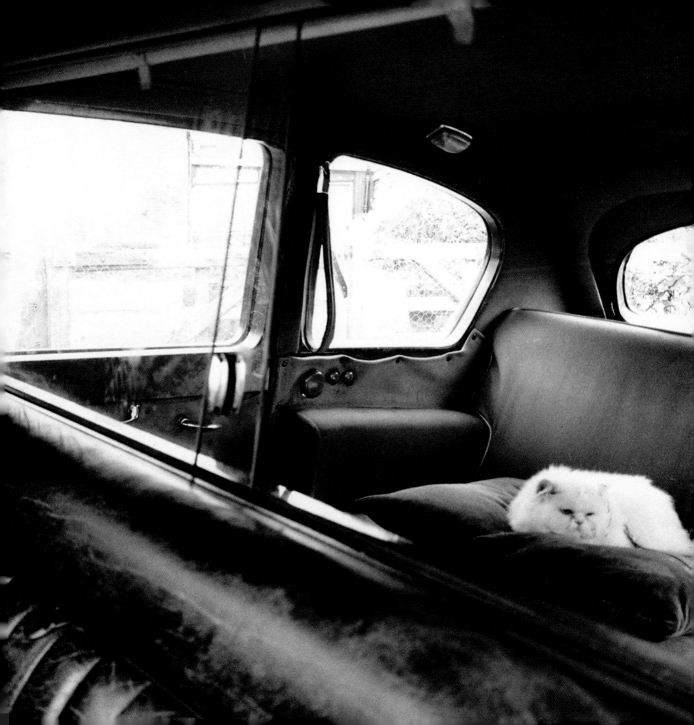

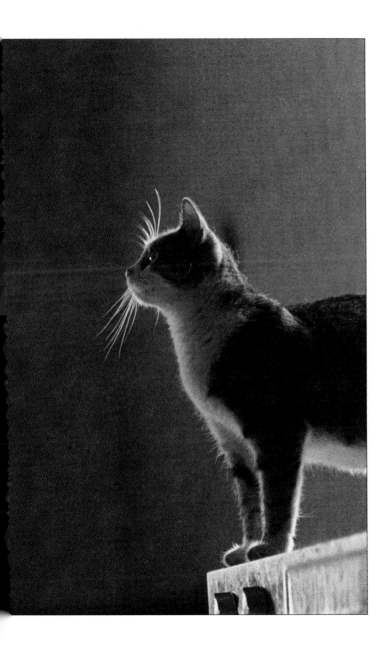

THOMAS WESTER
Maj Stina Larsson
Yttemas Roslagen,
Sweden, 1984

My cat Aretha hates loud rock, but she loves the sound of a good song. If I go to the piano and play something she likes, she'll come over to listen. She prefers something low-key, but she'll really get into the blues if she's in the right mood. She doesn't mind guitar, though she prefers it acoustic. And she hates the drums. I had a piano student who liked her a lot, and he used to bring her treats, like a can of tuna or sardines. After Aretha devoured the entire thing, she'd get up on top of the piano and roll over onto her side to listen to him play. She'd loll on top of that piano and purr for an hour while my student practiced his rolling bass lines.

S.A. SLIM, MUSICIAN, NEW ORLEANS

RIGHT:
DAVID McENERY
HIGH C,
LOS ANGELES, CALIFORNIA, 1994
"This is our cat, Lovejoy. He'd fallen asleep inside the guitar case, and when he woke up, he gave a big yawn. Anything we leave laying around, Lovejoy adopts and falls asleep in it."

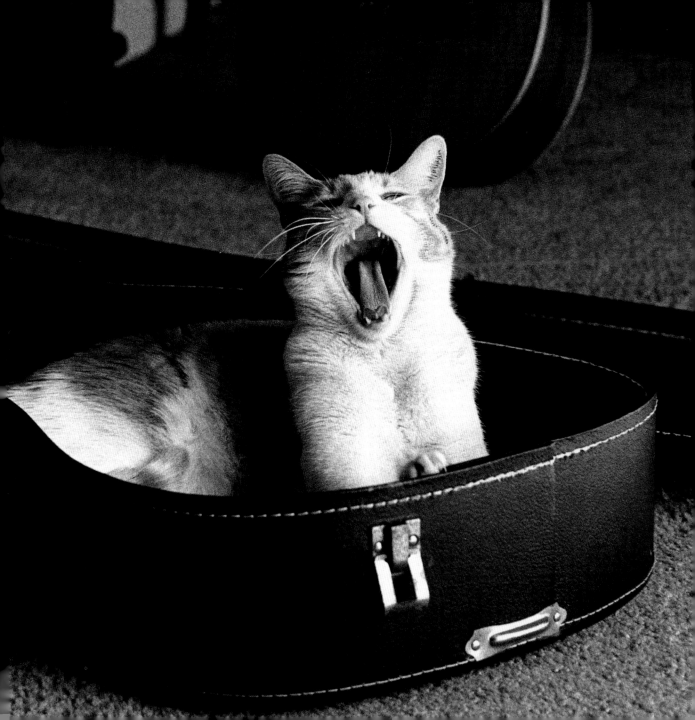

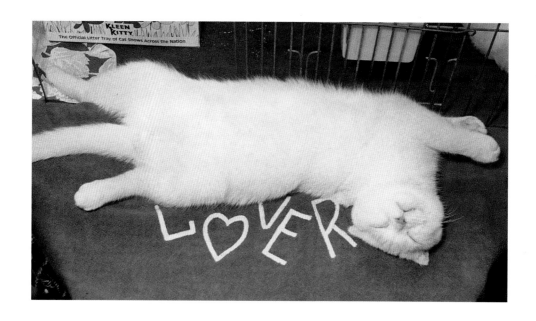

KARL BADEN
LOVER, BOSTON, 1992

"This cat was rolling around, trying to seduce me.
Fortunately, or maybe unfortunately, I resisted."

RIGHT:

ANN FINNELL
SAM, NEW YORK CITY, 1997

"Sam, our domestic shorthair tabby, knows when I'm
taking his picture. He likes to get into as feline a posi-
tion as possible, preferably on my favorite armchair,
and do a little on-camera demonstration of how impos-
sibly supple and adorable cats are — as opposed to
people, who can't quite stretch out the same way."

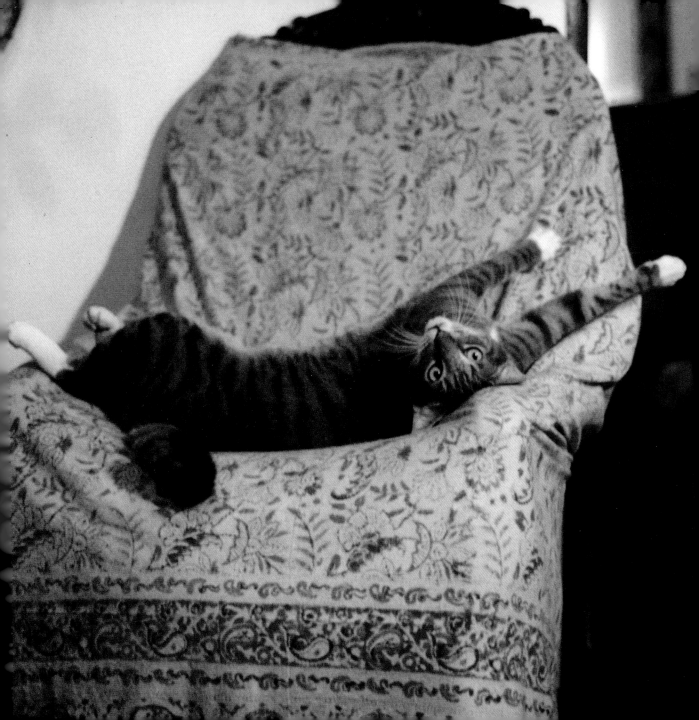

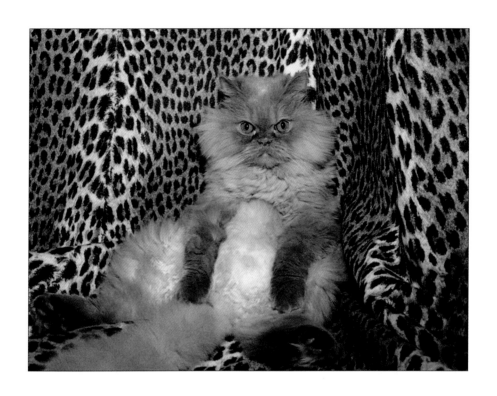

ABOVE:

ROBIN SCHWARTZ
SONY,
NORTH BERGEN, NEW JERSEY, 1997

"Sony, a very pretty cream Persian,
likes to sit on her behind like a person.
She's about three years old."

122

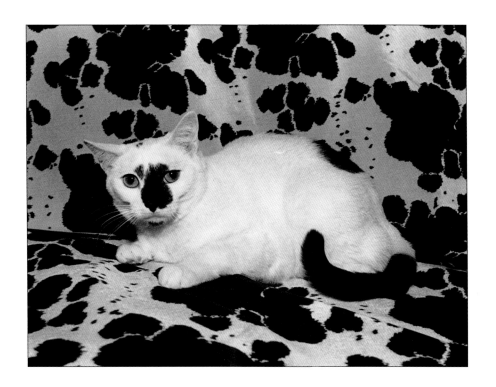

ROBIN SCHWARTZ
CHINA,
RUTHERFORD, NEW JERSEY, 1996

"China, a domestic shorthair, was very
shy the whole time I was around.
Here she's about two years old."

Romance

ROBIN SCHWARTZ
Noah and Nathaniel
Hoboken, New Jersey, 1994

I know cats feel differently. But they have their own kind of romance. When they fall in love, it's deeply. The Big Daddy around my house is Sir Oliver, a handsome and distinguished tabby who loves attention. One of my females, Glistening Sylvia, is an absolute flirt at nine years old, and she will not leave Oliver alone. She hugs him, kisses him, tries to snuggle underneath him when he naps, and follows him everywhere. When he requests a little privacy by putting out a paw, she sits a few feet away and stares at him adoringly. When they lie together on the throw rug in the hall, she'll growl to keep everyone else away. She wants him for himself, and I think he loves it. I've never seen him admonish her.

MARGE BEEBE, ANIMAL BEHAVIORIST
AND BREEDER OF MAINE COON CATS

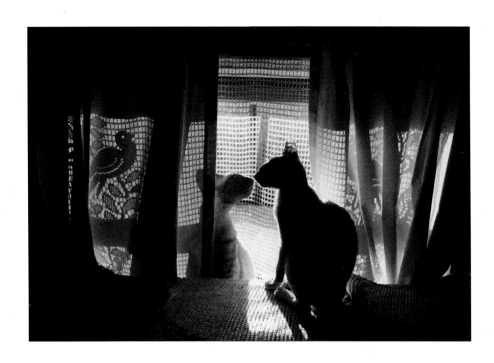

I had rather be a kitten, and cry mew

Than one of these same meter ballad mongers

WILLIAM SHAKESPEARE

YLLA
Tico-Tico Encounters a Cat
New York City, c. 1950

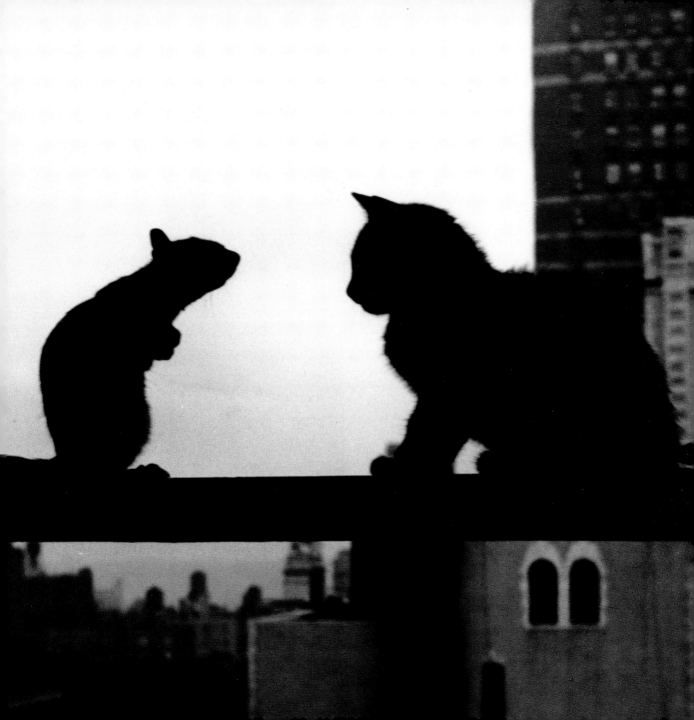

KRITINA LEE KNIEF
SINBAD AND ALFIE, 1985

These are my cats in Weehawken, New Jersey,
where I lived then. I had just recently taken in Alfie,
the orphan kitten. Sinbad, who was usually not
very cordial to other cats, just fell in love with Alfie.
He'd let her do anything to him.

OVERLEAF: TERRY deROY GRUBER
WHOOPSIE AND POOPSIE,
NEW YORK, 1979

These are the cats of the Offset Printing Company,
on Broome Street in Soho. They have a lot of
Russian Blue blood. I'd heard a lot about them, but
every time I went to take their picture they were out.
The sixth time I showed up, they were both in. As soon
as I made the shot they took off again. Some of the
customers call them the Bureaucats, since they do
nothing around there but hold up the operation.

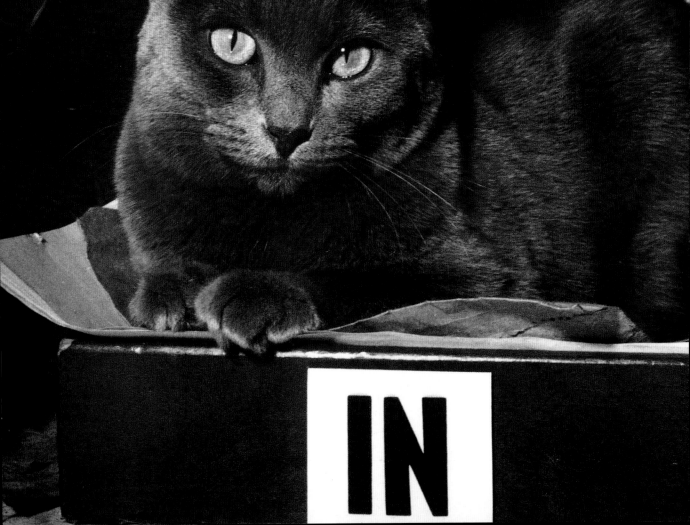

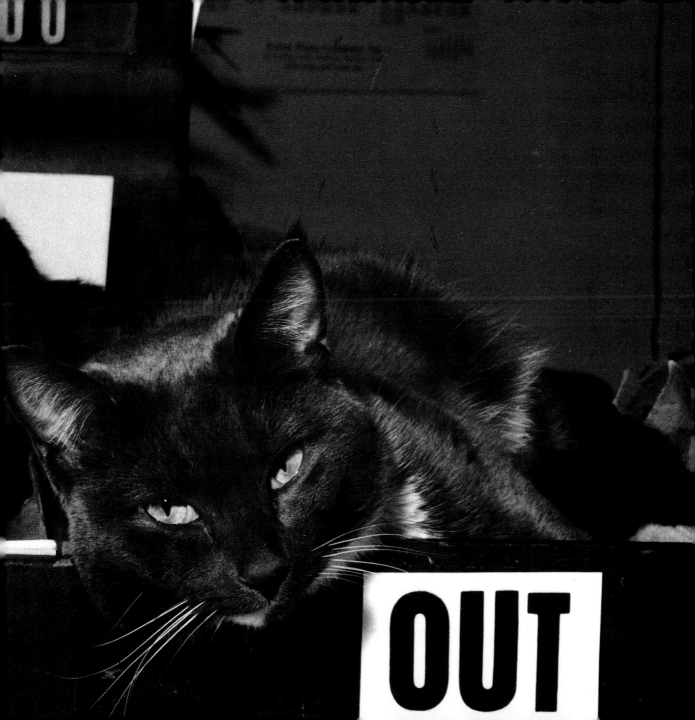

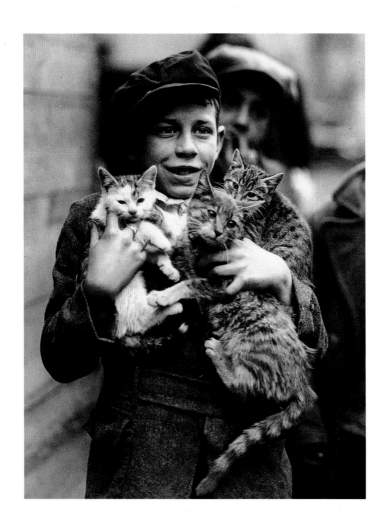

The Great Cat Round-up
Bowling Green, New York, March 28, 1925
Jack Jagerke is the proud captor of three of the thousand-
odd stray cats that were rounded up by the Bowling Green
Neighborhood Association and then adopted as pets.

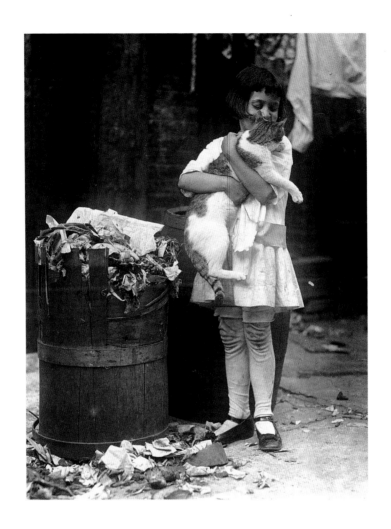

DONNA RUSKIN
GREENVILLE ARMS TABBY,
CATSKILLS, NEW YORK, 1991

"This shorthaired tabby, resident cat at a bed-and-breakfast in the Catskill Mountains, thinks nothing of lying straight across the path of oncoming guests. His excuse may be the sunshine, but does he get a kick out of watching guests step gingerly around him?"

MIKAEL BERTMAR
CAT AND SHADOW,
GOTHENBORG, SWEDEN, 1990

"One very sunny summer day, I was walking through a nice Gothenborg neighborhood. It's an area with both smaller villas and bigger houses, where everything is very tidy. I saw this cat stalking around, accompanied by his wilder shadow, and I thought, here's somebody's ordinary housecat feeling just like a tiger. After I took the picture the cat came up and rubbed against my leg, and seemed domestic once again. I like to think he was thanking me for sharing his secret life."

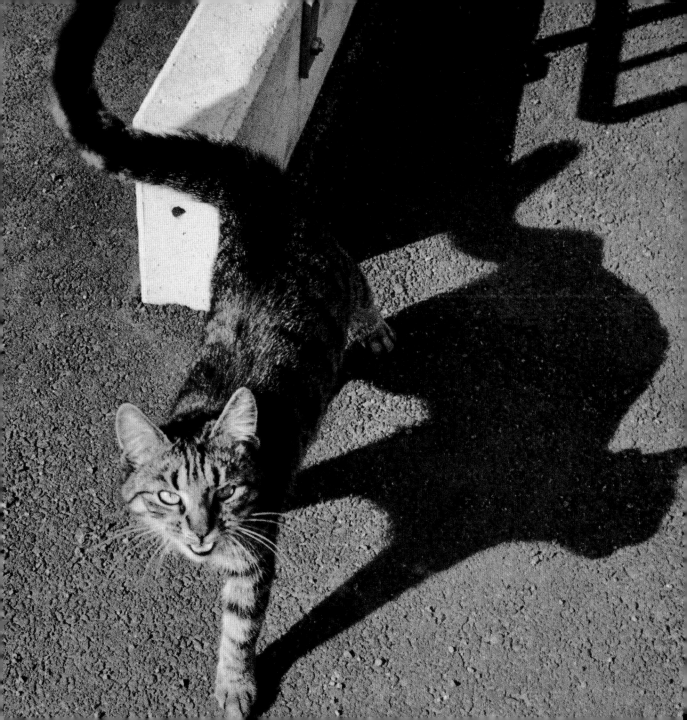

ROBIN SCHWARTZ
BROOKLYN, NY, MID-1980S

"Whitey [right] had been my
cat since I was ten years old.
He was my cat brother. I used to
sleep with him in my arms. On
trips Tobey [my other cat] rode in a
carrier, but it would have been an
insult to put Whitey in a cage."

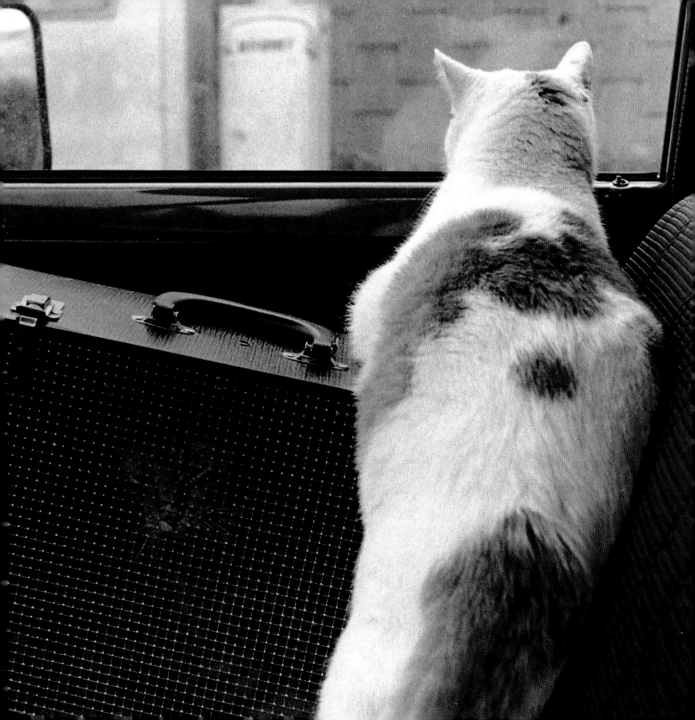

Cat was a real oddity. The others didn't know what to make of him at all. He lived in a hollow tree in the wood. Every night, when the rest of the creatures were sound asleep, he retired to the depths of his tree—then such sounds, such screechings, yowlings, wailings! The bats that slept upside-down all day long in the hollows of the tree branches awoke with a start and fled with their wing-tips stuffed into their ears. It seemed to them that Cat was having the worst nightmares ever—ten at a time! But no. Cat was tuning his violin.

TED HUGHES
How the Cat Became

ROBIN SCHWARTZ
SAFRAM SPHYNX KITTENS, YORKTOWN HEIGHTS,
NEW YORK, 1993

I went to Safram, Sandra Adler's cattery, to see her new litter. They were very young, and very unkitten-like. Rumpelstiltskin is the one sitting up. The Sphynx is a rare breed: there are less than six hundred in the world, though they've been around for a hundred years. According to the breed's historians, they're descended from a feral cat on the streets of Toronto, or from a Minnesota barn cat. They used to just appear as a mutant gene in litters, but now they're bred very carefully. As kittens, they feel like warm suede. Sandra says that the word 'alien' seems more appropriate than cat.

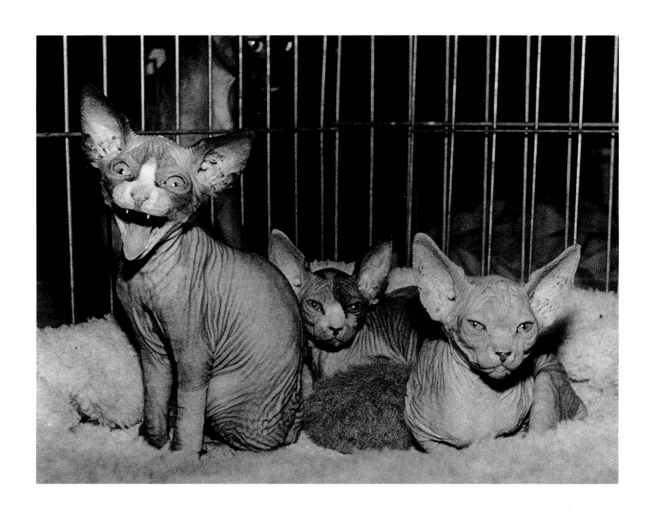

Cats are always elegant.

JOHN WEITZ
THE ARTISTIC CAT

NED ROSEN, NY, 1997
Dinah, named after the cat in *Alice in Wonderland,* is
three years old and weighs about seventeen pounds.

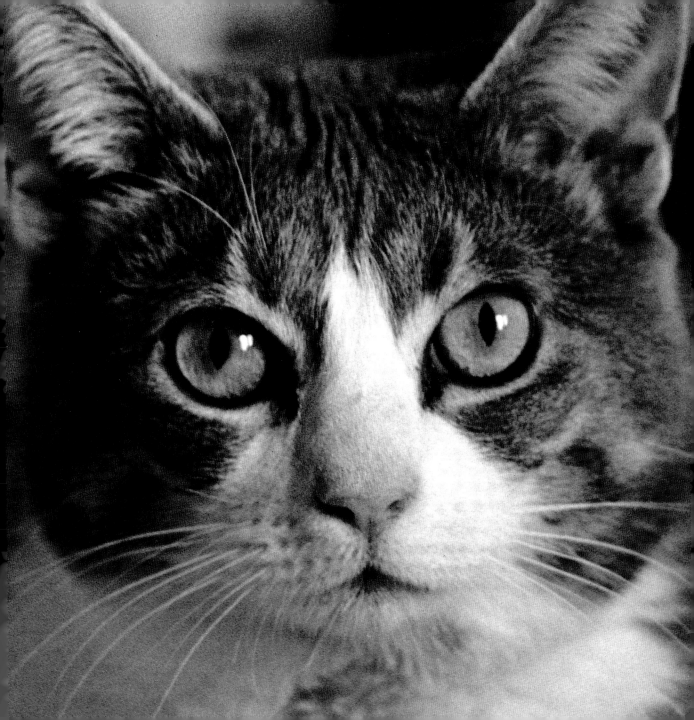

The Girl Next Door

DONNA RUSKIN
Untitled
New York, 1989

One of my cats had an affair with the female kitten next door. It was a presexual, childhood affair. They would romp and cuddle. But as soon as she got fixed, he stopped getting along with her. She seemed devastated for about a day. She came to my door and wailed. Then the next day she had a new beau.

ANNE MARLOWE, WRITER

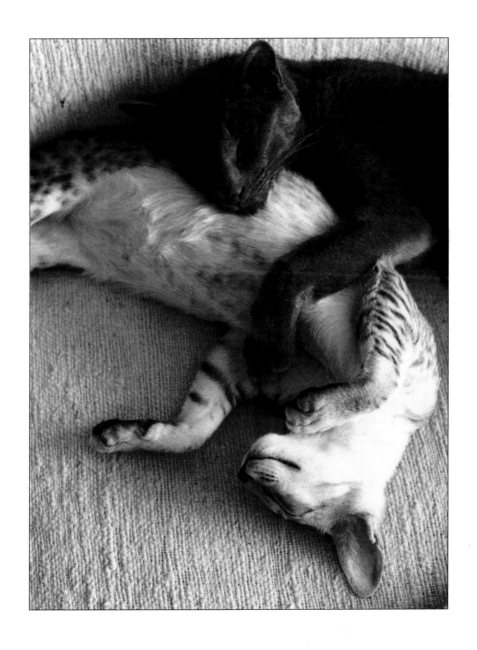

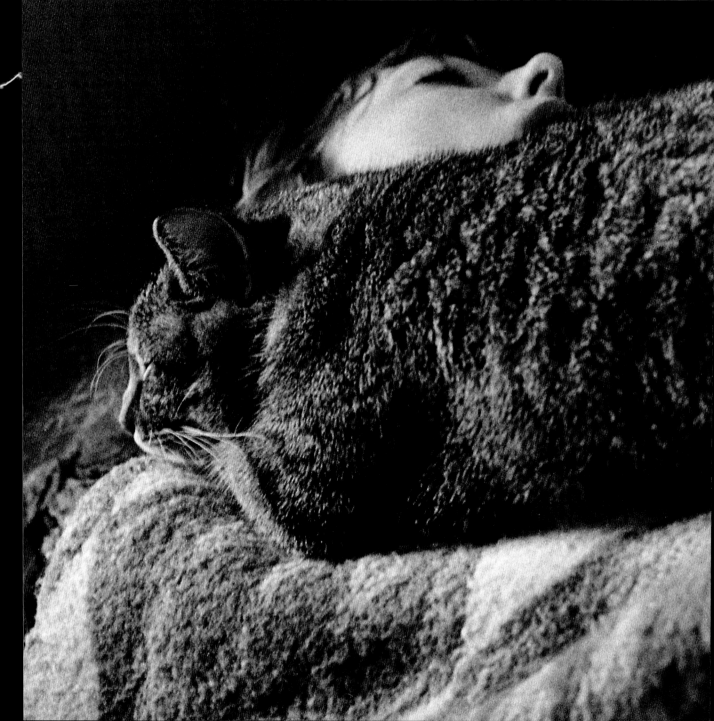

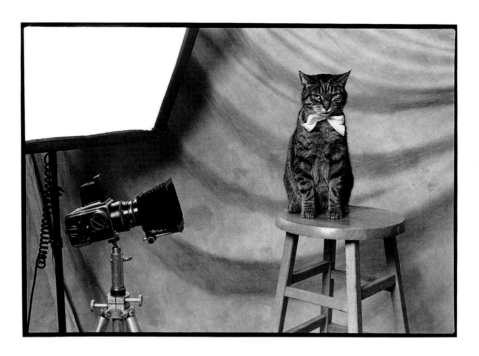

KRITINA LEE KNIEF
CAT POSING, NEW YORK, 1992

This is Alfie, who arrived on my doorstep nine years ago. I'd just lost a cat and my friends found her. They asked me if I could just watch her overnight. Of course that stretched out to a little longer. I can always count on her to stay in one place.

PHOTOGRAPHER UNKNOWN
CAT'S-EYE VIEW, C. 1945

So many gag photos were sent over the wire to newspapers across the country that a cat's most unnatural behavior became perfectly unsurprising. Still, no one will ever know what really sent this large American Shorthair to the viewfinder of the Speed Graphic, or whether—a moment later—the tripod stayed up.

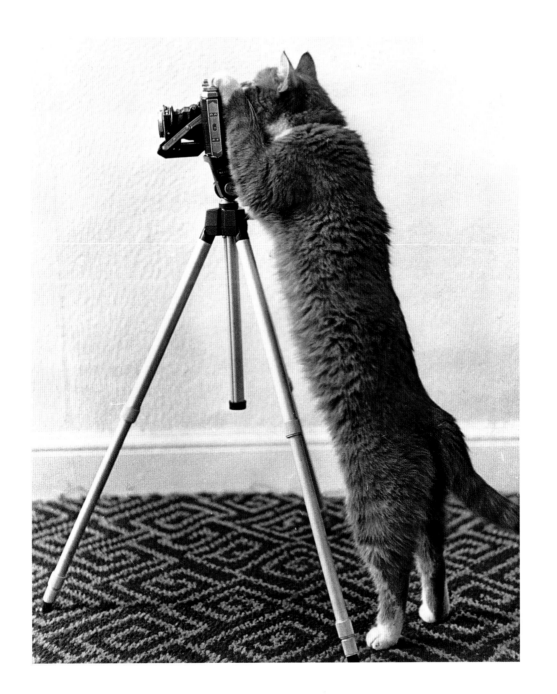

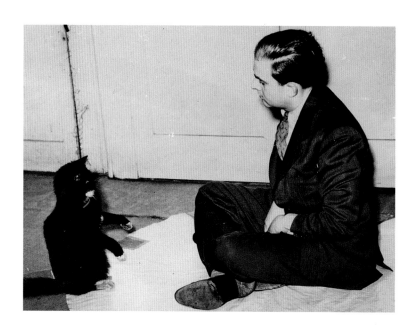

**UNIDENTIFIED
CLEVER CAT,
NEW YORK, 1940s**

This clever tuxedo-patterned cat, according
to his trainer A. Coxe, can juggle with
figures up to six, and can add, multiply,
and subtract. He gives his answers by
sitting down on the right square.

RIGHT:

**UNIDENTIFIED
GOING THROUGH HOOPS,
NEW YORK, 1940s**

Trainer A. Coxe and his assistant
hold the hoops while a spotted
shorthair leaps neatly through them.

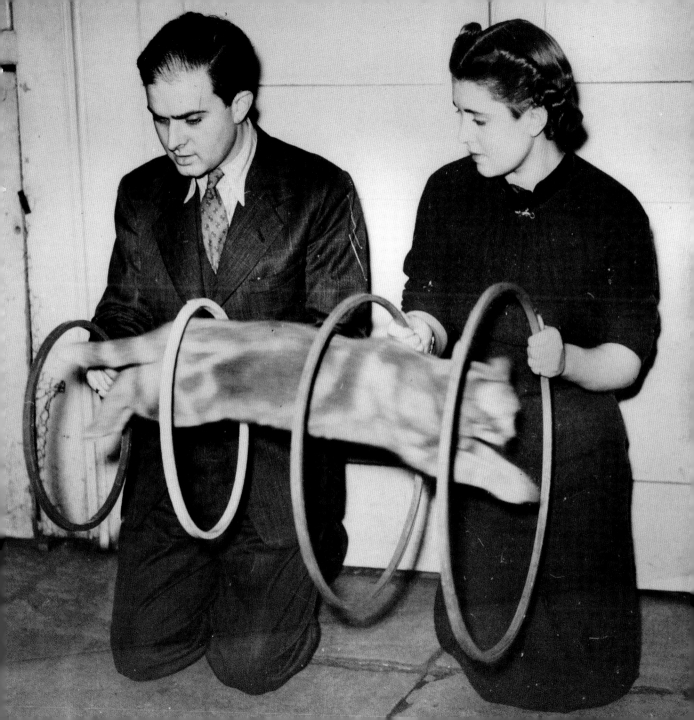

THOMAS WESTER
A Warm Place
Stockholm, Sweden, 1990

overleaf:
DAVID McENERY
Satisfaction
Brighton, England, 1992

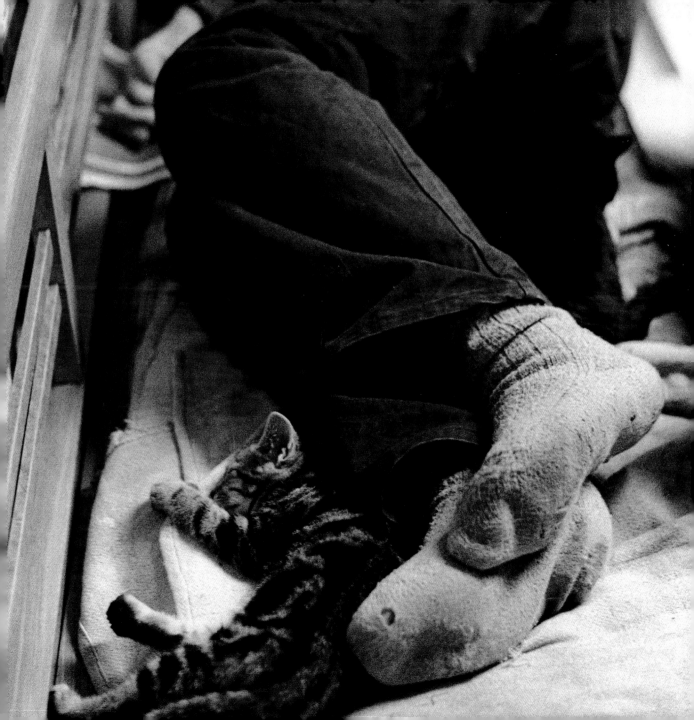

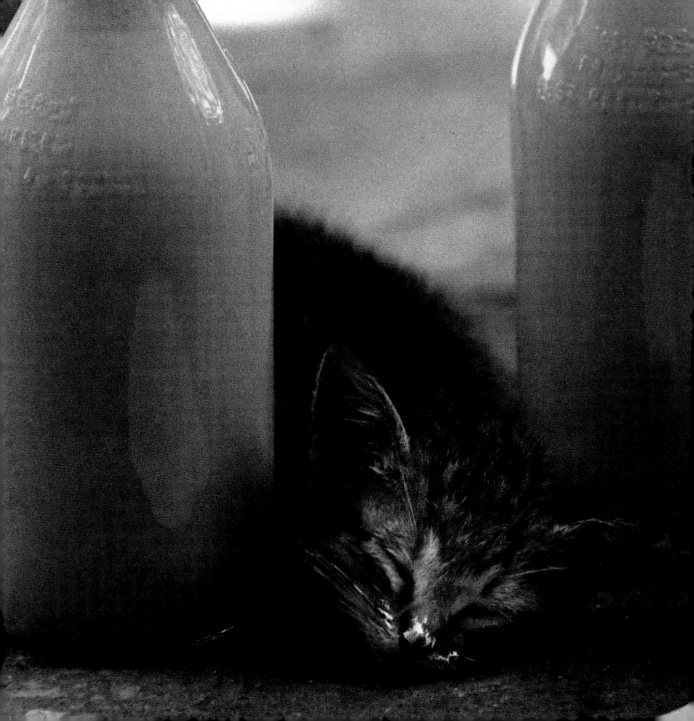

ROBIN SCHWARTZ
Potatoes and Stigby
Hoboken, New Jersey, 1995

The Love of a Pride

THOMAS WESTER
Fence Romance
Dalhem Gotland, Sweden, 1984

My Maine Coons always surprise me. They're pride cats, descended from wildcats in Maine. Most domestic cats are descended from North African wildcats, which were lone hunters. Maine's wildcats live in prides, and not only accept each other's company, they want it. To make a stronger distinction think of dogs, who are pack animals. A pack animal will find a morsel of food and steal away so he can eat it all by himself. A pride animal will bring it back for everyone else. My cats not only bring home the bacon, they make a big show of it and invite each other to share in the wealth. Then they lie in happy heaps and just purr.

I had a kitten who once got into a big mess and I had to wash him off. So I took him over to the sink and started rinsing his fur. I was very gentle but a kitten is a kitten and he started to scream. All the other cats heard him. Before I knew it I was surrounded by the pride. They were so concerned that they tried to stop me by putting their arms around my legs. If you've ever felt a cat put their arms around your leg, you know the message. It's "Stop, right now. I insist." I had a choice: risk scratches and worse, or stop. I got the kitten rinsed off enough to be safe, and put him down. Immediately, the pride ushered him into the next room and began to clean him themselves.

MARGE BEEBE, ANIMAL BEHAVIORIST AND BREEDER OF MAINE COON CATS

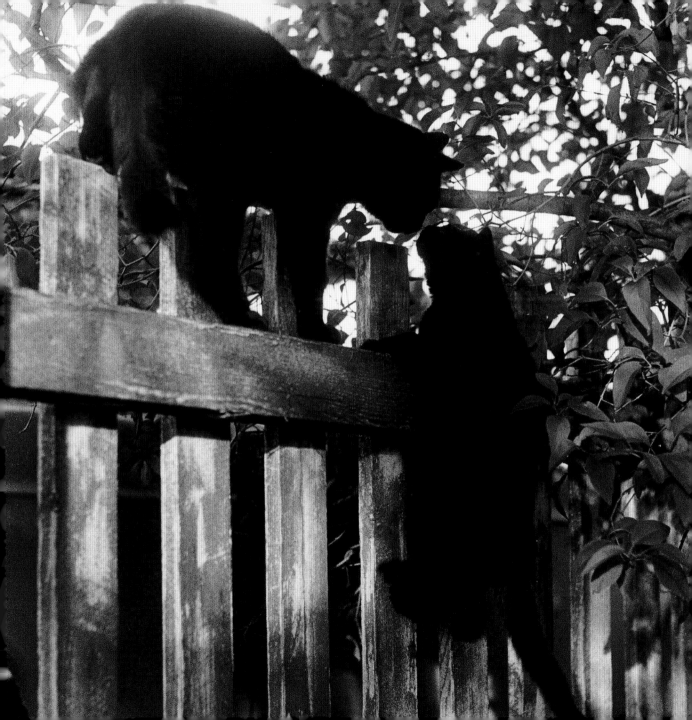

Silence of a Siamese

Kritina Lee Knief
Jasmine and Sabu
Chicago, 1991

My neighbor has a Siamese, Ethel Merman, who is very vocal. I can hear them talking to each other. He's been sick, and recently had to leave for a week to have some tests, and I fed Ethel Merman. Everyday I'd let myself in and walk into my neighbor's kitchen and Ethel would come running in, chattering away. Then she'd stop and give me this look. Just a long, steady look. And she'd be silent until I left. When he came back, the reunion was very emotional. I know. I heard it.

Ritsuko Uchida, artist

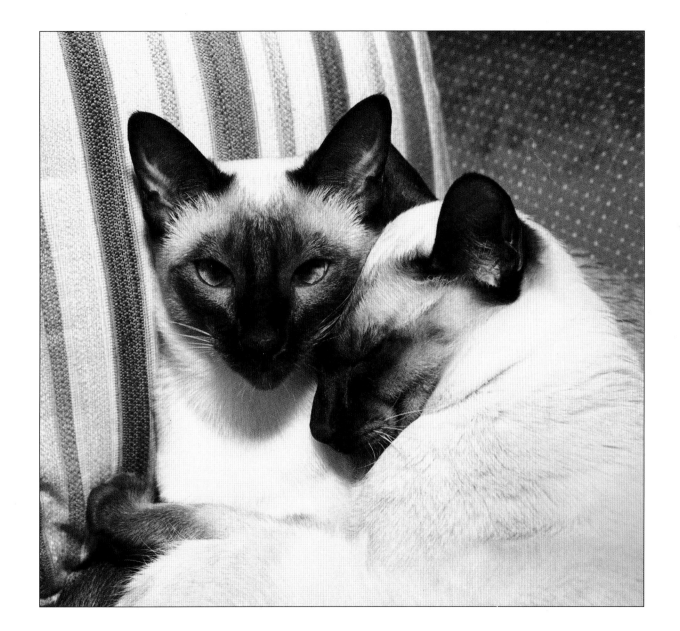

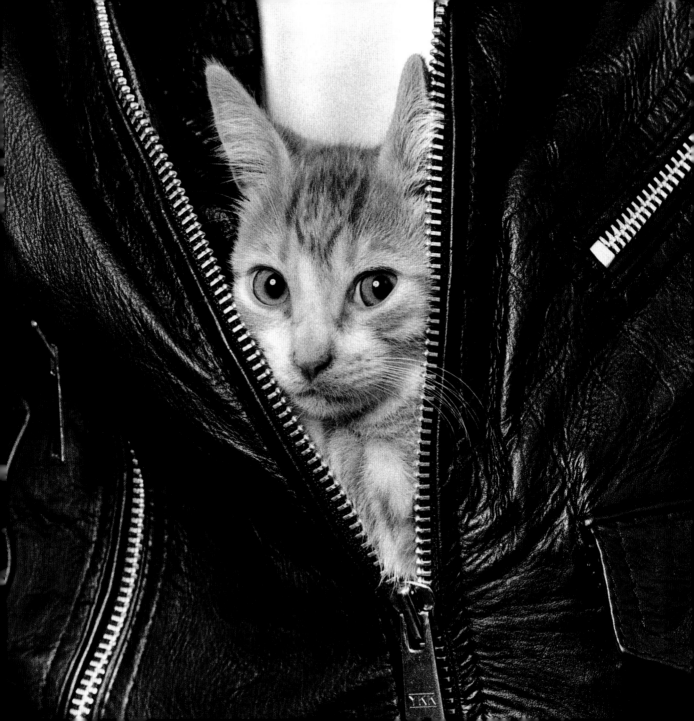

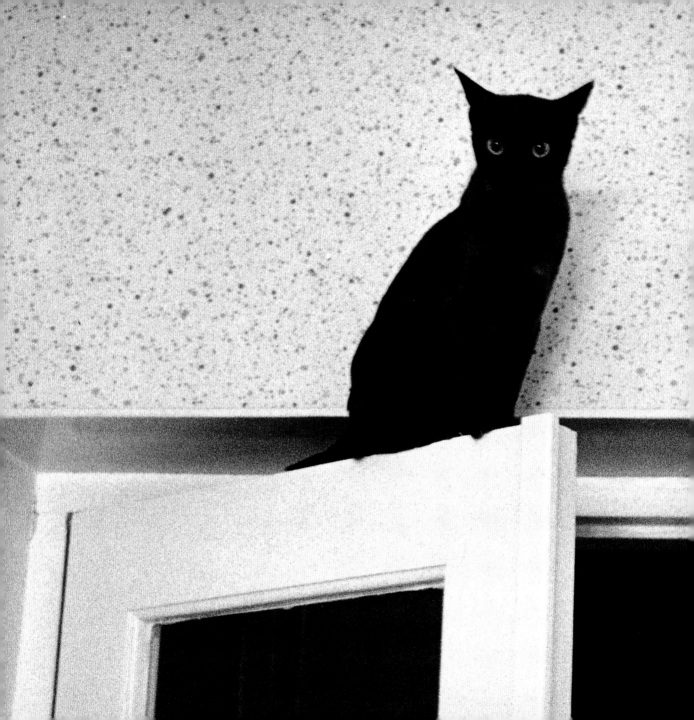

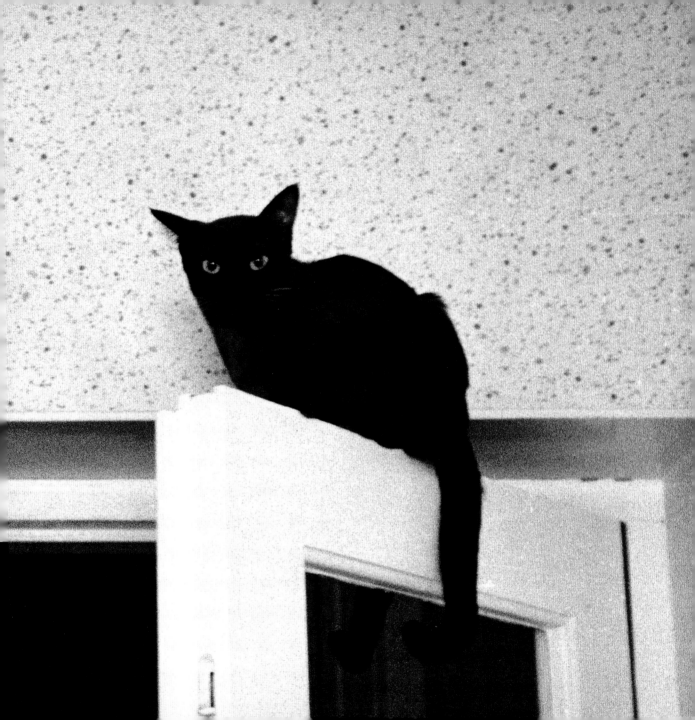

Getting Underfoot

I breed Persians, who are very self-possessed. The kittens are so cute you could scream, but they hate to be fawned over. One of my favorites, Money, now a champion, was a gray furball as a kitten, always getting into things. He crept into my husband Mike's sock drawer one morning. Mike's very groggy when he wakes up. He tried to unroll Money and put him on his feet, which resulted in quite a scene.

MERYL SHAWNESSEY

CAT BREEDER

PENNSYLVANIA

KRITINA LEE KNIEF
Persian Kitten Squooshing Hat
Boston, Massachusetts, 1991

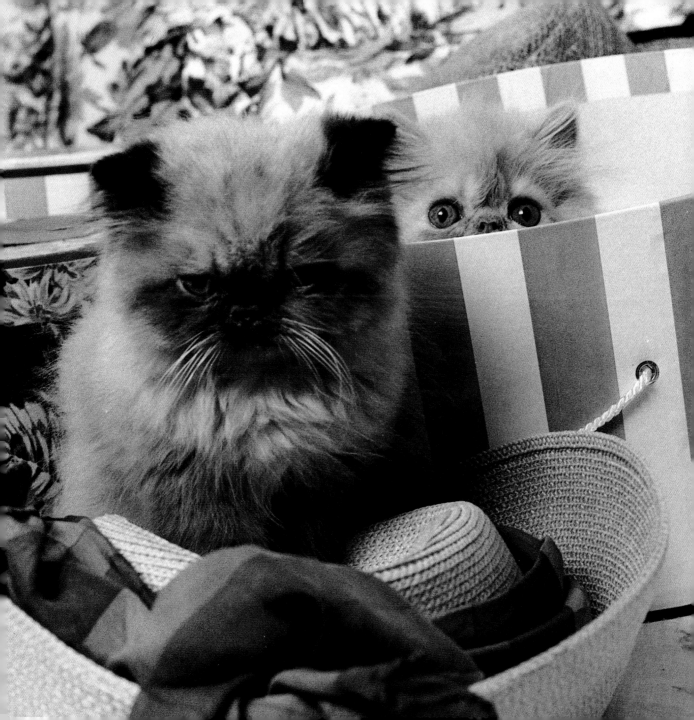

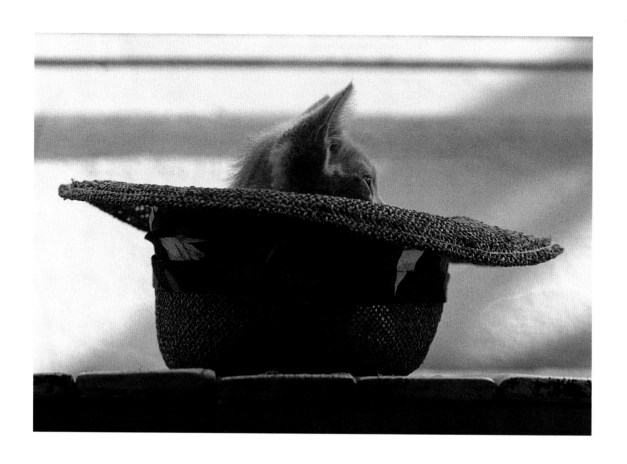

DAVID McENERY
HAT CAT, 1992

There's a pet store in Santa Monica that lends me kittens for a few days.
This was one of the loaners.

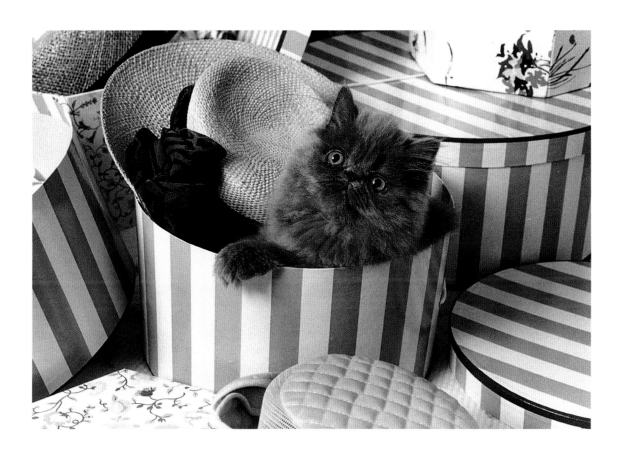

KRITINA LEE KNIEF
KITTEN IN HAT BOX, 1991

This was taken in Boston for my children's book, Alphabet Cats. *The little guy's name is
Muddy Waters. His breeder, who's known for her Persians, names all her cats after musicians.
We put fifteen kittens and cats in this set, and they had a great romp, scattering the boxes and
crushing the hats. It may have been work to us, but it was a playground to them.*

The Cat Who Came to Work

THOMAS WESTER
Untitled
Stockholm, Sweden, 1984

Of all the cats I've ever known, Polar Star is the most lovable. He's named after Polar Bear, the cat who came for Christmas, who was also a wonderful cat but in a different way. Polar Star is also white, a big guy with six toes on each paw. Someone on Martha's Vineyard just threw him out of her house at the end of the summer. And now I want her to know what she's missing, because he's the most all-around lovable cat I have seen in my life. When I first met him, he came and put his paw on me, and I was blown away. I always tease people that they taught him to do that. The Board members love him. The whole office loves him. Anyone who comes in, Polar Star has to sit in their lap and find out what they're up to. Since he's been here, more than 300 people have asked me if they could adopt him. But I'd never give him up. He's affectionate, philosophical and sweet: everything you could ever want in one cat.

CLEVELAND AMORY, PRESIDENT AND FOUNDER, THE FUND FOR ANIMALS

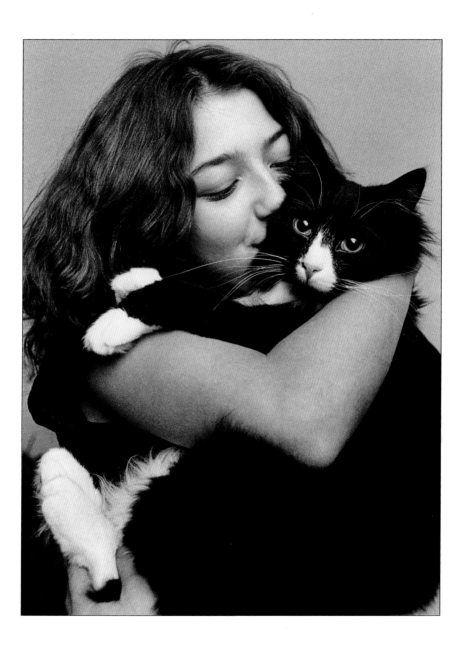

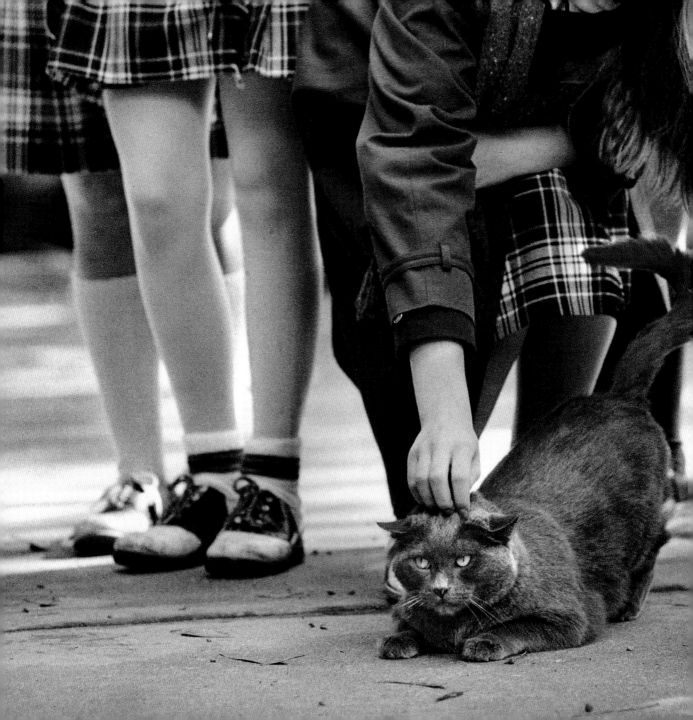

TERRY deROY GRUBER
Humbert Humbert, from the *Fat Cats* Series
California, 1980
"Humbert Humbert belonged to
the Argyle Academy—an all-girls school."

"As their mother didn't show any interest in them, these kittens left the comforts of the farmhouse for a pile of straw bales in the stable. Soon they graduated to the warm back of the donkey, who didn't seem to mind at all."

"Dave, who as you can see, is very handsome in his gray and white tuxedo, is the older (and more conniving) member of Sam and Dave, the duo we adopted from Bide-a-Wee in 1995. We'd planned to adopt a little female kitten but instead wound up with two full-grown males. What happened is that we were walking through the shelter's adoption area when Dave stuck his paw through the bars of his cage and touched our hands, as if to say, 'Here I am, what took you so long?' He was irresistible. By the time we found out he was part of a package deal, it was too late. Cats do this. No matter what your plans are, it's really up to them."

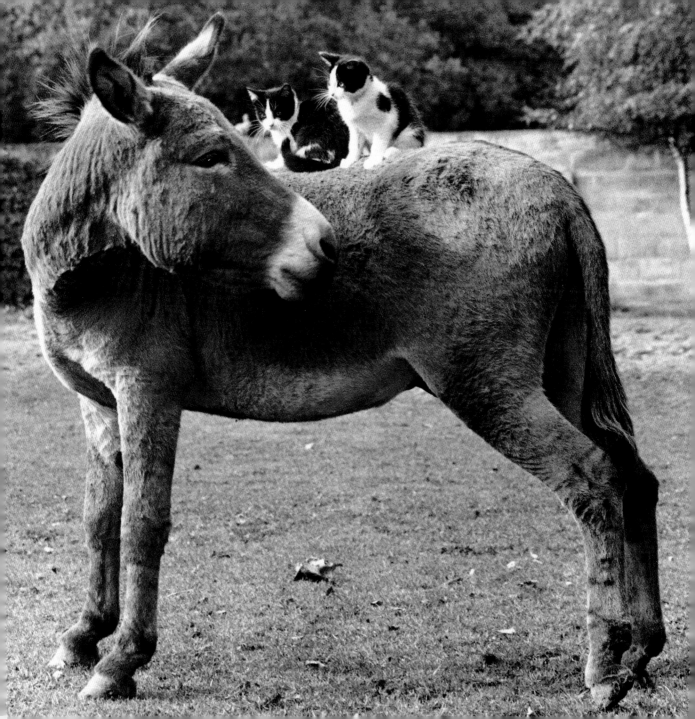

Tender Ziggy

Thomas Wester
Curious Man and Cat
Stockholm, Sweden, 1988

My sister has this old cat named Ziggy, a big fat alley cat. He's usually very disdainful and haughty when there are a lot of people in a room. He either glares at you or makes himself scarce. Well, one day I was visiting and was only one of many people in the room, so of course the cat was being very snooty and I was being snooty back. Then, suddenly, everyone else walked out. We were alone. I was on the sofa, he was prowling the floor. And I have to say that he made the first move. He climbed up to me and put his paws on my shoulders, just like an embrace, and then he just stared me in the face. I felt an intense love coming from him then. We touched noses in a delicate, intimate gesture. Then someone came into the room and it was over. I guess he only loves people one on one, in private. Then he's actually very tender.

SPENCER BECK, WRITER

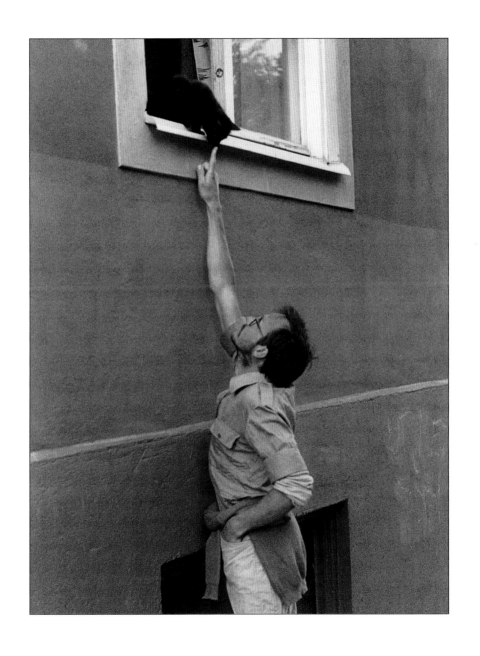

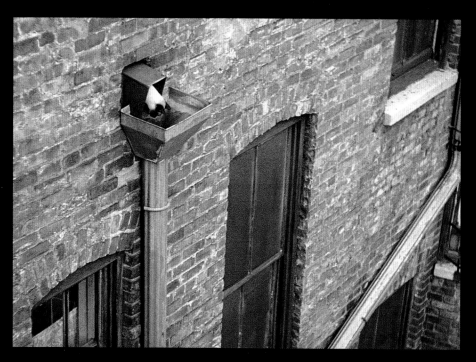

ALFRED GESCHEIDT
Ciba
New York, 1958
"I had two Siamese then: Columbo and Ciba, named
after a company I did a lot of work for. We'd play on the roof,
which like most of the old tenement roofs, had a lot of nooks and
crannies. I was throwing a ball when it suddenly disappeared,
and Ciba with it. My heart sank. When I got around the corner
there she was, trying to get the ball out of the drainpipe."

Opposite:
PHOTOGRAPHER UNKNOWN
Animal Rescue League
1940

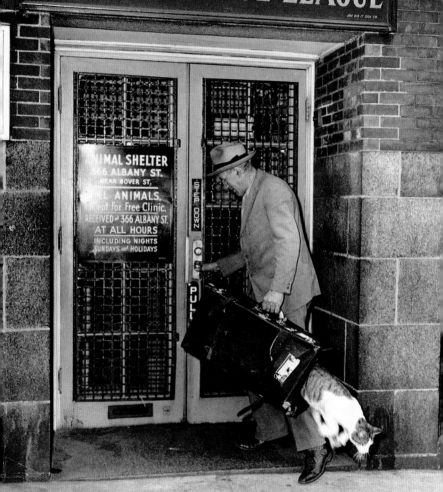

ANIMAL RESCUE LEAGUE

ANIMAL SHELTER
366 ALBANY ST.
NEAR BOVER ST.

ALL ANIMALS
kept for Free Clinic.
RECEIVED at 366 ALBANY ST.
AT ALL HOURS
INCLUDING NIGHTS
SUNDAYS and HOLIDAYS

STEP DOWN

PULL

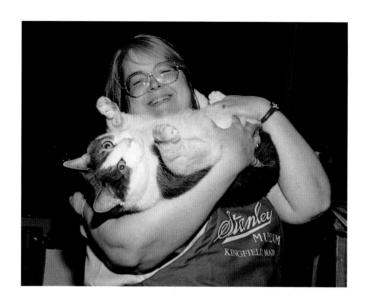

ROBIN SCHWARTZ
NEW YORK, NY, 1996

"This cat lives at Culver Pictures, a photo archive.
He looks as if he is smiling but actually, he's hissing;
he didn't care for the flash on my camera."

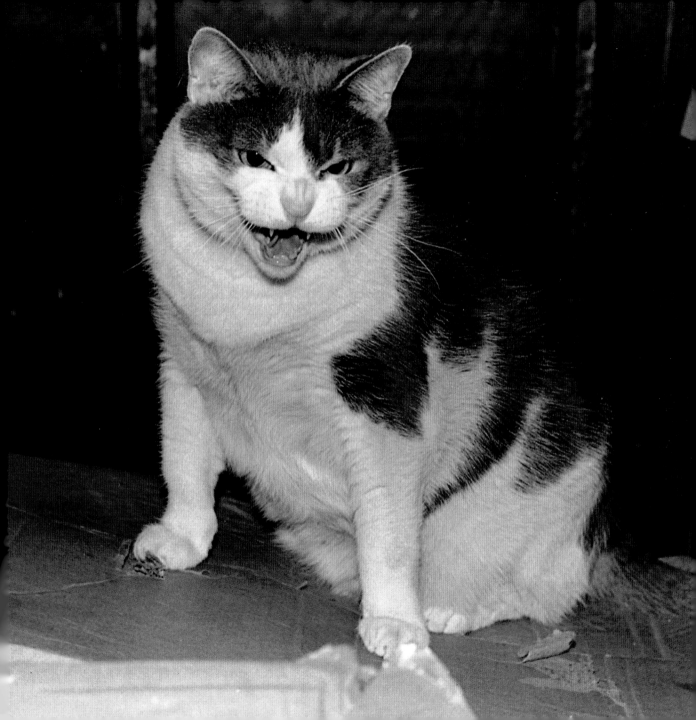

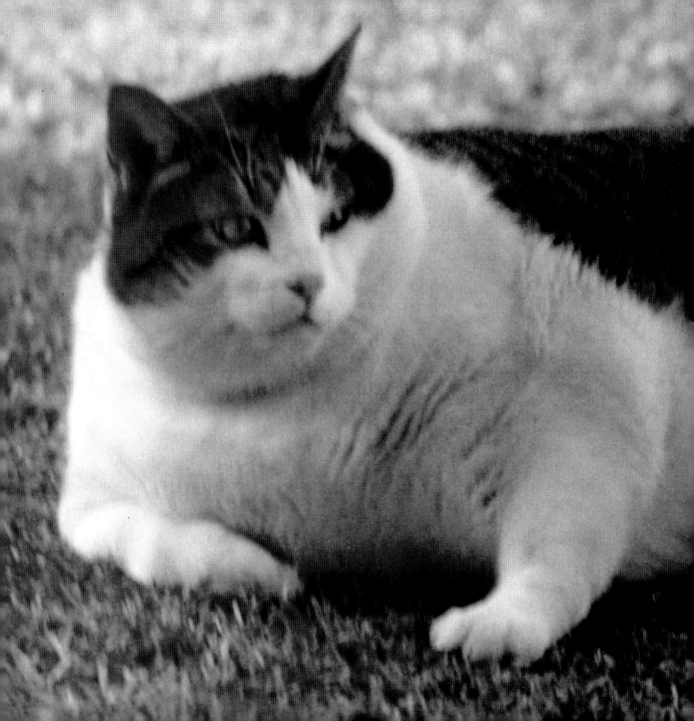

EXCUSE ME?

My black and white cat, Roland, adopted me. He's so
handsome—with enormous yellow eyes and a majestic ruff
around his neck—that I just had to take him in. I was eat-
ing breakfast on my front porch when he came galloping
out of nowhere, obviously very hungry. The problem was,
at that point, that I had three adolescent dogs who were
very disobedient, and a teenage son, and I was in the
habit of raising my voice a bit. As in "Hey! Get your nose
out of the refrigerator!" Or "Off the couch with those filthy
feet!" Well, the dogs are used to it, and my son forgave
me too, though he suggested I try a certain illegal herb to
relax. But Roland immediately let me know that he, being a
cat, would not tolerate such outbursts. One day I caught
him sharpening his claws on a chair leg and yelled "Bad
cat! Stop that now!" Instead Roland just turned his head
and gave me a piercing stare. It was as if he were saying,
"Excuse me? Just whom do you think you're talking to?"

LISE KLAMMER, NURSE, AMSTERDAM

RIGHT:
DAVID McENERY
STREET OF CATS, DINAN, FRANCE, 1994
"There is a street in Dinan that leads down to the port.
It's a very old street, twisting and cobblestoned. I
think everyone who lives on it must have a cat,
because they are everywhere you look. I noticed this
one peering at me as I took an afternoon walk."

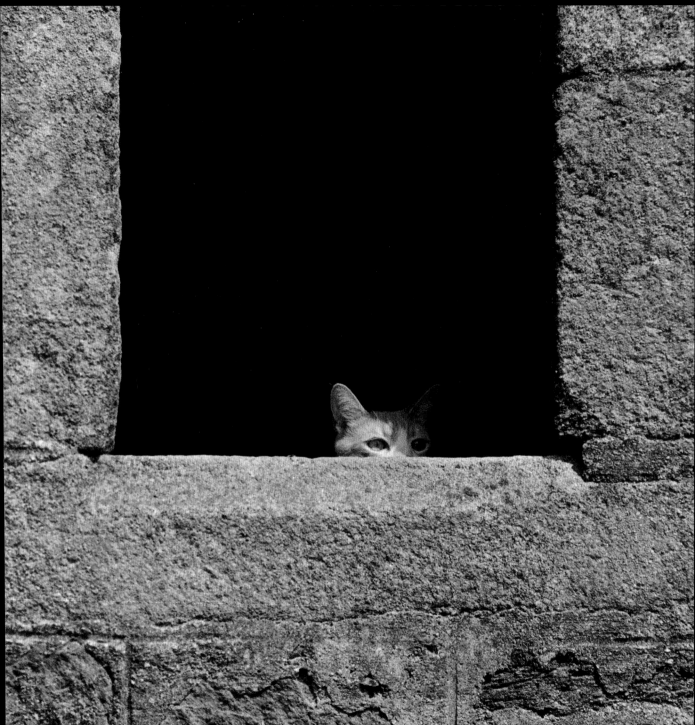

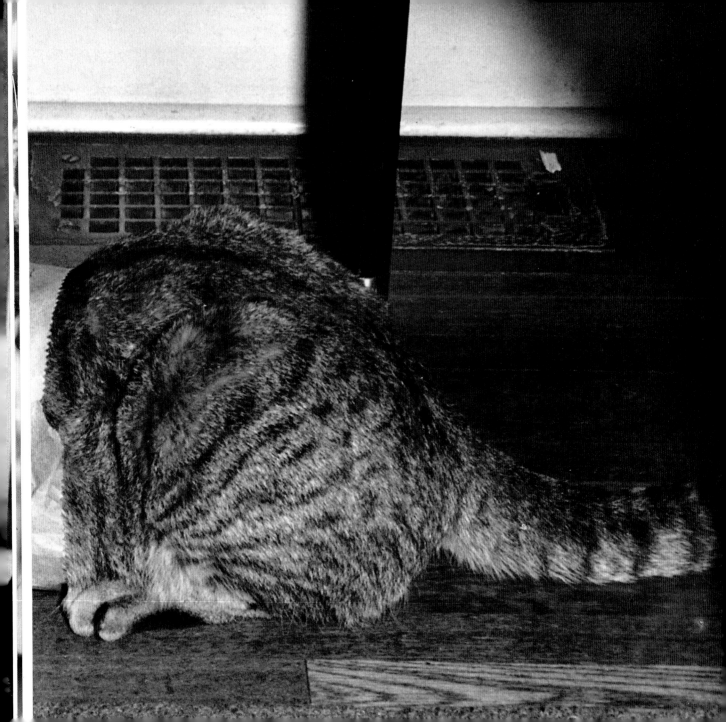

THOMAS WESTER
Untitled
Stockholm, Sweden, 1984

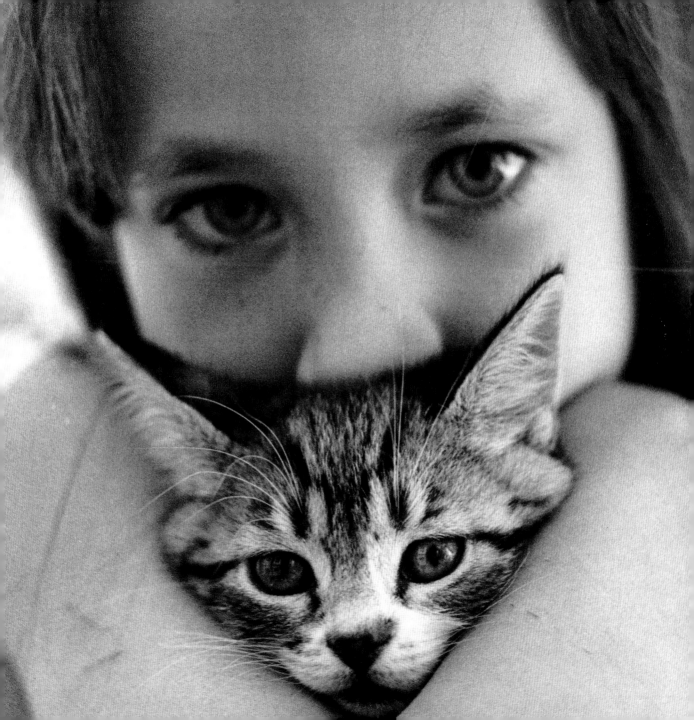

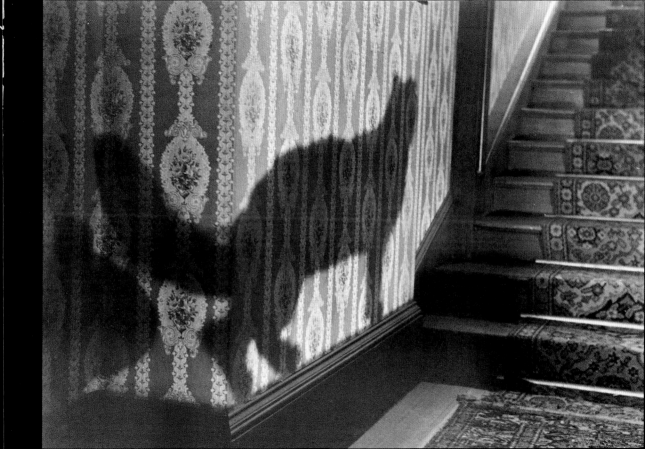

EYE OF THE CAT. 1969
*In another scene from the Universal thriller, Gayle Hunnicutt
is terrified by the cats as they surround her.*

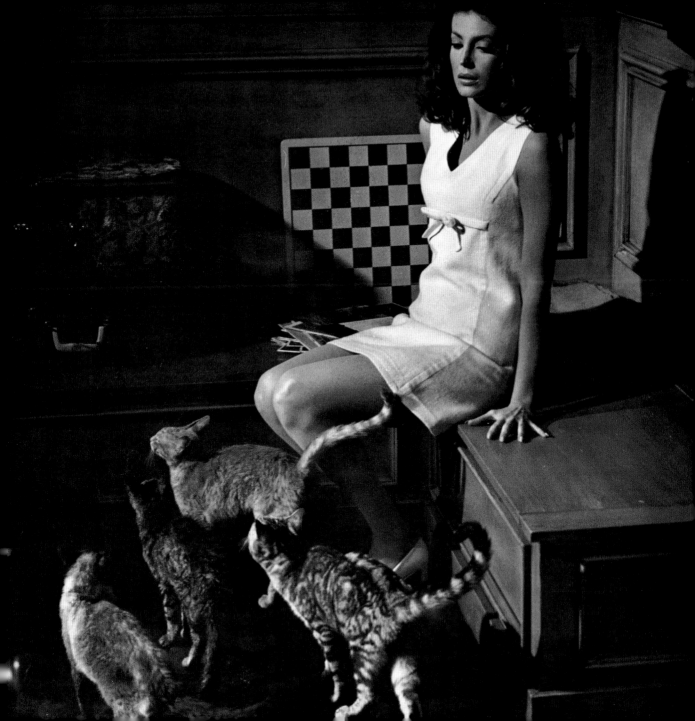

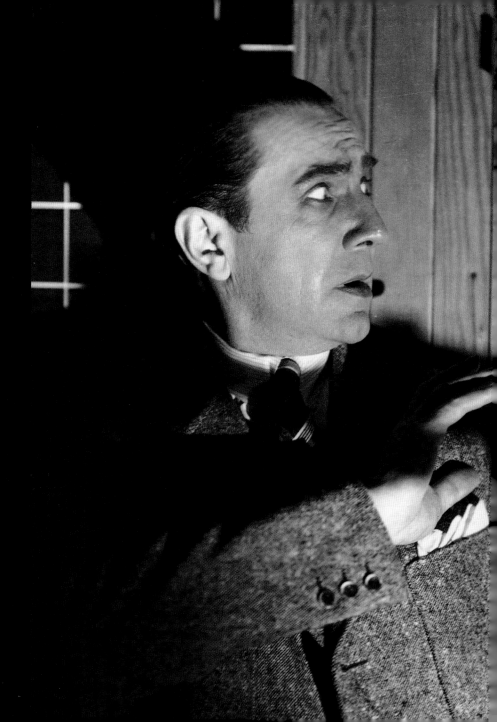

THE BLACK CAT. 1934
Bela Lugosi co-starred with Boris Karloff for the first time in this loose adaptation of Edgar Allan Poe's story of a cat returning from the dead to haunt its master. The movie wound up having more to do with a story by director Edgar Ulmer than with Poe's tale, though a sleek black cat did appear. The title was changed to The Vanishing Body *when Universal released a second* Black Cat *in 1941.*

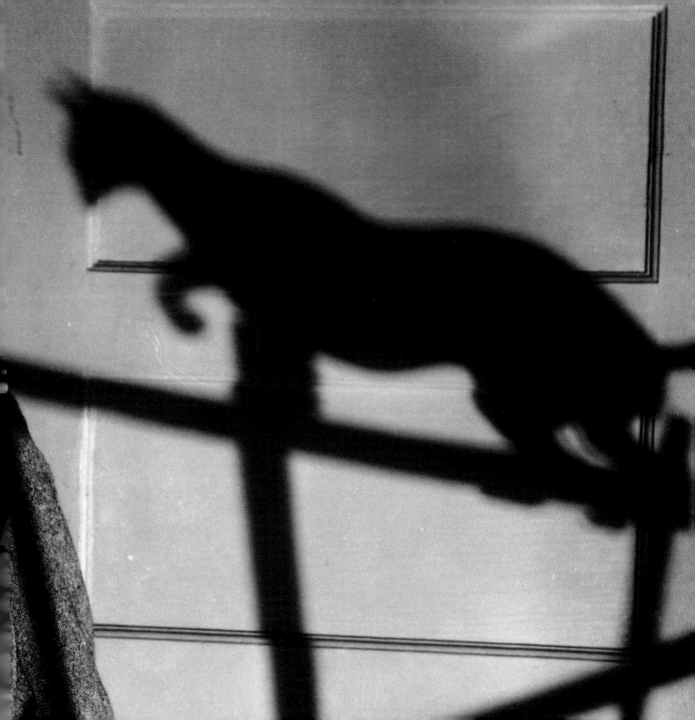

Sinbad

Harold M. Lambert
The Grooming Session
Philadelphia, c.1950

My cat Sinbad, who I got when he was a kitten along with his sister Salem, does this loving gesture I've never seen before: he sucks on my ear. I can hold him in my arms like a baby and he'll lean into my neck and suckle on my ear. It's a very intimate gesture. He can stay there for hours, completely content. Then he goes and finds Salem and they curl up together like a yin-yang symbol.

Jennifer Charles, recording artist

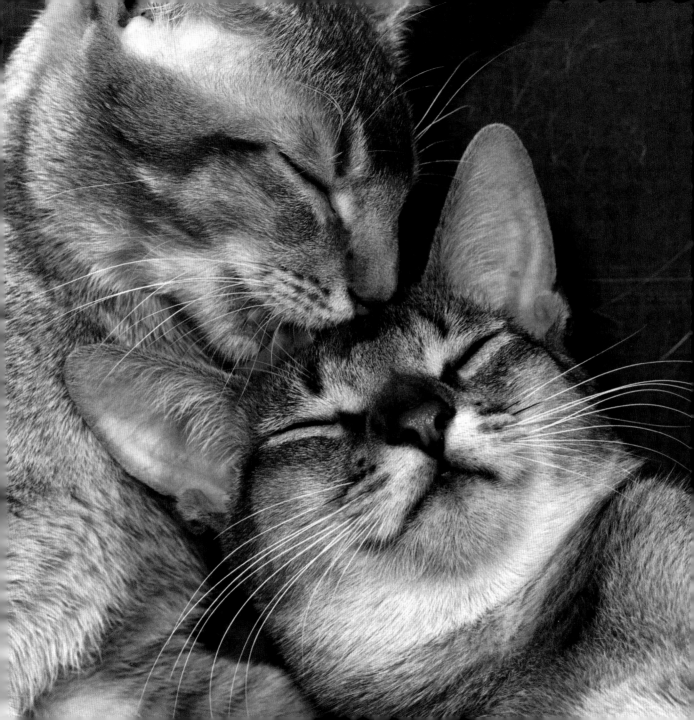

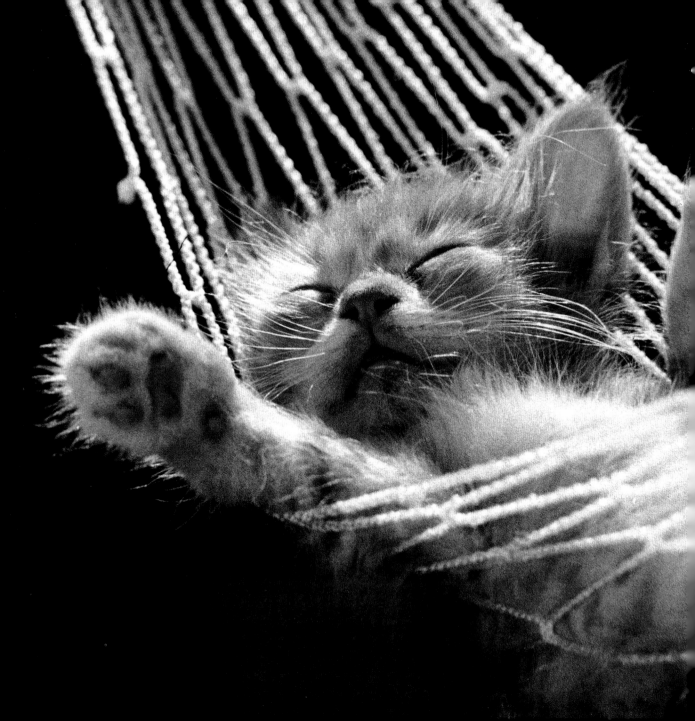

DAVID MCENERY
CATNAP II, 1992

*My wife, Pat, made the hammock. She's a great
hammock maker. The kitten thought so too.
They don't have hammocks at the pet store.*

OVERLEAF: WALTER CHANDOHA
TICKLING THE IVORIES, 1957

I guess the kitten liked the sound of the keys.

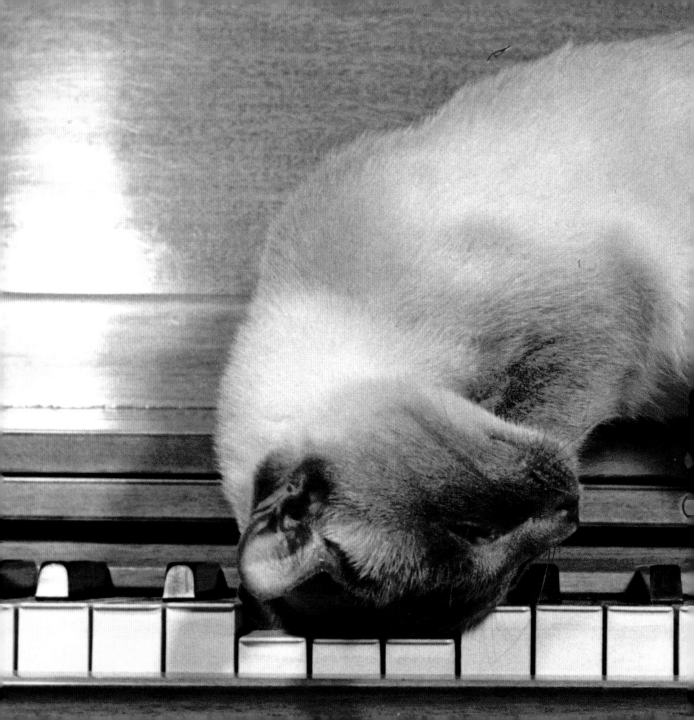

DAVID McENERY
CATNAP I, 1979

That is a genuine English deck chair and those are my wife, Pat McEnery's, feet.
The picture was taken on our patio soon after I came to America. The kitten was borrowed.

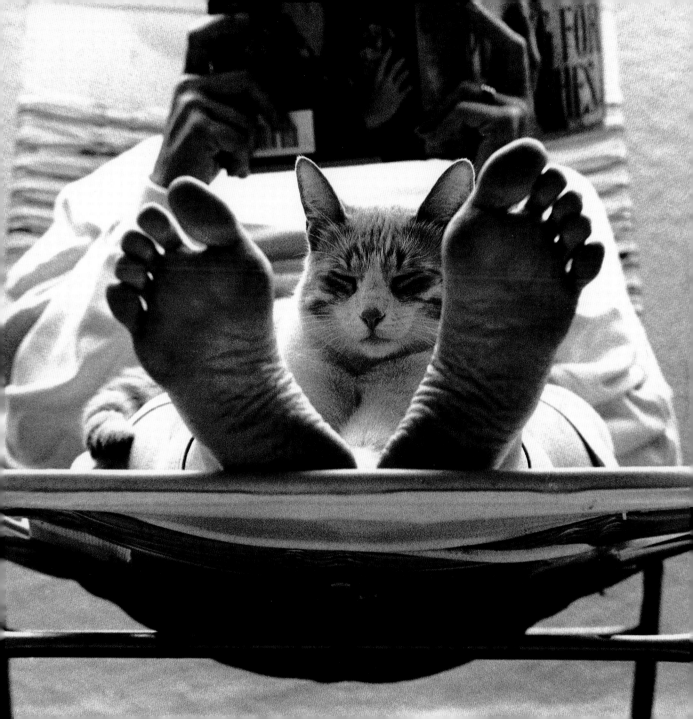

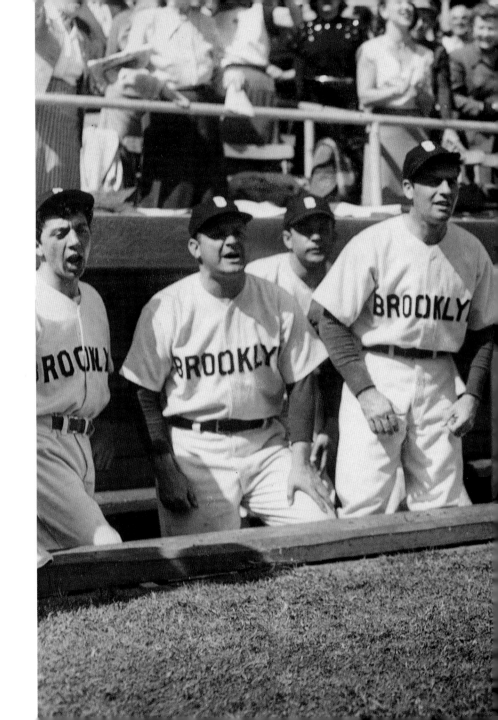

RHUBARB. 1951
At fourteen pounds, Orangey the cat had enough presence to look imposing on a baseball diamond, but the camera angle helped. The leash was there in case the star decided to bolt.

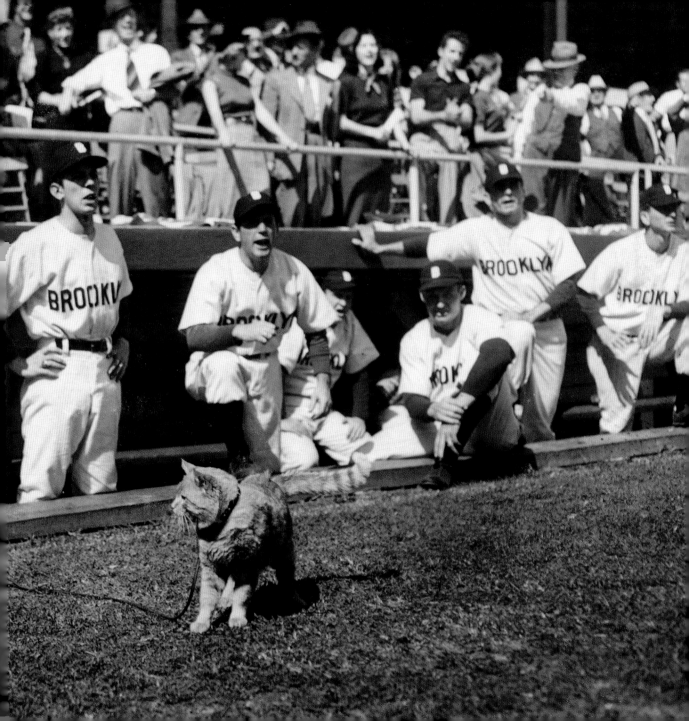

The great charm of cats is their rampant

egotism, their devil-may-care attitude

toward responsibility, their disinclination

to earn an honest dollar...cats are disdainful of

everything but their own immediate interests...

ROBERTSON DAVIES
THE PAPERS OF SAMUEL MARCHBANKS

JUST G. MOLLER
JUTLAND, DENMARK, 1959

This fat cat drinks milk from a saucer or a baby
bottle. No matter, as long as lunch is forthcoming.

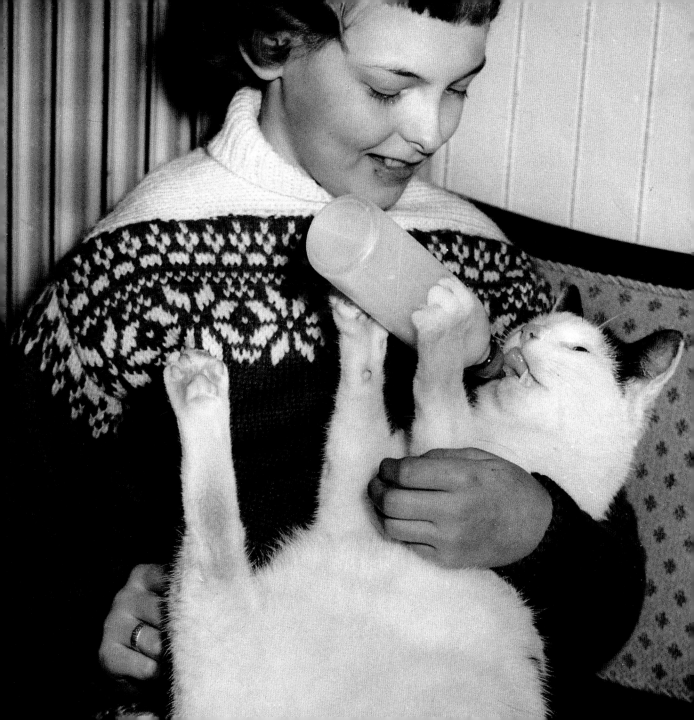

Cats are absolute individuals with

their own ideas about everything,

including the people they own.

JOHN DINGMAN
THE ARTISTIC CAT

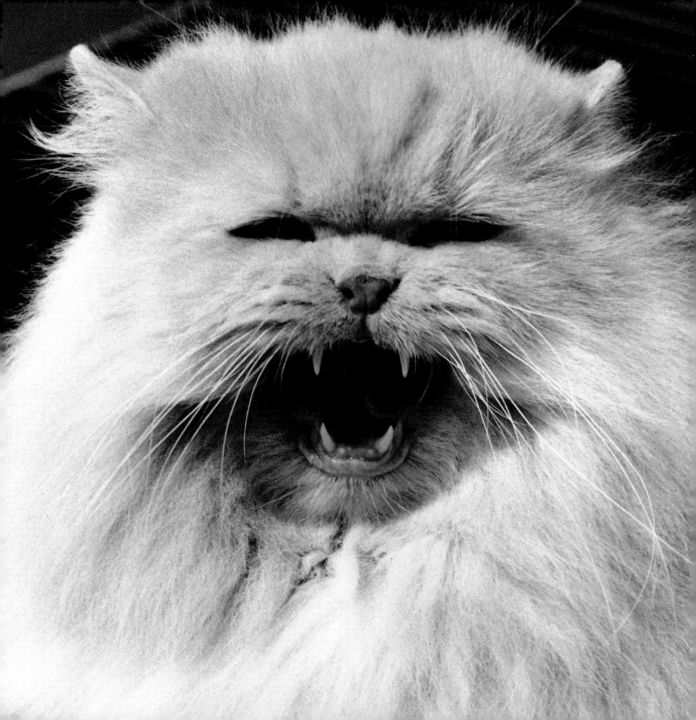

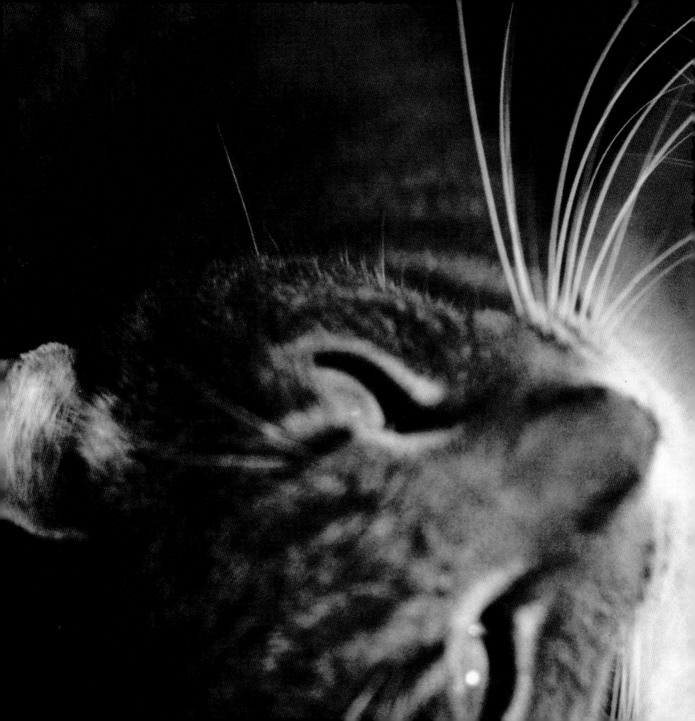

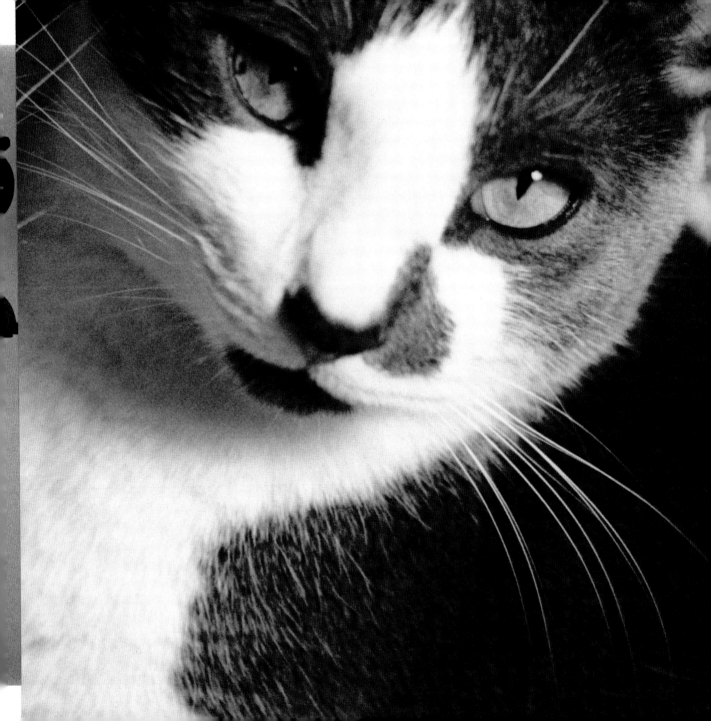

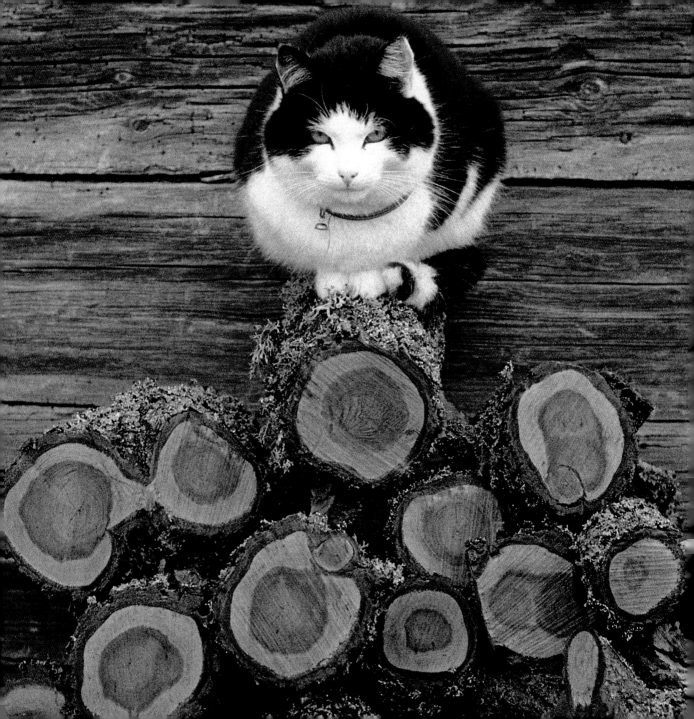

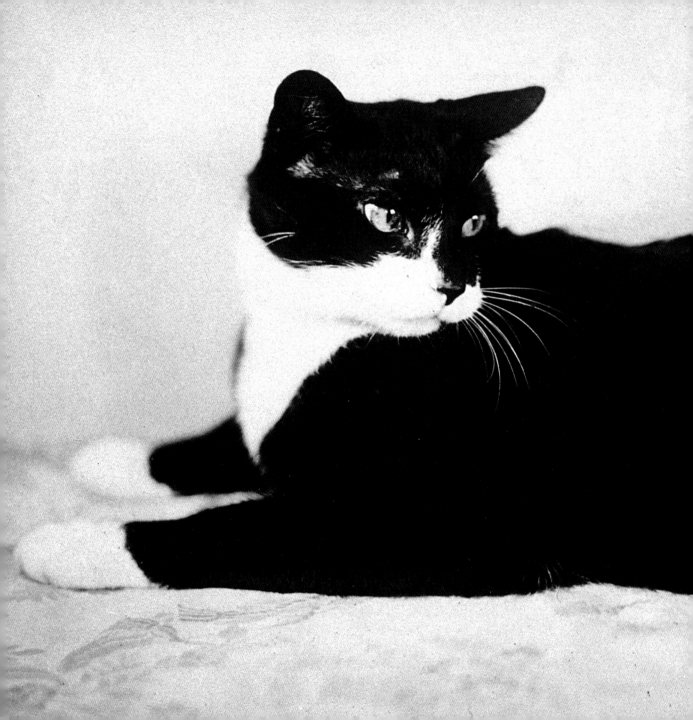

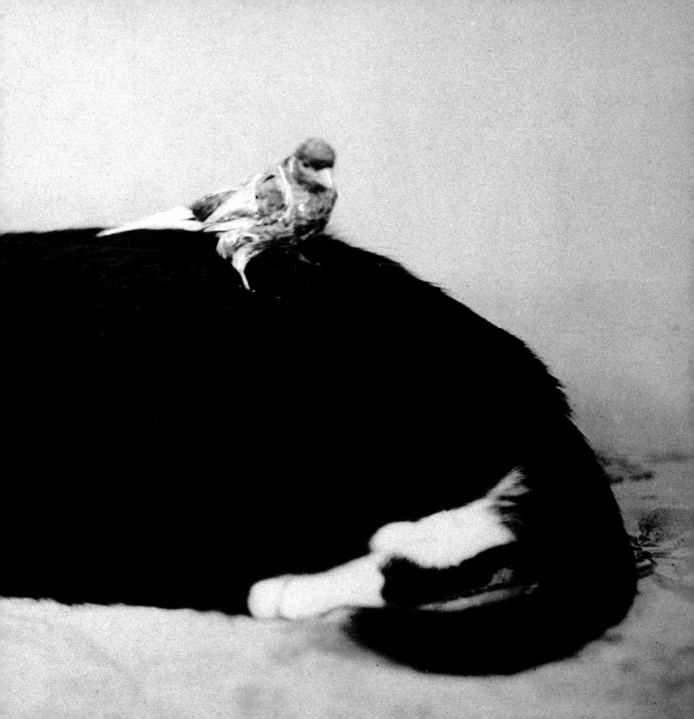

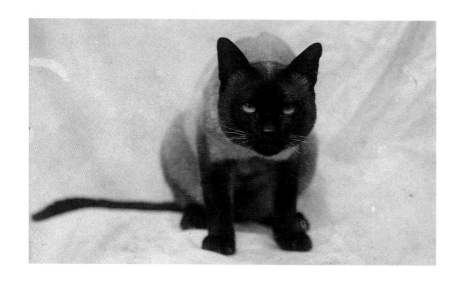

JESSIE TARBOX BEALS
Siamese Cat
c. 1905

Opposite:
YLLA
Face-off with Tabby
New York, c. 1950
A silent confrontation with a leader of what the
photographer called the "Feline Underworld."

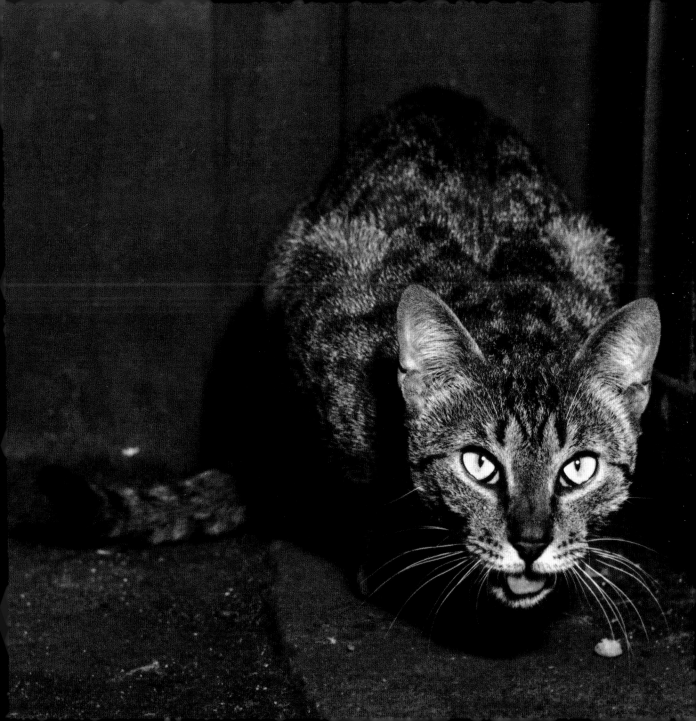

It is a very inconvenient habit

of kittens (Alice had once made

the remark) that, whatever you

say to them, they always purr.

LEWIS CARROLL

JOAN BARON
Kitten at the Barre, Phyllis Goldman's Ballet Studio
Upper East Side, New York City, 1983

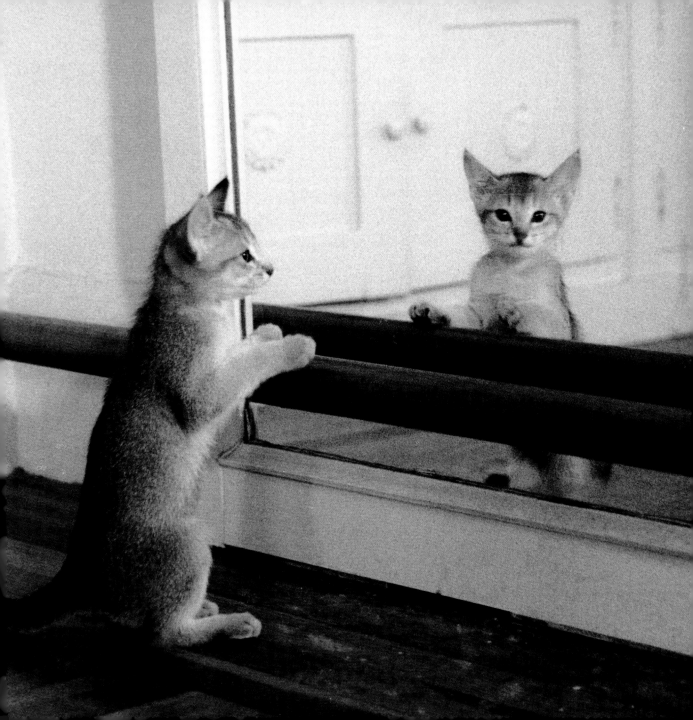

Mochi the Jungle Cat

PER WICHMANN
Kittens
Stockholm, Sweden, 1990

We come here maybe twice a year, more if we can get the time from touring, and our shack in the jungle is empty except for then. Mochi is a jungle cat, the same mixture of tortoiseshell and Siamese that a lot of cats in Puna, Hawaii, are— small and fierce, strong enough to kill a mongoose or a rat and live for days on nothing.

When we get here, she suddenly shows up. Every year. No one else ever sees her. And every year she shows up pregnant, as if she times her litters for our arrival, knowing somehow that when we're around, there's good food and good care. She moves right in in her quiet, sweet way, never pushing us, never demanding, just watching. Her belly swells bigger and bigger and of course we hand her all the extras from whatever meal we've made, and she never gets fussy or upset.

We are her guardians—her midwives—she seems to be saying, and she pays us back in affection. One by one on the first days we're all together here, she climbs into our laps and welcomes us. Then the routine is exactly as it has always been. The day we are all scheduled to leave, she has her kittens. There's a box downstairs, an old banana box, and it's been the same box every year since this started. I have no idea how she knows it's our time to go, but that's when she drops. She shows us her kittens and has one last big meal. Then she takes them and heads back into the jungle, and we head back to touring, knowing we'll see her again.

JOHN MEDESKI, MUSICIAN

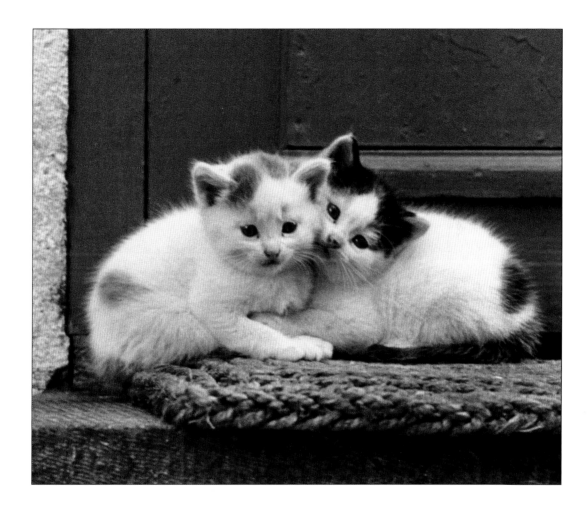

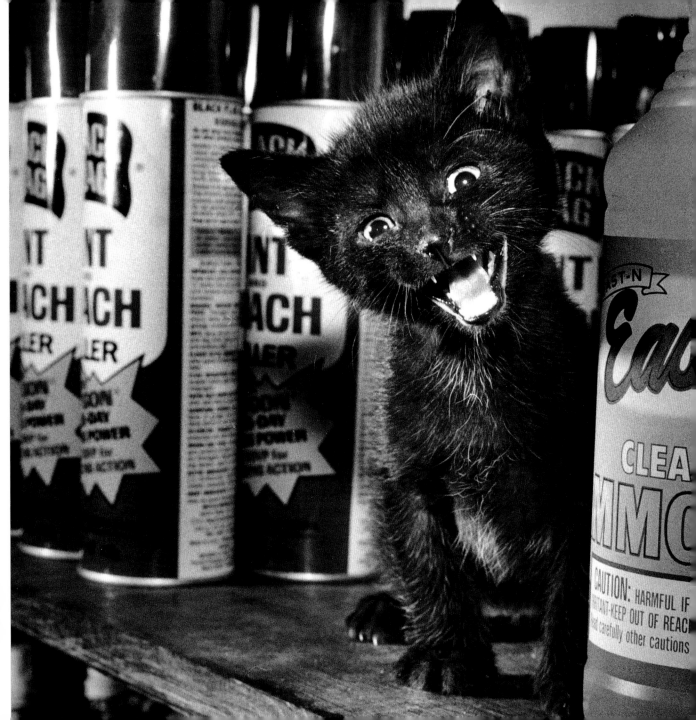

TERRY deROY GRUBER
GROCERY STORE CAT,
NEW YORK, 1979

*The stock boy told me that he was over on Aisle B
with the household supplies, just stamping prices.
He reached up to a shelf and started stocking and whap!
The little monster nailed him.*

I once got a scare from a little cat of ours named Charlie. I came into the kitchen and found him prostrate on his stomach on the floor, breathing heavily. In a panic, I lifted him gently and tried to get him to stand on his legs, but they collapsed under him again. And as I supported him I noticed that his stomach seemed bloated. I stood up, trying to decide whether to telephone our veterinarian or rush Charlie to the animal hospital emergency room, and then I noticed something. Almost an entire platter of spaghetti with clam sauce that had been on the counter had disappeared. Charlie wasn't suffering from some terrible neurological disorder—he'd simply OD'd on spaghetti, and his skinny adolescent legs wouldn't support his overloaded stomach.

PATRICIA CURTIS
THE INDOOR CAT

THOMAS WESTER
STOCKHOLM, SWEDEN, 1984

Moses had several homes. Unfortunately, he lived with people who turned out to be allergic to cats. He went from one foster home to another until finally, he ended up in an apartment with four girls who truly loved him. While moving from place to place, Moses learned to console himself with food and became very good at locating it. He probably weighed over fifteen pounds.

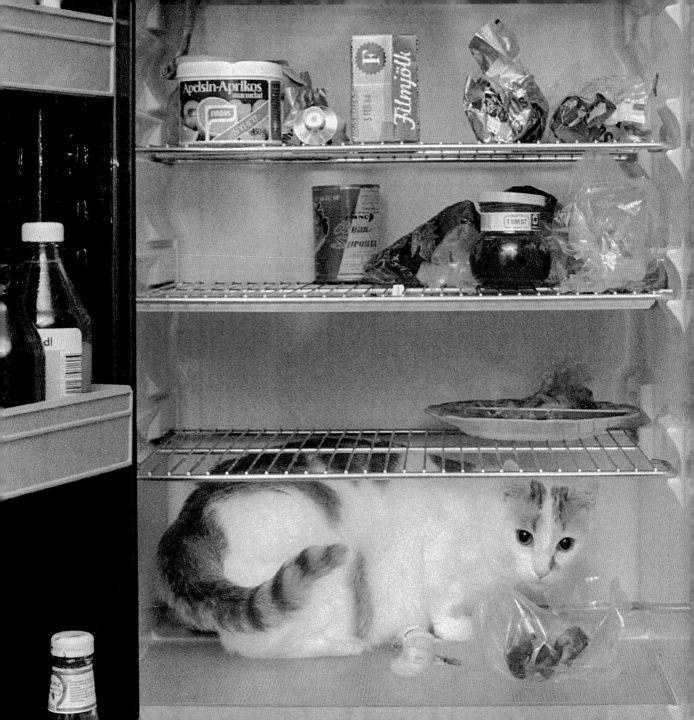

Webster was very large and very black and very composed.

He conveyed the impression of being a cat of deep reserves.

Descendant of a long line of ecclesiastical ancestors who had conducted

their decorous courtships beneath the show of cathedrals

and on the back walls of the bishops' palaces, he had that exquisite poise

which one sees in high dignitaries of the Church.

P.G. WODEHOUSE
The Story of Webster

TERRY DEROY GRUBER
PARAMUS, NEW JERSEY, 1979

This seemed to me like the perfect combination. The judge holding Stanley, an Oriental
Shorthair, said, "It's tough modeling all day and traveling all over the country.
But Stanley here knows what he's doing."

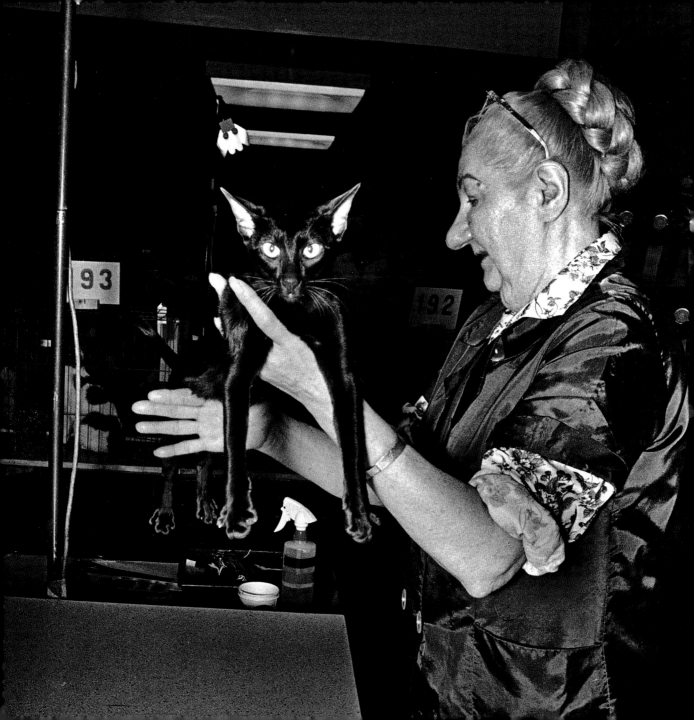

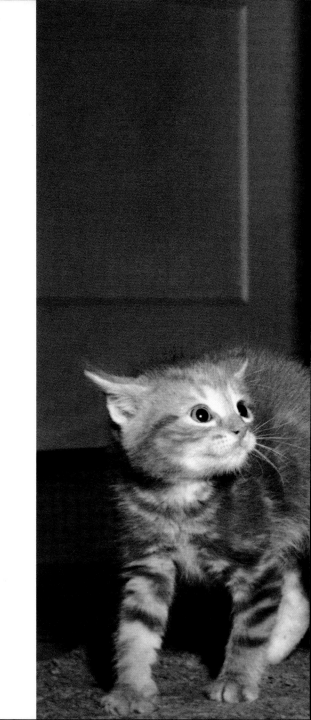

WALTER CHANDOHA
You Don't Scare Me
Annandale, New Jersey, 1975

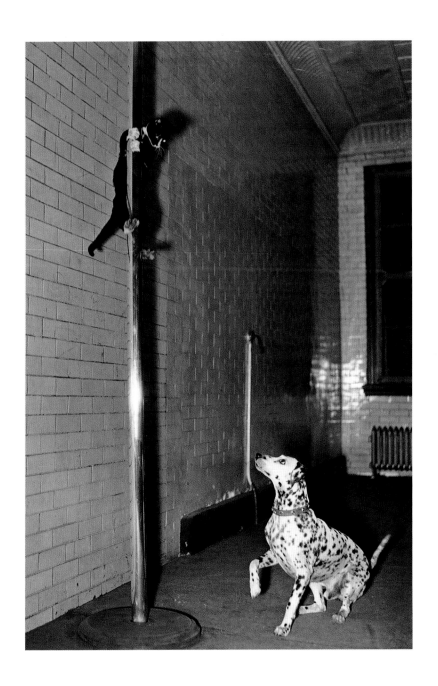

Buddies

JOHN DRYSDALE
Wild Relationship
Market Drayton,
England, 1972

Varner and Akbar are kind of cool cucumbers. I mean if there's an animal they want to hunt down and kill, they get crazed over that. I've certainly known cats that were total mushpots, but not my guys. Of course I know they love each other. They are out-and-out buddies. And I know they love us. But I couldn't quite prove it.

CONSTANCE HERNDON, EDITOR

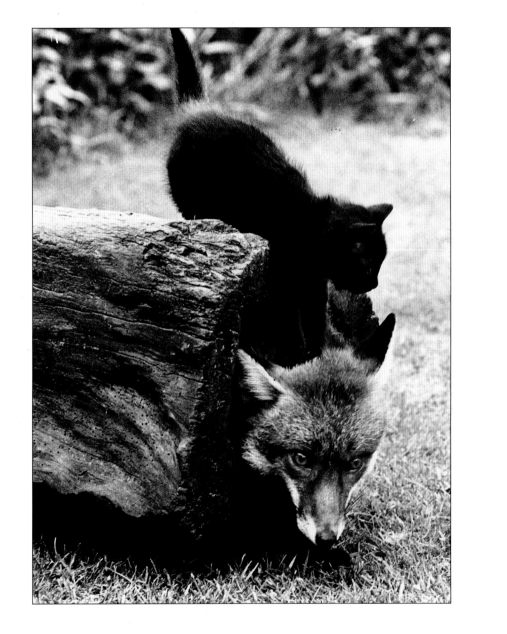

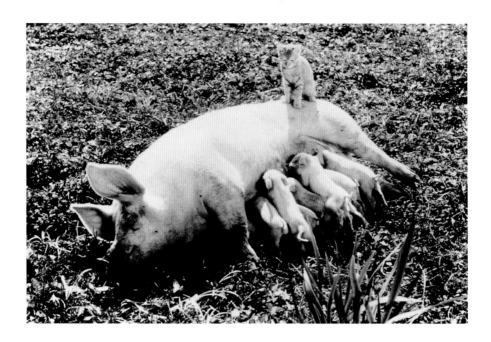

THE ADVENTURES OF MILO AND OTIS. 1989
Above: *The American release of this Japanese film about the misadventures of Milo, a tabby kitten, and Otis, a Pug puppy, was narrated by Dudley Moore. Eighteen animal trainers worked under animal supervisor Mikio Hata on the production.*

THE WRONG BOX. 1966
Right: *In this comedy about inheritance, Peter Sellers played the mad surgeon Dr. Pratt, his office overrun by kittens. As one cat sits in the surgical bowl, the doctor contemplates the phony death certificate he's just made out for Michael Caine.*

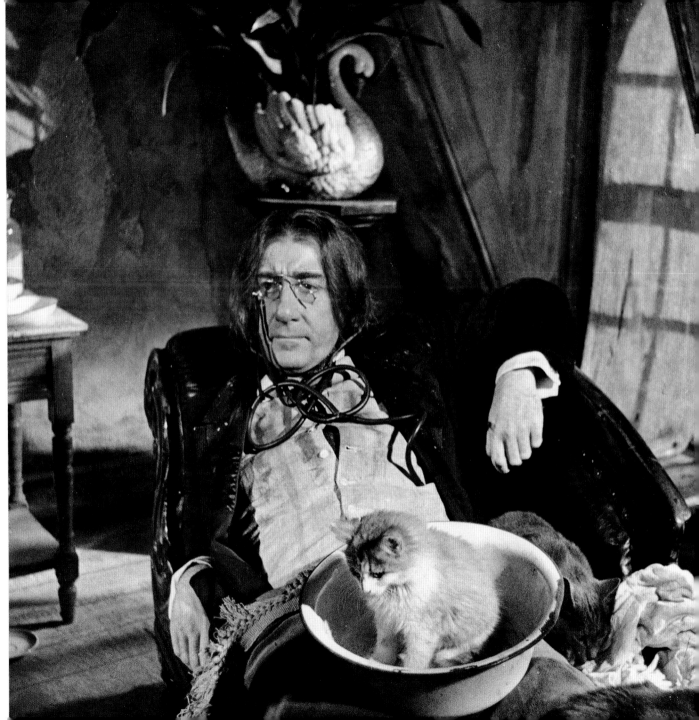

The Easter Cat

JOHN DRYSDALE
Peaceful Coexistence
Kings Lynn, Norfolk,
England, 1970

I always had rabbits. Then my friend's cat had kittens and I took a little white one because it looked the most like a rabbit. The kitten, Lily, grew up with rabbits hopping around. I think she knew she was not a rabbit, but she may still not know that they are not cats. As a youth Lily pulled some great capers with the bunnies—playing chase games all over the house, wrestling, nestling up to sleep with them. But she grew up to be as big as the rabbits. She could easily hurt one. Instead she guards them with great concern. If one strays into the yard, she keeps watch to make sure none of the other cats around the neighborhood mess with it. If one of the rabbits gets startled, she lies down next to it and her warmth seems to calm it down.

One time a rabbit got stuck behind the refrigerator and couldn't get out, and Lily came to my study and harassed me until I had to stop working. She leaped onto the desk and skidded into all my papers—which she knows is a bad move—and made a big racket. I finally got up and went into the kitchen to see if she was out of food. But she wasn't. Instead she led me to the refrigerator and then tried to get behind it. I thought maybe she'd lost a toy, but instead I found one of my rabbits. Or should I say our rabbits. If I hadn't have found the rabbit, it could have died.

KELLY CORE, FINANCIAL PLANNER

Overleaf:
THOMAS WESTER
Elsie Wigh
Grabo, Sweden, 1984

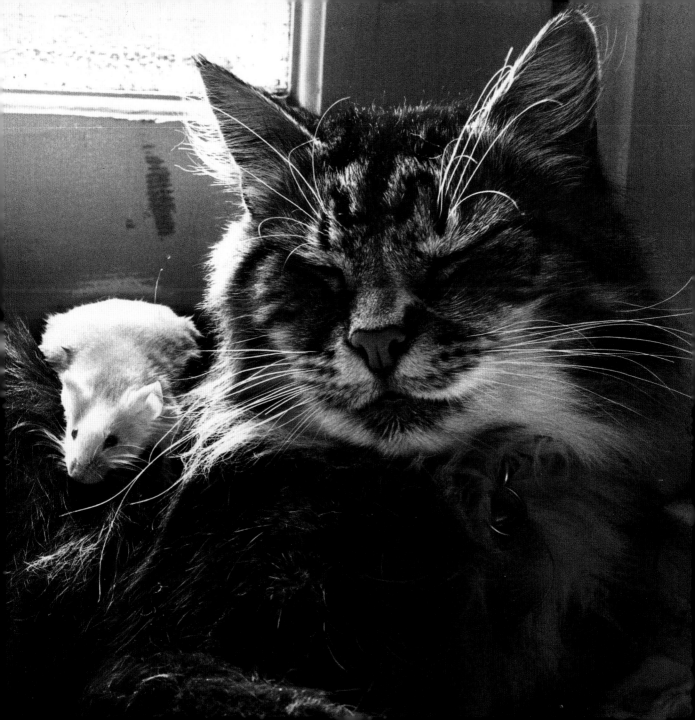

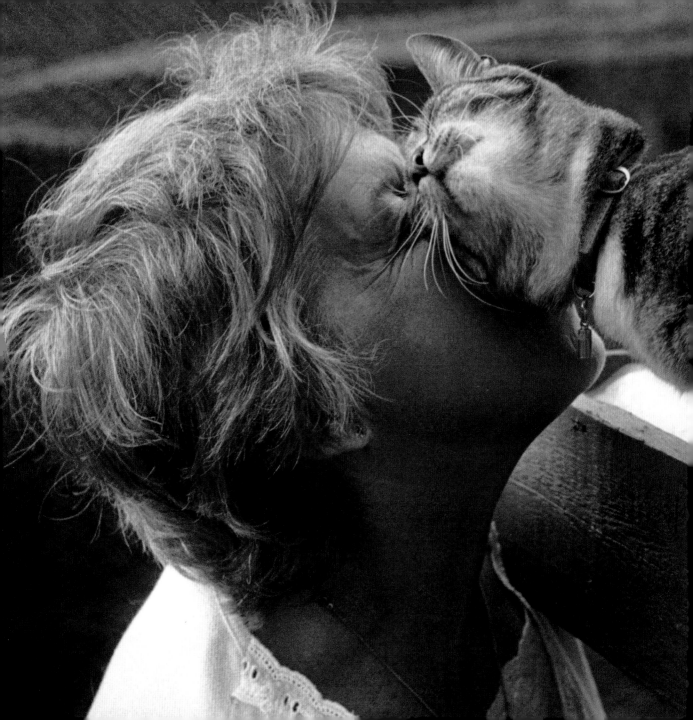

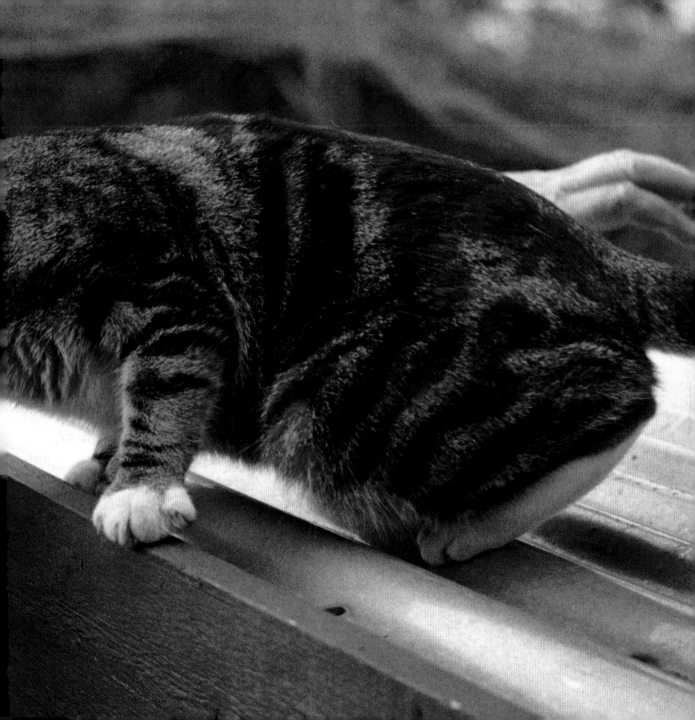

WALTER CHANDOHA
Of Course I Know Where I Am
Annandale, New Jersey, 1970

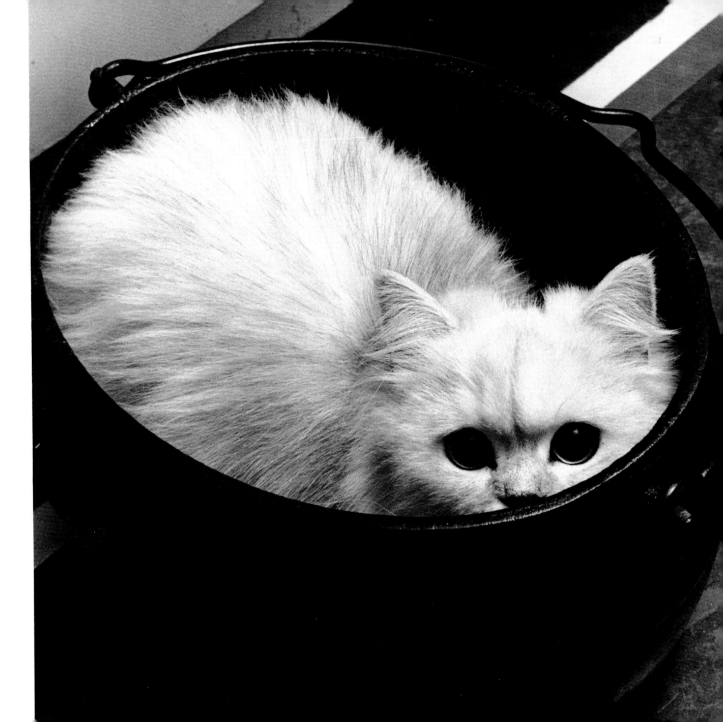

CLAUDIA GORMAN
Box Full of Fluff
Pleasant Valley, New York, 1994

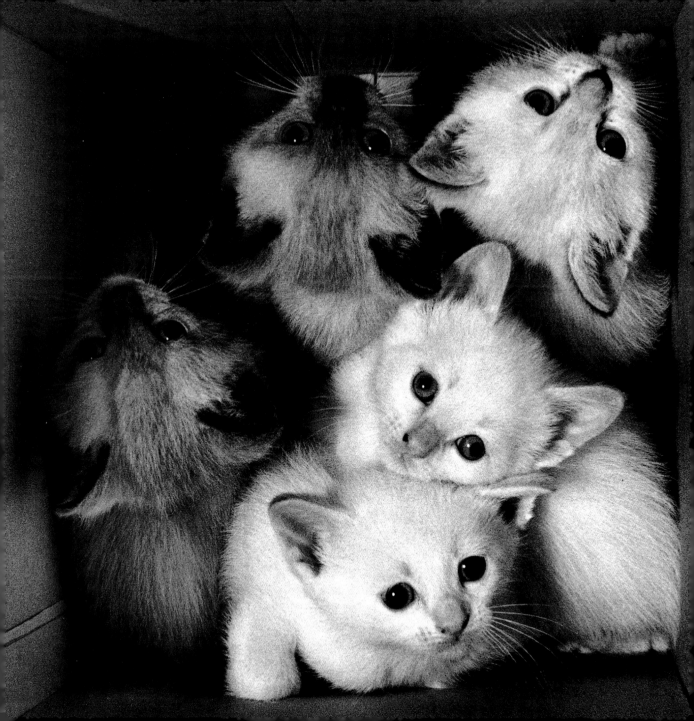

I saw the most beautiful cat today. It was sitting
by the side of the road, its two front feet neatly
and graciously together. Then it gravely swished
around its tail to completely and snugly encircle
itself. It was so fit and beautifully neat, that
gesture, and so self-satisfied—so complacent.

ANNE MORROW LINDBERGH
Bring Me A Unicorn: Diaries and Letters of
Anne Morrow Lindbergh, 1922-1928

THOMAS WESTER
STOCKHOLM, SWEDEN, 1984
A formidable fat cat who weighs in at 18.5
pounds, Mose strolls the streets of southern
Stockholm with nary a care for passing cars.
Once home, he patiently waits for someone to
let him into his apartment building. Inside he
knows another good samaritan will come along
and take him up in the elevator to his floor.

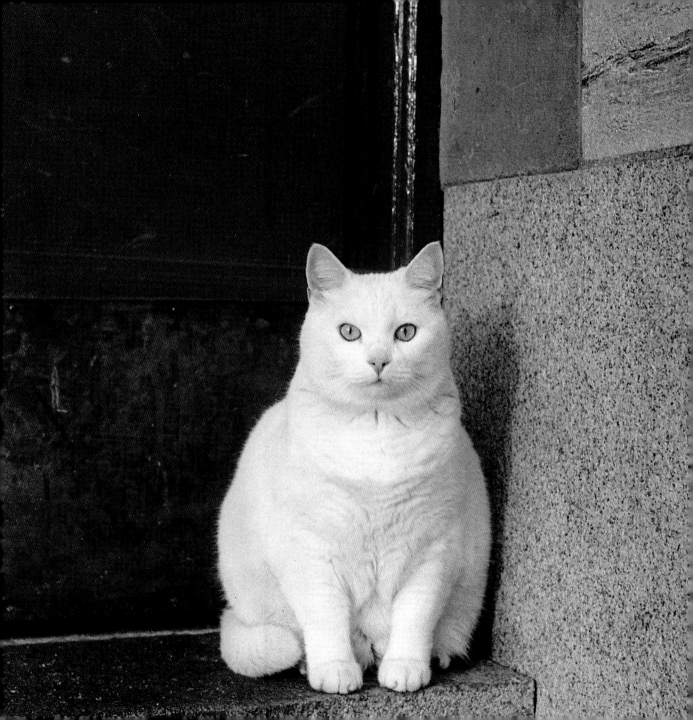

Love to a Cat

Kritina Lee Knief
*Muppet-Faced
Mother and Kitten
Boston, 1991*

This is how I see it: cats pretend they don't need anybody's love. This makes us feel incredibly insecure and then we lavish all this extra attention on them and then they get annoyed and reject us. Spurned like this we try even harder—special treats, extrasoft blankets, total clemency when they bring in dead birds. We decide another cat in the house might make them feel less lonely. So one day we bring in their new companion and all hell breaks loose. Our cat becomes a bully and chases the newcomer under the sofa. Our cat makes us feel awful for disrespecting her sovereignty over our house. So we feel guilty. We obsess over our latest infractions. We talk about nothing else. At the water cooler in the office, at the gym, on the phone: we confess our guilt and wonder how we will get rid of the intruder. We spend lunches finding a new home for this second-class cat. We find one and feel great—life will calm down again and our cat will be grateful for our getting rid of this problem and will become more affectionate, surely.

Then we get home to make everything nice and ready for the new owner to come for their new cat. But there is silence in the house. Both cats are hiding. See, in our absence, they have bonded. They are now inseparable. They refuse to be divided, spend every minute with each other, sleep in mirror images of each other, purr only for each other, and are united forever in their solemn pact to completely ignore us except for a perfunctory moment at mealtime. That is love, so far as I can tell, to a cat. No matter what we do, we are still left out of the picture. But actually, that's only my version. I hear of loving feline-human relationships all the time. It's just that my cats haven't.

RICHARD S., POET

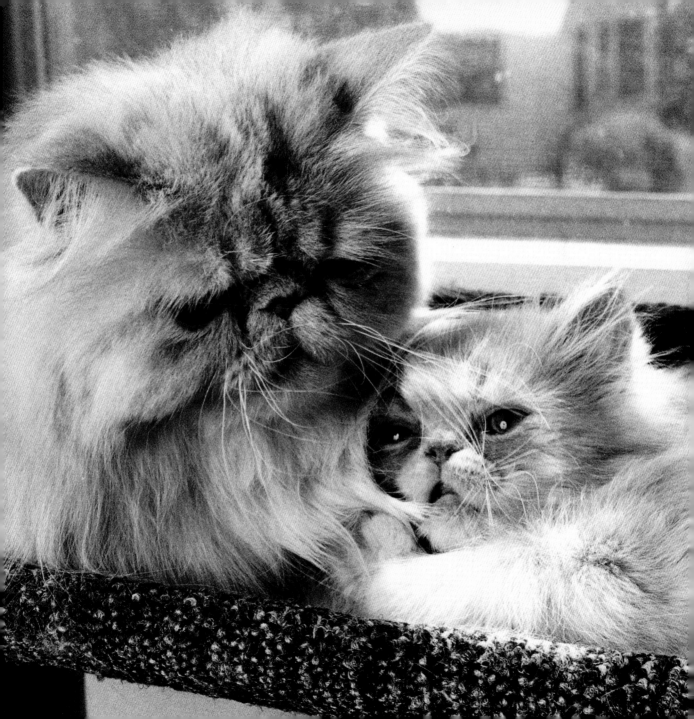

JOYCE RAVID
Batty Ravid, chat de luxe
New York, 1980

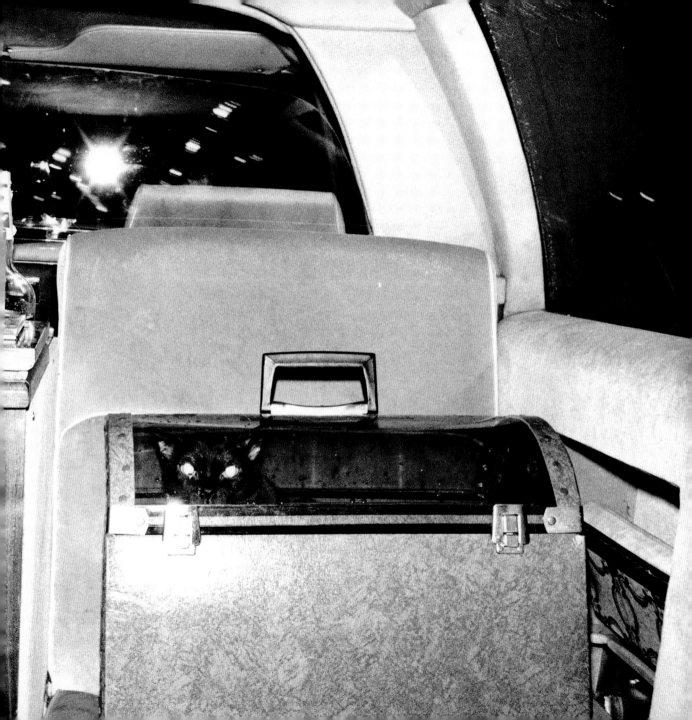

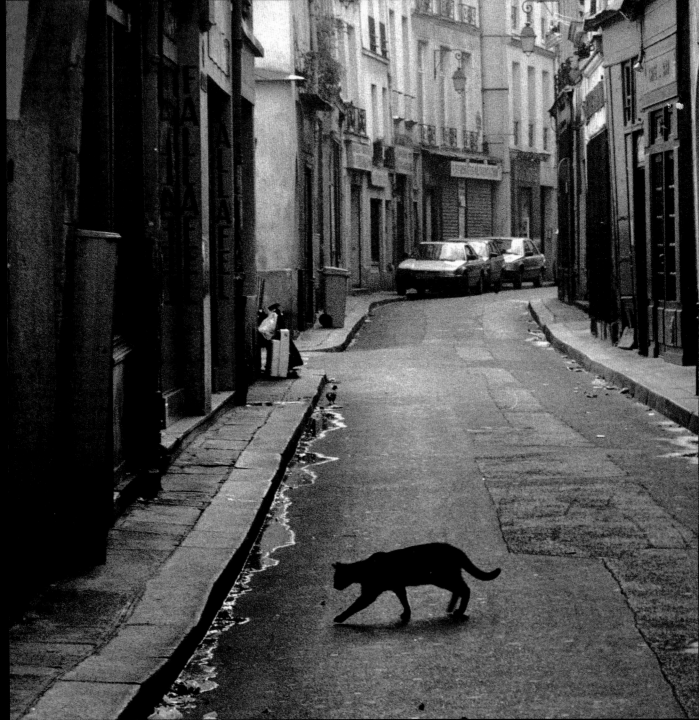

Marvin W. Schwartz
Crossing the Street in the 4th
Paris, 1986
"One Sunday morning I happened to notice
this cat crossing the rue du Rosiers in the Marais.
Usually nobody notices street cats,
who are completely different from domestic ones.
They live day to day and are the best fighters
in the world, but most of the time they're invisible.
The Marais was a very poor area before gentrification.
Now the cat lives in a housing project."

The Cure

A woman brought in a little gray kitten and said, "Rosie's listless and won't play with me." I put Rosie on the exam table and she just lay there looking pathetic, her ears hanging down. I figured she wasn't going anywhere, and left her in the room to take a phone call. But when I came back, the room was trashed. In one minute little Rosie had knocked over all the jars, scattered my papers, and shredded the happy animal posters on the wall. We found her high atop the cabinets, purring away. I told the woman, "I think she's cured."

C. KALLINI

VETERINARY ASSISTANT

TUCSON

THOMAS WESTER
Felicia's Kitten
Stockholm, Sweden, 1978

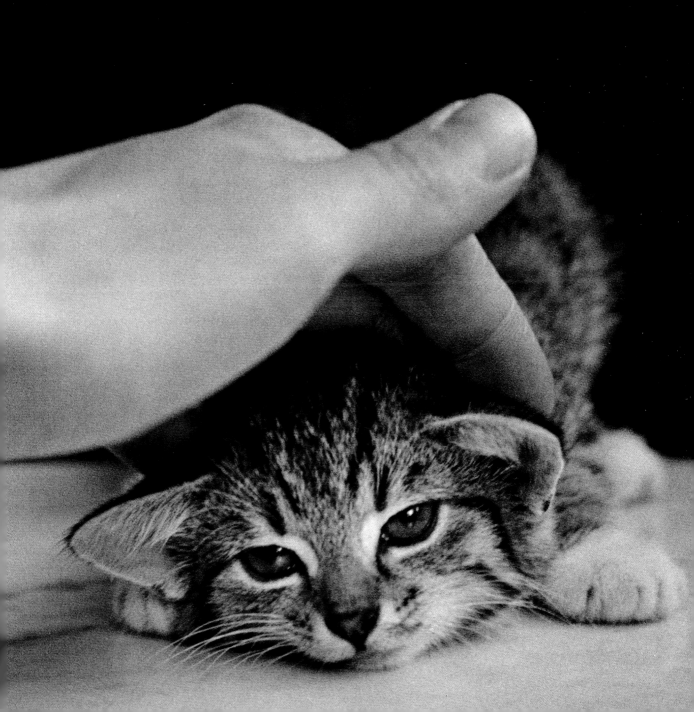

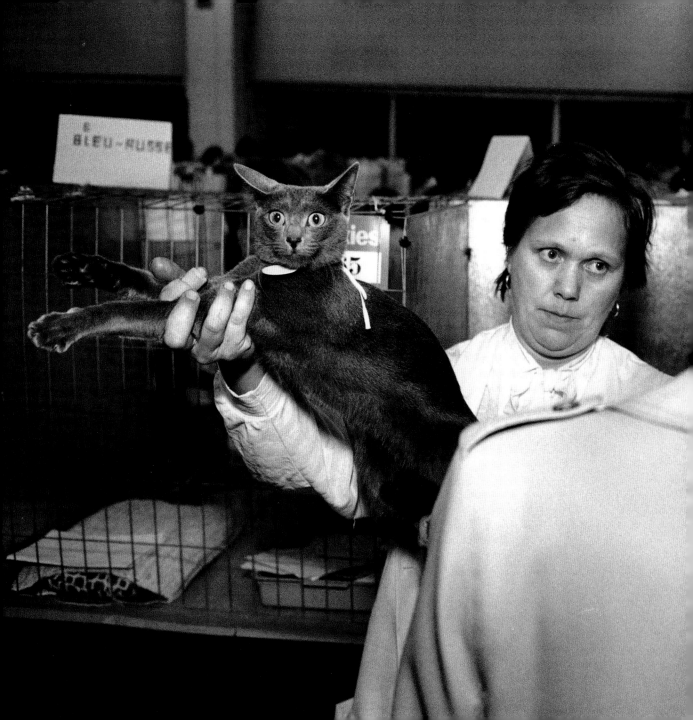

RICHARD KALVAR
PARIS, 1985

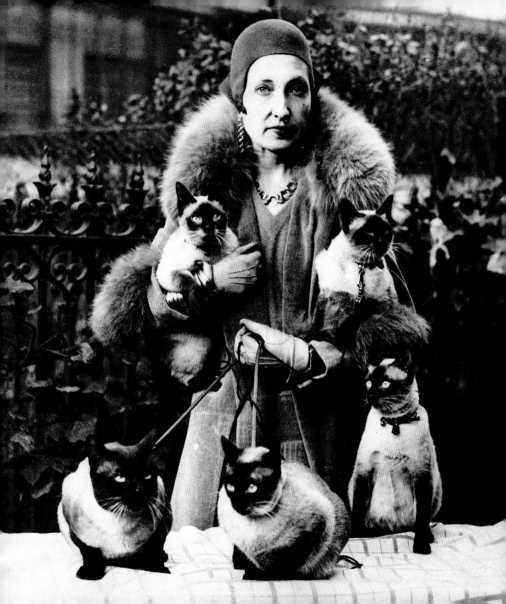

TERRY deROY GRUBER
CHINESE LAUNDRY CAT,
NEW YORK, 1979

The only thing Charlie was forbidden to do
was absolutely everything.

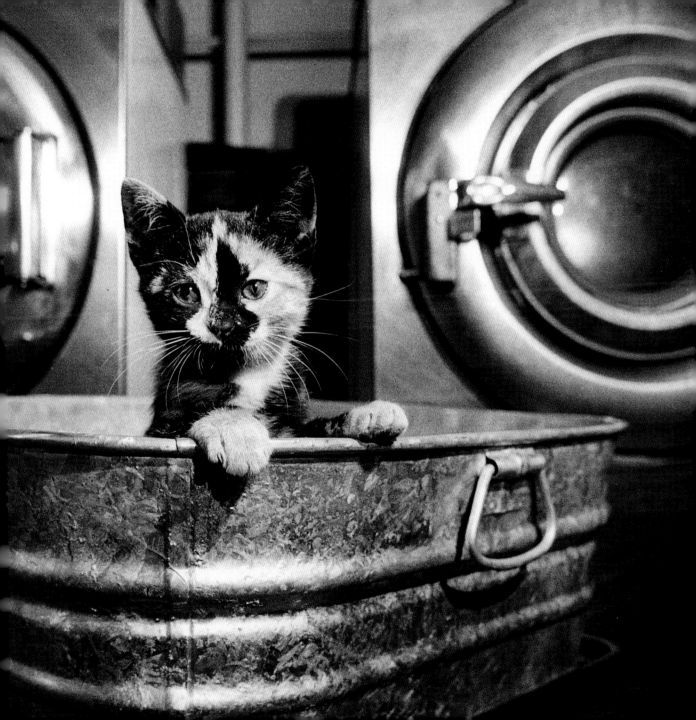

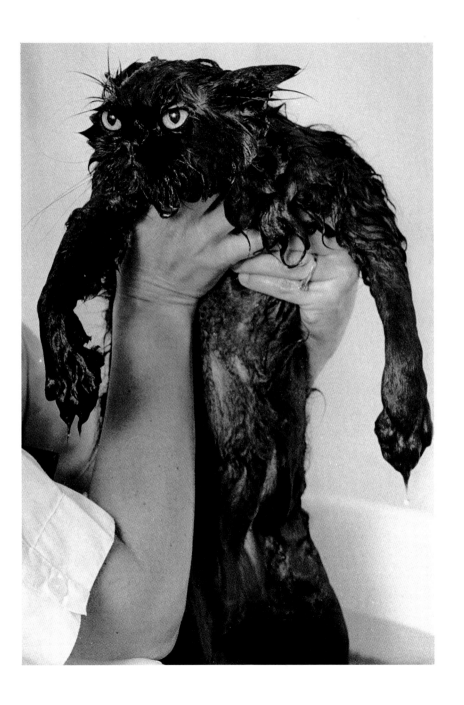

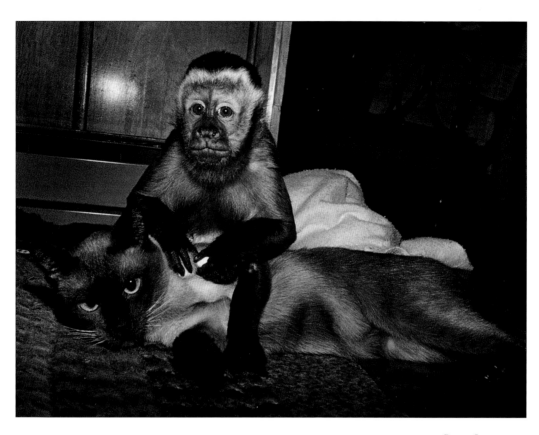

ROBIN SCHWARTZ
Teddy and Katja
Massachusetts, 1988

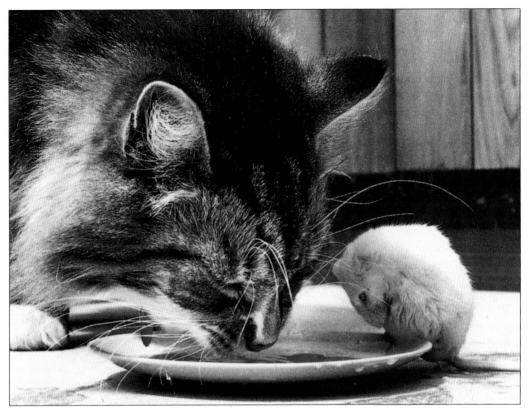

JOHN DRYSDALE
Tom and Jerry Sharing
Kings Lynn, Norfolk,
England, 1970

PHOTOGRAPHER UNKNOWN
PLACE UNKNOWN, DATE UNKNOWN
Actress Yvonne De Carlo, known for her role as
Lily on *The Munsters*, with a beautiful fat Persian.

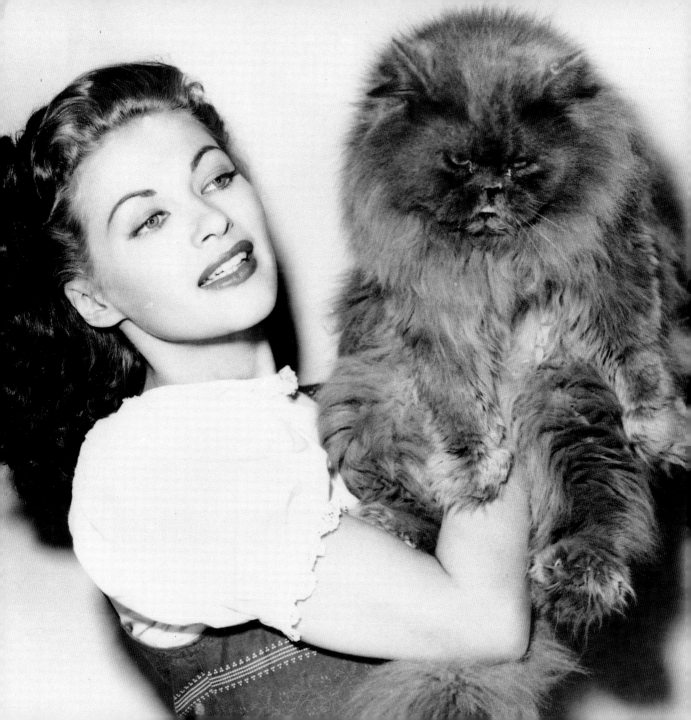

A home without a cat and

a well-fed, well-petted

and properly revered

cat, may be a perfect

home, perhaps, but how

can it prove its title?

MARK TWAIN

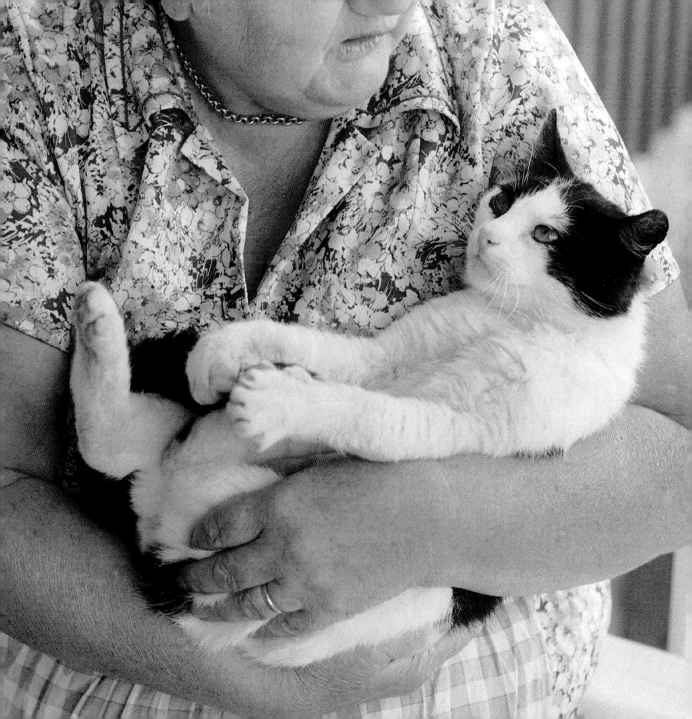

Even overweight cats instinctively

know the cardinal rule: when

fat, arrange yourself in slim poses.

JOHN WITY
CAT QUOTATIONS

CHAIM KANNER
VENICE, ITALY, 1987

"This cat acted like a dog out for a stroll with his
master. He was placid, complacent, and unafraid."

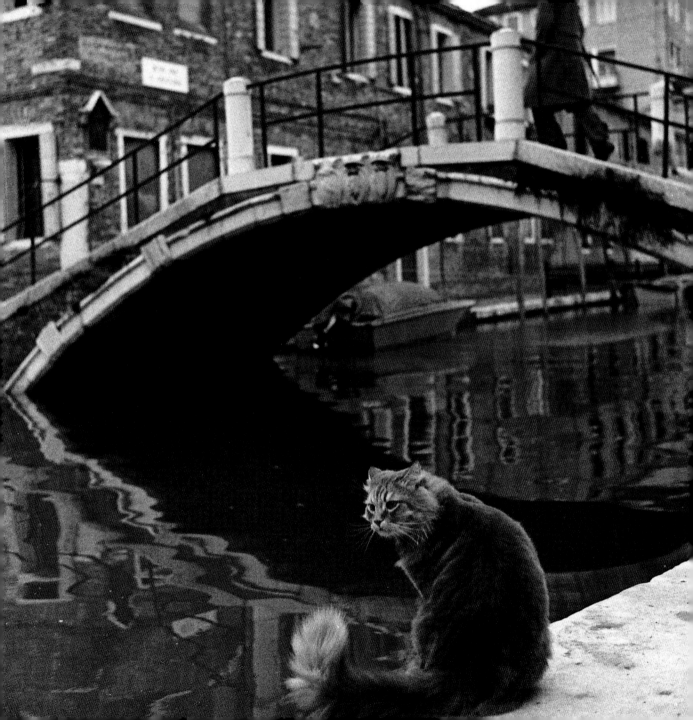

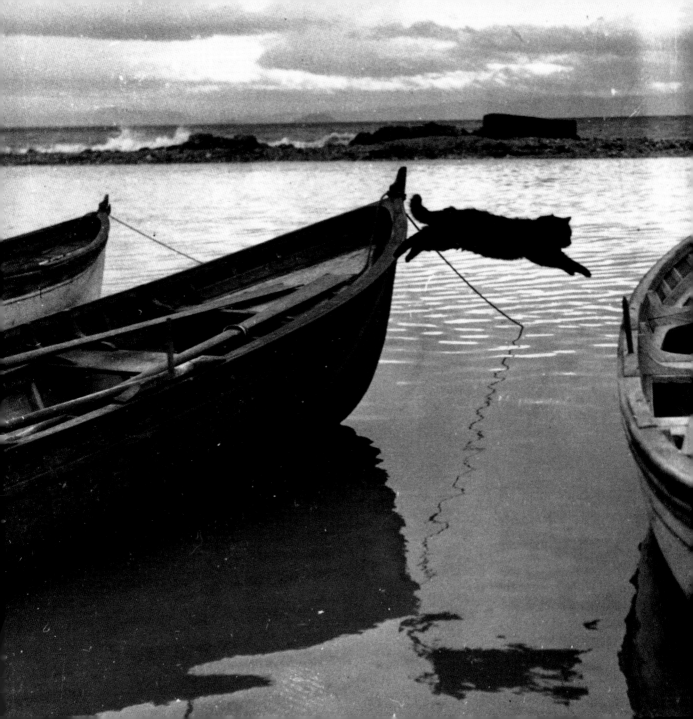

**ANONYMOUS
DOCK CAT,
NEW ENGLAND**

As familiar with boats and water as he is
with land, a burly fisherman's cat transverses
the rowboats on his way in for the night.

**UPI PHOTOGRAPHER
SWIMMER THE KITTEN,
SANTA MONICA,
CALIFORNIA, 1956**

Ten-year-old Donna Pick helped her two-
and-a-half-month-old tabby kitten get used
to the water by pulling her on a raft. Soon
the cat was leaping off a diving board
and coming along for morning laps.

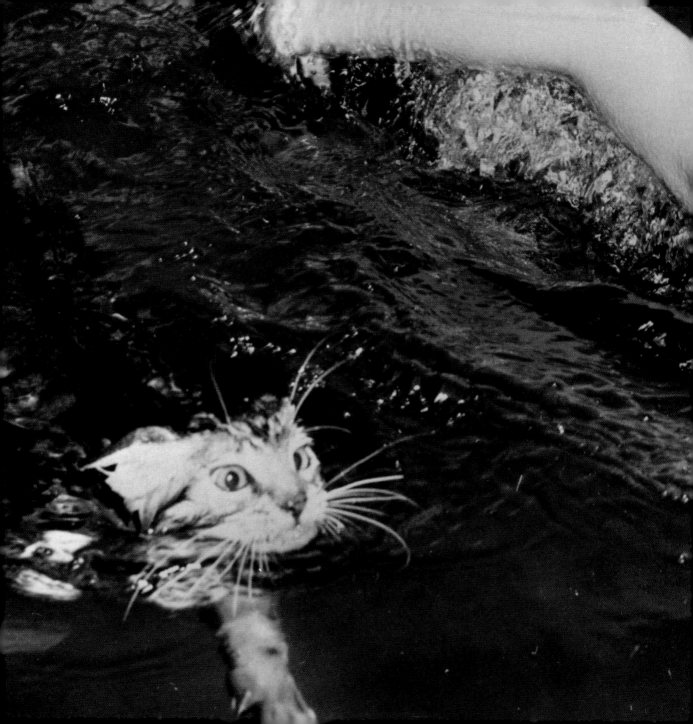

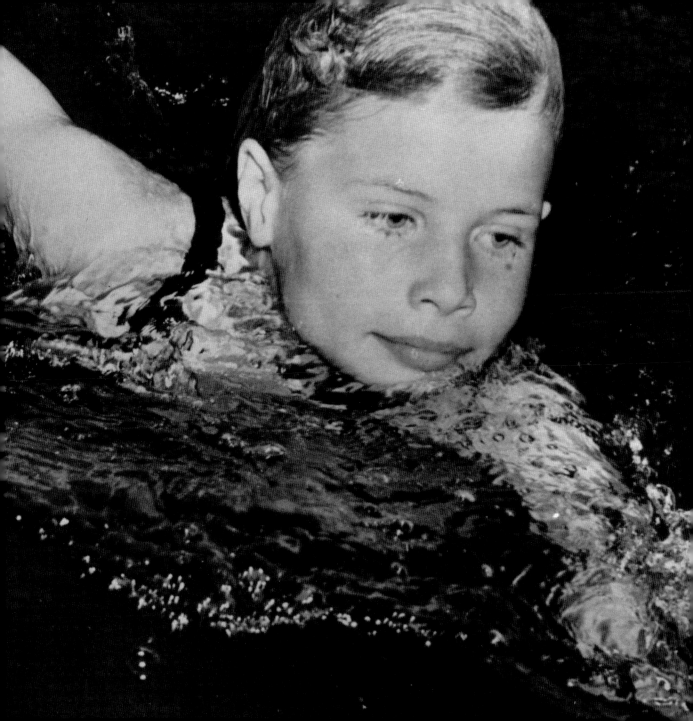

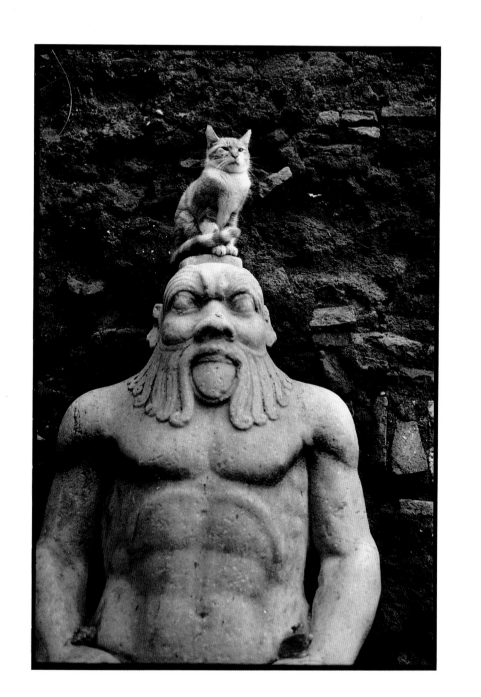

WALTER CHANDOHA
Tudor City Cat
New York, 1970
"In those days, the East Side had a lot of character.
The cat, for instance—he was clearly from the neighborhood—
didn't budge an inch when I poked my camera in his face."

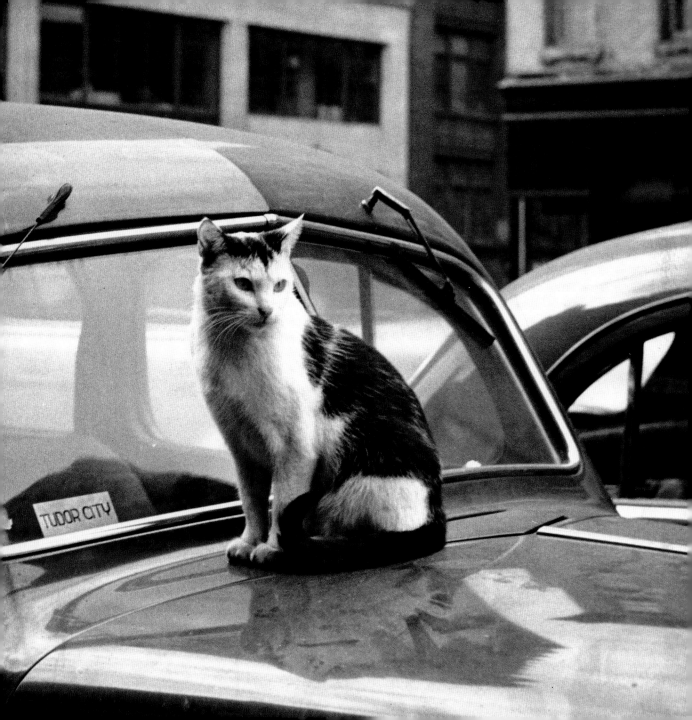

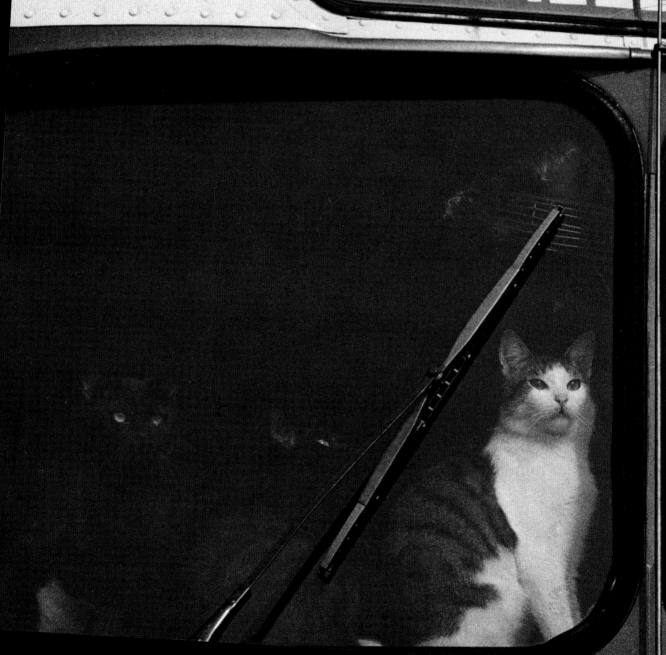

ARIES (March 21–April 20)

The original cat on a hot tin roof, most active and ambitious of them

all. From clean laundry to flower beds, he makes a (hollow) impression

everywhere. Fond of wandering, and when at home liable to create his

own obstacle course with no inhibitions about broken ornaments.

Fond of fighting, impetuous at loving.

Best Owners (only owners able to survive him): Sagittarius, Leo.

ANN CURRAH
The Cat Horoscope

PHOTOGRAPHER UNKNOWN
AUDREY HEPBURN AND THE CAT CALLED CAT, 1961

Orangey, a 14-pound prima donna, is a legend in the small world of feline acting.
His Patsy-award winning performance in Breakfast at Tiffany's required all the efforts of his
trainer, Frank Inn, including guard dogs at the exits so Orangey would stick around.
It was his second Patsy, the first gleaned from his work in the 1952 feature Rhubarb, which
also earned him the title, "The World's Meanest Cat."

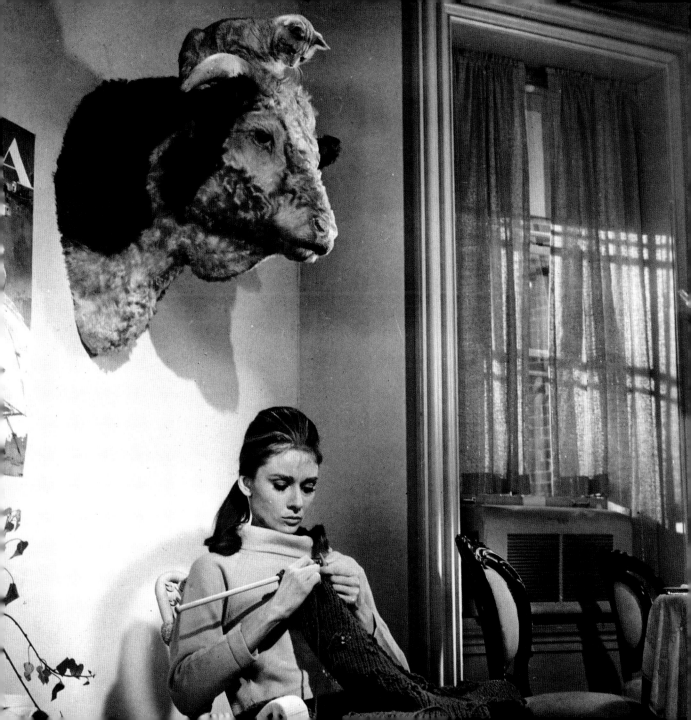

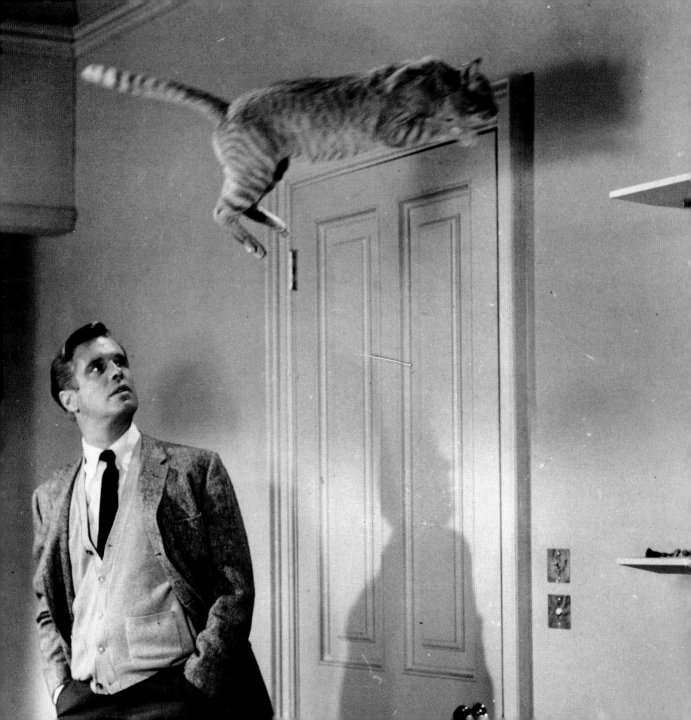

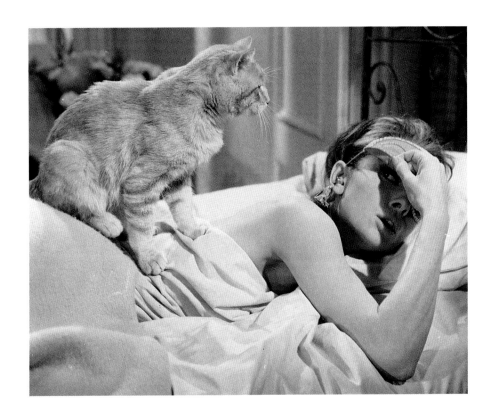

BREAKFAST AT TIFFANY'S. 1961

Above and left: *Defining cat irascibility for all movies to come,
Orangey method-acted his way through the Audrey Hepburn-
George Peppard romance in trademark style. As "Cat," Holly
Golightly's "poor slob without a name," Orangey jumped onto
the back of his hungover mistress to wake her up, and then
leaped from the floor to Peppard's shoulders to a nearby shelf.*

That Barn Cat

JOHN DRYSDALE
Kitten Makes an Ass of Itself
Glamorgan, Wales, 1981

There's a cat in love with my horse Harpo these days. The cat is a big old barn tom, but Harpo's a Thoroughbred, and was pretty high-strung until the cat came around. In the morning when I go to feed him that cat is always lying in the feed bin. If Harpo lies down for a nap, the cat lies down between his front legs, and Harpo is very careful not to move them. They play hide-and-seek out in the field: Harpo nickers and lowers his nose to the grass and the cat meows and pounces. Thing is, this cat doesn't give a hoot about any other animals—not the dog or the other cats, or even the other horses. Harpo is it. And if I go for a ride, I can lift the cat up with me and he'll stay on the whole way. I hold the cat and the cat holds Harpo, holding onto the mane with his teeth.

ANNE FORELLI, RESEARCH BIOLOGIST

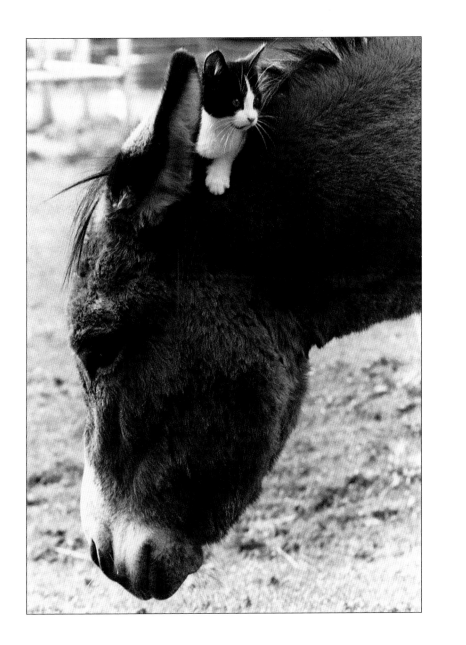

A cat I keep

that lays about my house

Grown fat with eating

Many a miching mouse.

ROBERT HERRICK

RIGHT:
THOMAS WESTER
KALMAR, SWEDEN, 1977
"This cat, Felicia, or Puppan in Swedish, had
eaten her Christmas rice pudding and then
settled in for a long snooze near the warm
radiator. She weighs about thirteen pounds."

OVERLEAF:
THOMAS WESTER
STOCKHOLM, SWEDEN, 1990
"This fat cat loves to take sunbaths."

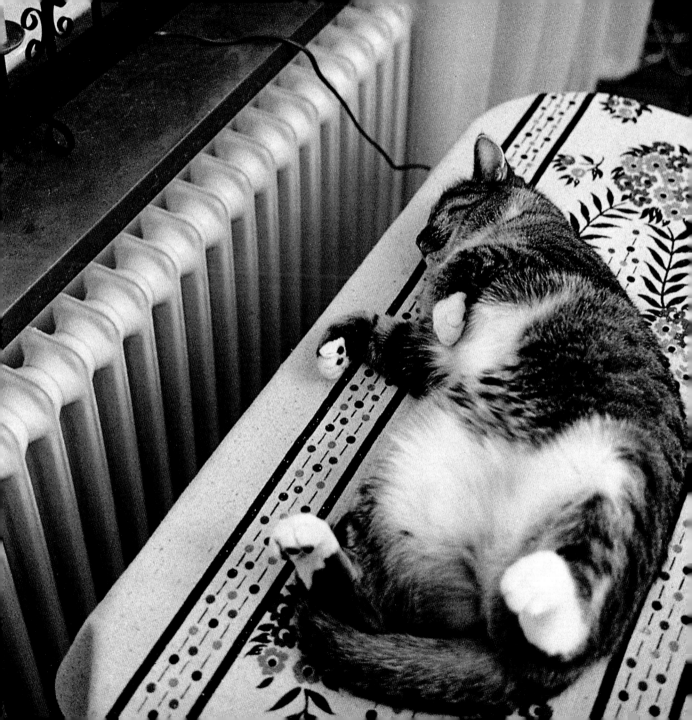

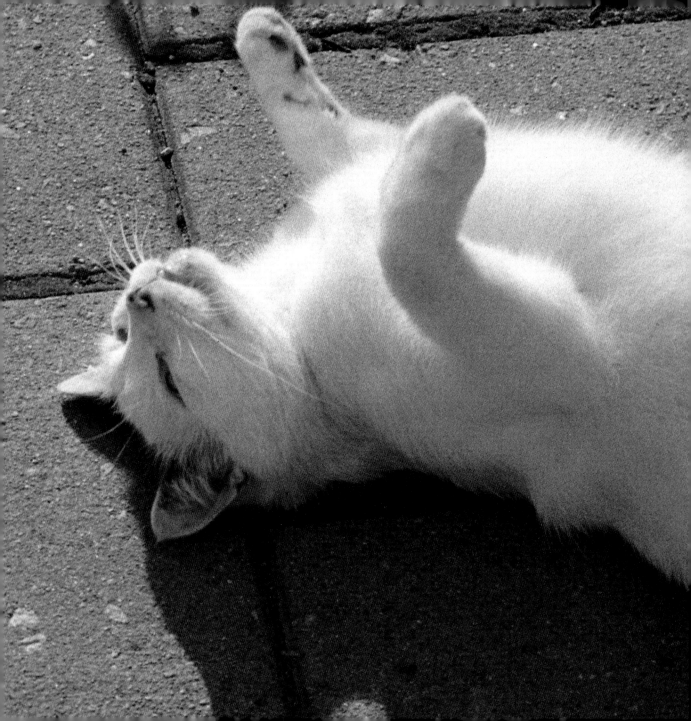

Grinch and the Burmese

WALTER CHANDOHA
City Courtship on 46th Street
New York, 1950

The animal clinic I work in got in a burly cat that was part Persian and all grump. A tooth infection made him so irritable he hated to be touched—though his owner said that was nothing new. His nickname was Grinch. After surgery I put him in the cat room in a quiet cage next to a little Burmese that ignored everyone. She was a sad little cat: her owner was away on business a lot, and the cat boarded here. It didn't seem like much of a life.

When I went to check on Grinch's recovery I thought, "Well, he'll probably be in a really bad mood." I shoved my hands into my pockets to keep myself from reflexively reaching for him and getting clawed, and walked into the cat room. There was Grinch, sitting up with his eyes shut, purring so loudly the cage rattled. His lips were curled into a funny smile and his tongue was hanging out. His paws did little kneading motions into the blanket.

I was really worried. Did I have a stoned cat on my hands? Had I given him too much anesthetic? I checked the dosage, but it was right. Then I noticed the little Burmese—she was kind of hidden, crouching right next to him. She was grooming him through the bars. This was the source of Grinch's bliss. He lay down like a majestic lion and the Burmese followed, pressing herself closely against him. They turned their heads towards each other as if they were lovers inhaling each other's wonderful scents. They slept all day like that.

The next morning, when Grinch's owner came to get him, he hissed at her. He yowled from his crate and the Burmese yowled back. It was cacaphony. None of us knew what to do. Home, he hid from his owner and scratched up the furniture. And the Burmese, here, went on a hunger strike.

But this story has a happy ending. Grinch's owner, desperate to have a mellower cat, offered to take the Burmese. The Burmese's owner agreed to let her cat go live with Grinch. Now Grinch has no more tantrums, and the Burmese is sleek and fat. If one has to go to the vet, they come together. The Burmese needed to stay overnight recently and Grinch stayed with her. They were in heaven. It was like a second honeymoon.

CHRISTOPHER KALLINI,
VETERINARY ASSISTANT

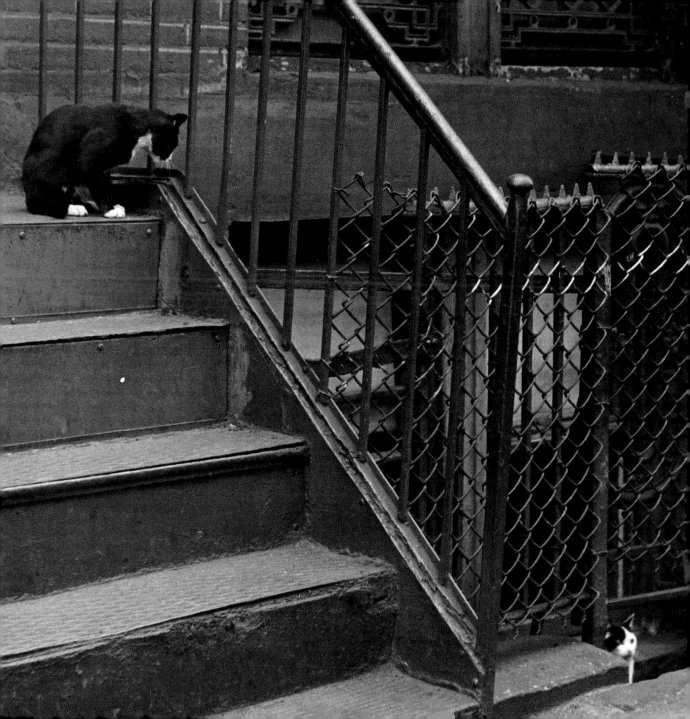

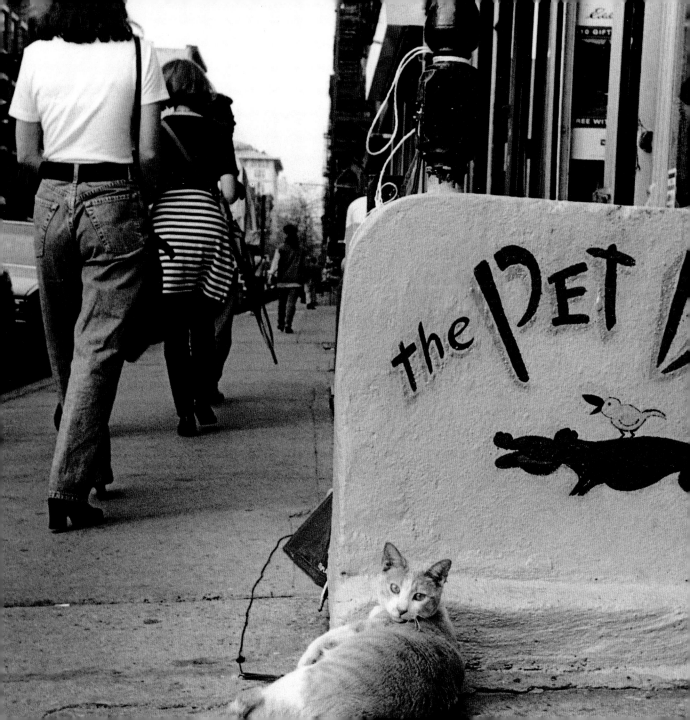

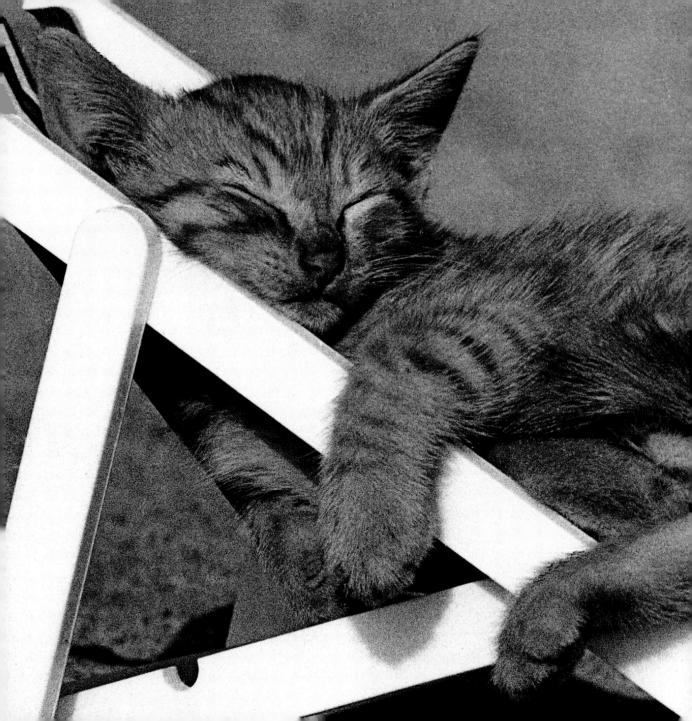

DAVID McENERY
Life of Reilly
Santa Monica, California, 1992

overleaf:
YLLA
Six Siamese Kittens
New York City, c. 1950

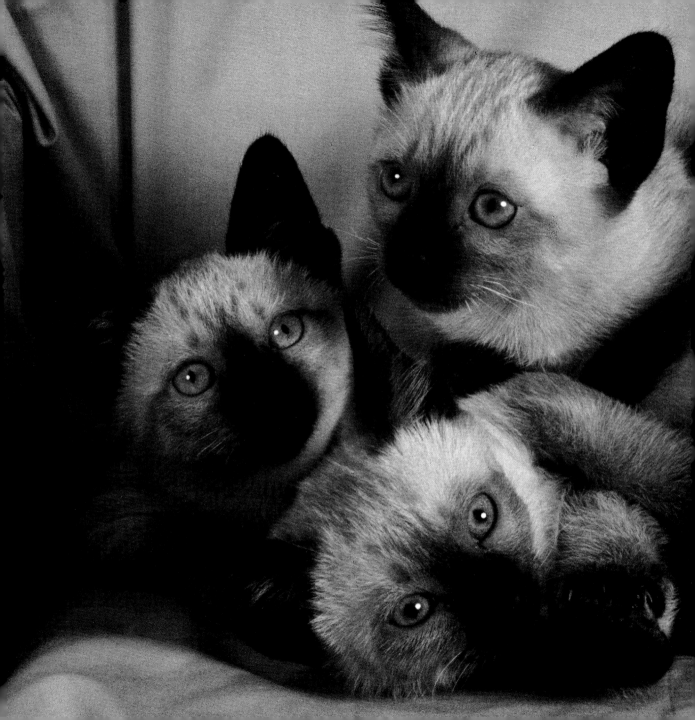

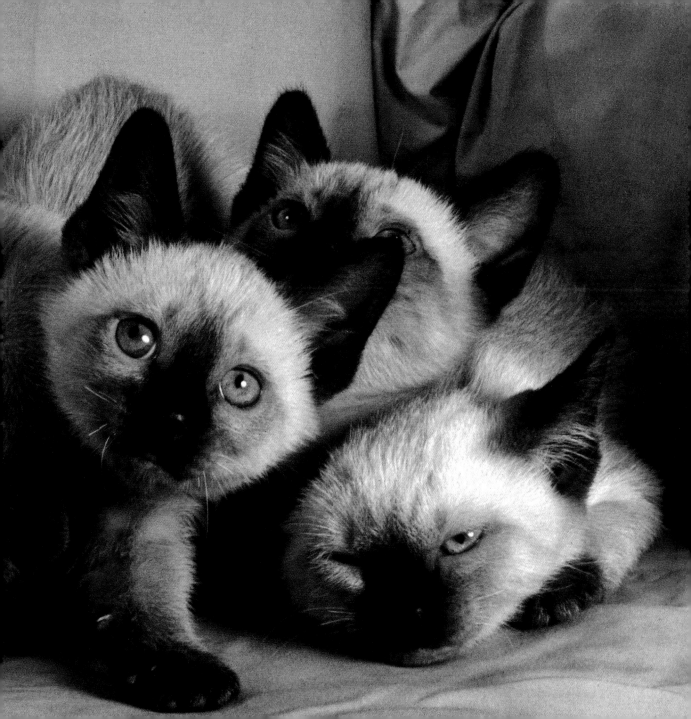

Don Gato of W. 105th Street

MARY BLOOM
Meri and Kitten
Sharon, Connecticut, 1983

When I lived in Spanish Harlem, I had a cat who was clearly in love with my girlfriend. Even after we got him fixed, he'd get all aroused. Every night he would come into bed and move against her. He was definitely a passionate cat. One day he was resting on the windowsill and it started to rain. I was asleep under the window. In a half-conscious state I reached up to close it and instead of coming in the cat jumped out—three flights down. He wound up hanging around in the backyard having a quick fling with a girl cat, and then came back up three days later, completely unhurt. He was hungry, but he was happy. And he stopped bothering my girlfriend.

BEN PEROWSKI, DRUMMER

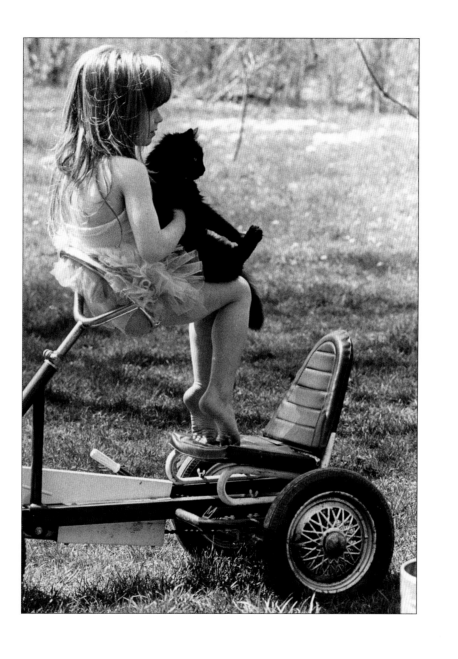

KRITINA LEE KNIEF
Captain, Spaghetti and Cat
Venice, 1992

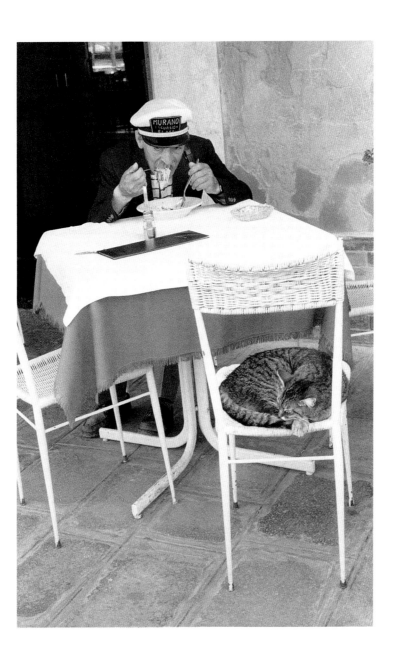

As anyone who has ever been around

a cat for any length of time well knows,

cats have enormous patience with the

limitations of the human mind.

CLEVELAND AMORY
The Quotable Feline

RIGHT:
THOMAS WESTER
SUNDRE, GOTLAND, SWEDEN, 1985
This fat cat weighs in at 15.4 pounds and
loves to amuse himself in the dining room.

OVERLEAF:
KARL BADEN
CAMBRIDGE, MA, 1990
"Ohmie has belonged to a friend for eighteen years. On a
visit to the local animal hospital, despite her girth, the vet,
amazed at what great shape she was in for a cat of her
age, said, 'This cat has the body of a twelve-year-old.'"

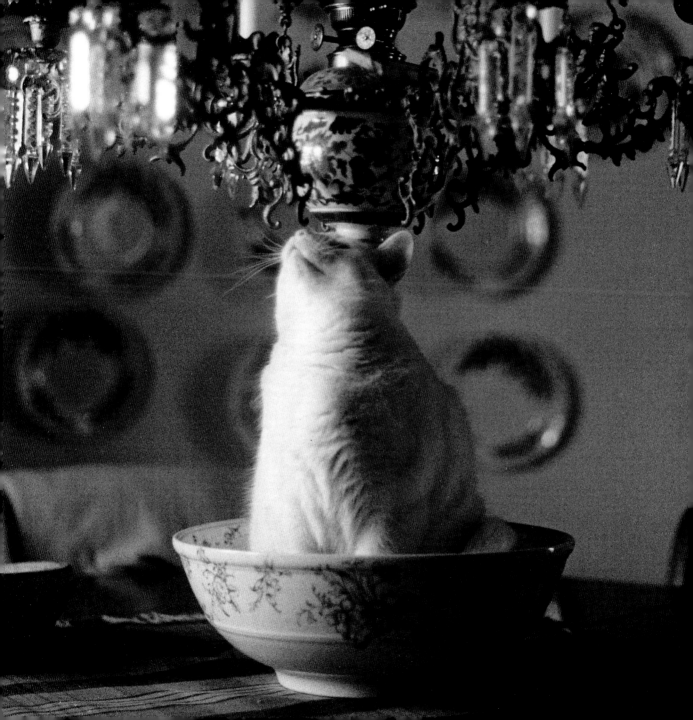

LARS PETER ROOS
CATNAP,
WEST AFRICA, 1986

"My friend was working on a health project in
West Africa, and I was her houseguest. Her
kitten, a little tabby, followed me everywhere.
He had the habit of figuring out just where I
wanted to be and getting right in that spot. Or
lying on the piece of paper I was writing on
until he lost interest and fell asleep."

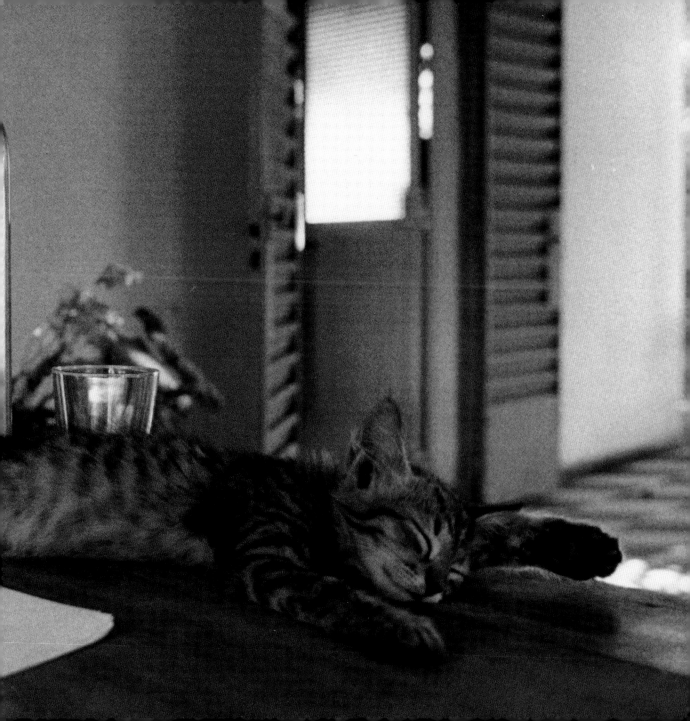

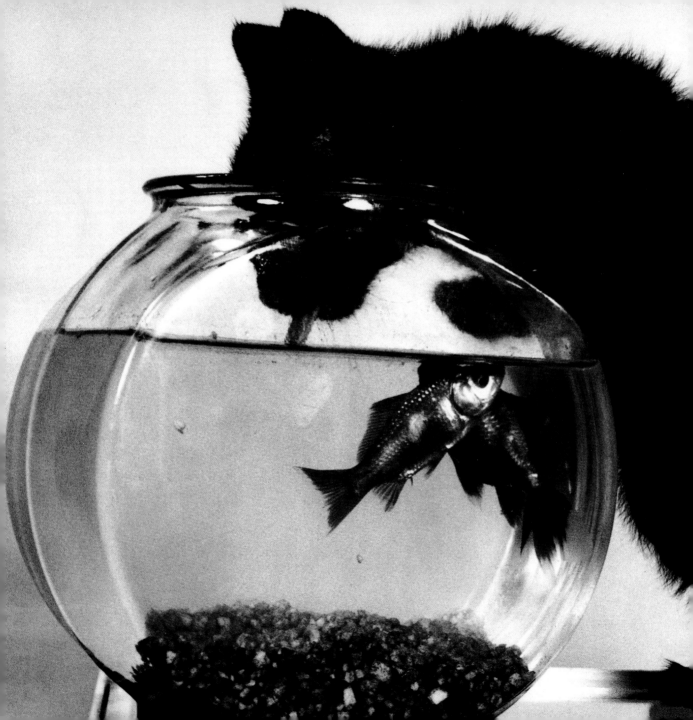

YLLA
Diable and Goldfish
New York City, c. 1950

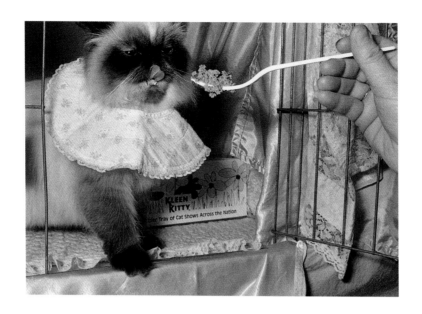

ABOVE:

KARL BADEN

CAT AND FORK, BOSTON, 1992

"You'd think that this cat wore a bib for mealtime.
Actually a lot of long-haired cats wear bibs at cat
shows, so they won't lick themselves and mess
up their hair before they're judged."

RIGHT:

ROBIN SCHWARTZ

CHANEL, NEW YORK CITY, 1996

"This lion-cut calico Persian named Chanel is a veteran
show cat. She comes to Madison Square Garden every
year from Florida, where she lives with Lise, her owner,
who's a groomer. Chanel is thirteen years old. I think
older cats have more of a sense of laissez-faire than
younger ones. They have a certain dignity about them
that comes from having been around the block."

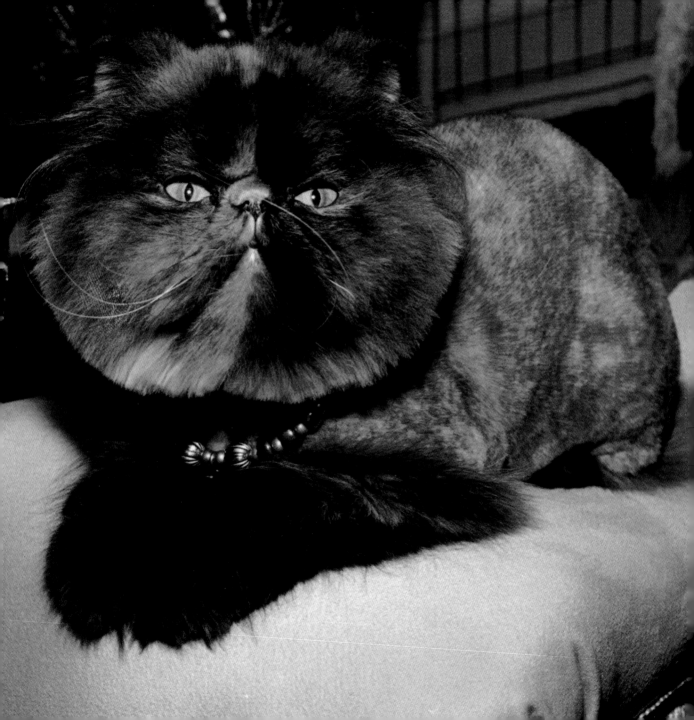

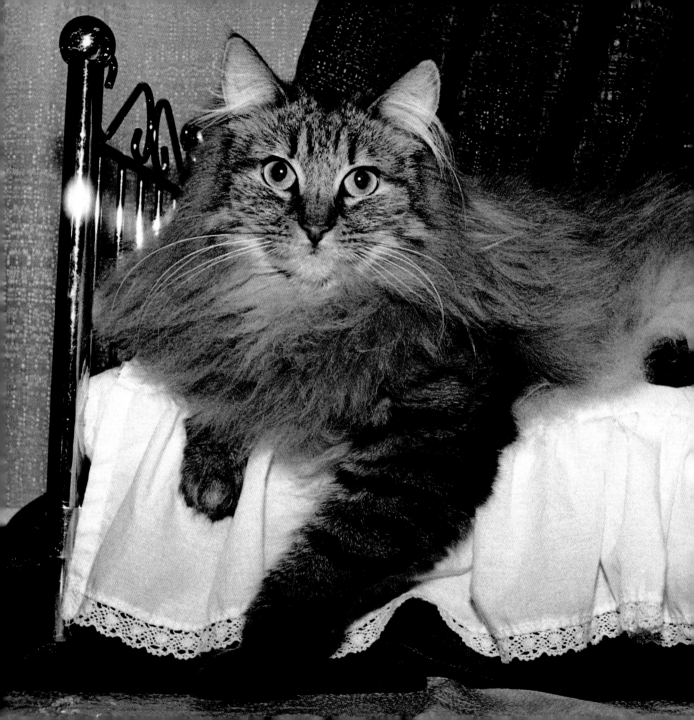

ROBIN SCHWARTZ
NEW YORK, NY, 1994

"A Norwegian Forest cat at the
International Cat Show in
Madison Square Garden.
His name is Billy Joe."

BELL, BOOK AND CANDLE. 1958
*A feline-eyed Kim Novak holds Pyewacket the Siamese as she
brews up a witch's plot to win James Stewart's love. The cat
won a Patsy Award—the American Humane Association's
Picture Animal Top Star of the Year award—for his
performance.*

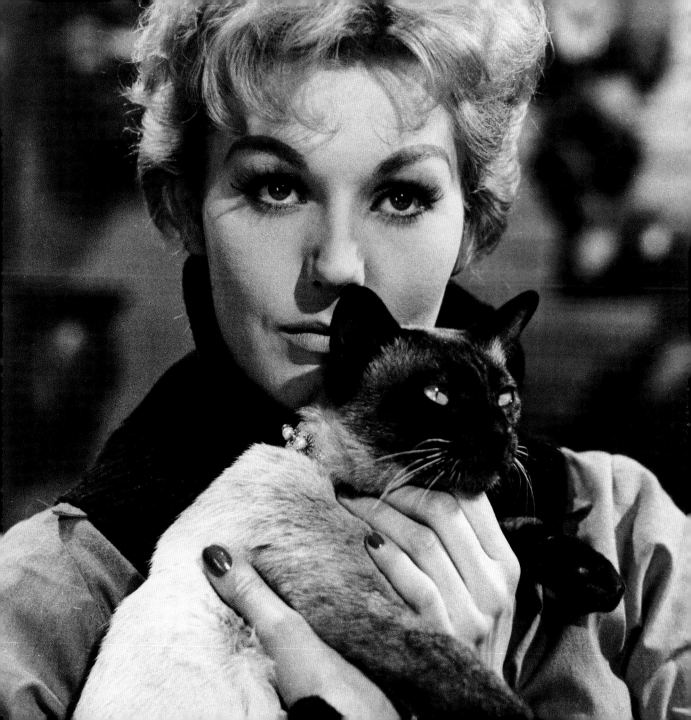

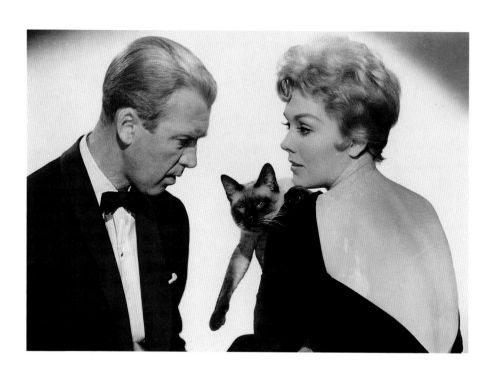

BELL, BOOK AND CANDLE. 1958
*James Stewart looks with amazement at Kim Novak's feline
ally, Pyewacket, who is asleep in the witch's arms.*

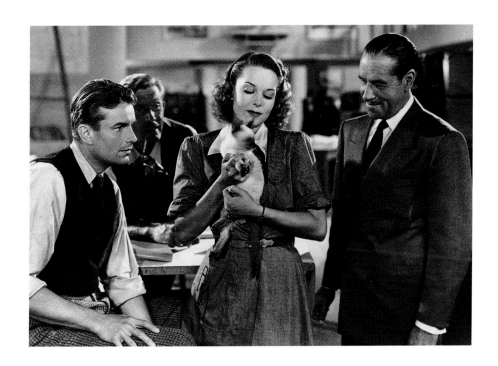

CAT PEOPLE. 1942

*Jane Randolph comforts the kitten that's been mewing away in
a box all day. Presented by Kent Smith to his mysterious
girlfriend, Simone Simon, the kitten hissed with terror and had
to be taken away—the first hint that Simon had an uneasy
connection with the feline world. Brought to the office, the cat
does fine with thoroughly human Randolph.*

A typesetter at this firm, which was called Zinn's and was in midtown, told me that Zinn the cat was great to have around the office, since she was a real talker, and it was nice to have someone to make conversation with when you just worked with printed words all day.

KARL BADEN
CAT SHOW, FRAMINGHAM, MASSACHUSETTS, 1991

The show was taking place in a high school gym, which seemed like a very noisy atmosphere. What interested me is that someone put a bed in the cage that's about three times as fancy as the one I sleep in, though it's a little smaller, of course.

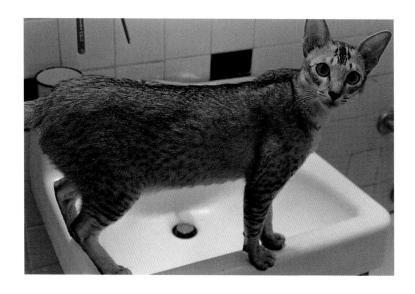

"I know some cats like to stay cool in the summer, but this was in October, and it wasn't particularly hot at all. Sebastian just likes cool, smooth places. Maybe he's trying to say something about his personality. Actually, he's not that smooth, he's just very present. This was taken in the morning: I was starting to brush my teeth, and he just wanted to be where I needed to be. In a minute, he probably started talking, because he's also very vocal. I have a friend who wants to make a video of him talking. He's sure we could win a big prize on *America's Funniest Home Videos*."

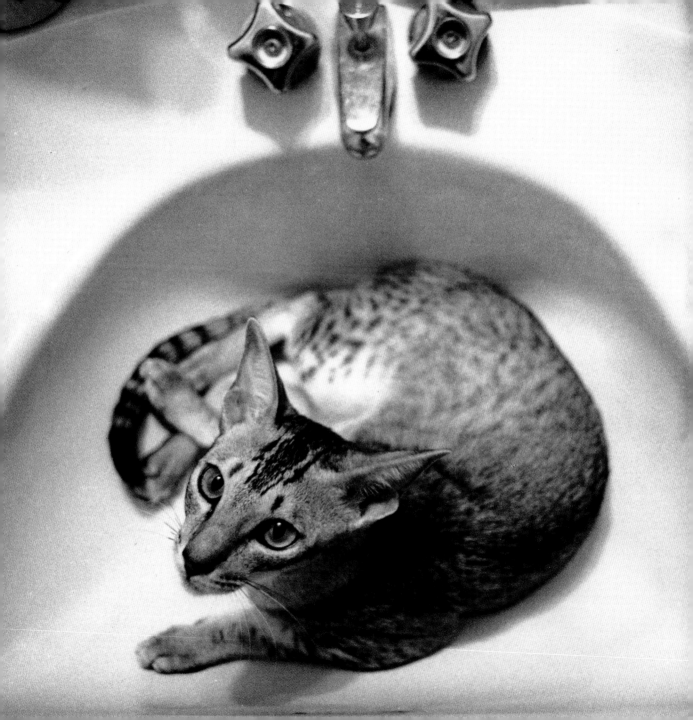

THE BLUE BIRD. 1976
This tuxedo-patterned Domestic American Longhair starred in 20th Century Fox's remake of this children's tale filmed in Moscow. Elizabeth Taylor, Cicely Tyson, and Jane Fonda were among the other stars in the lavish fantasy.

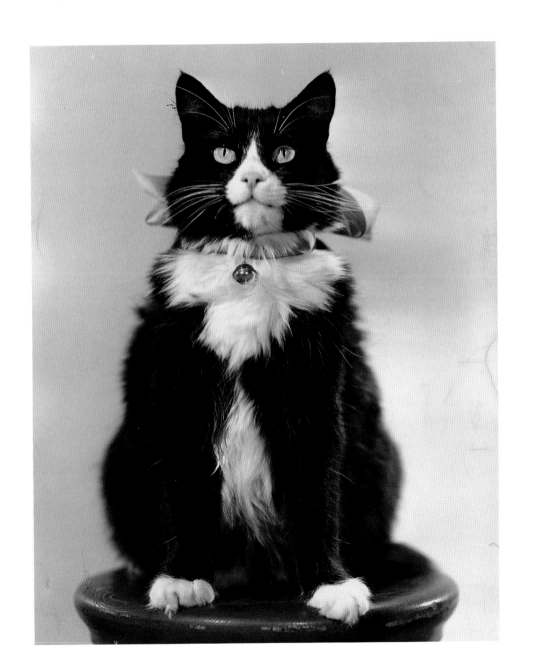

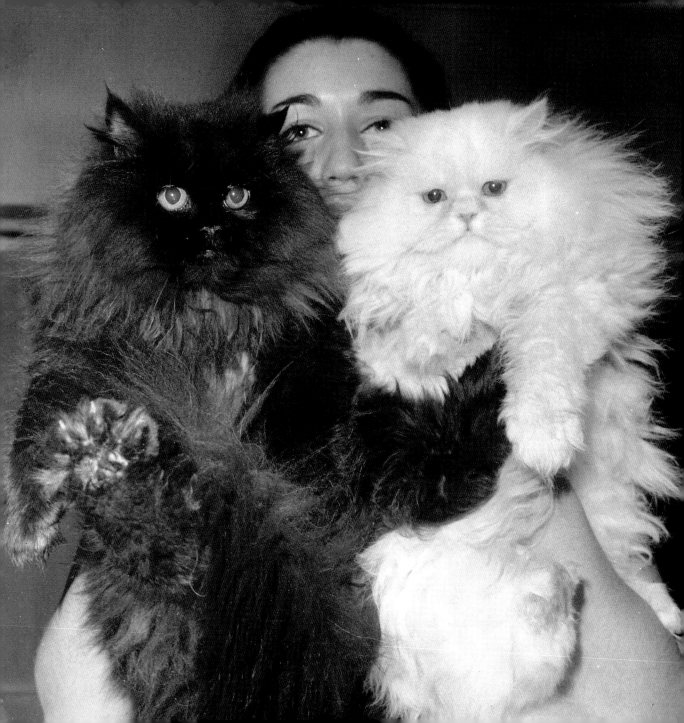

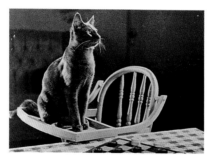

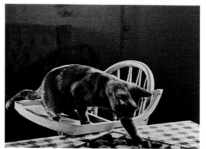

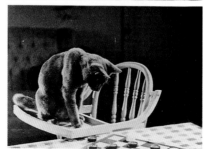

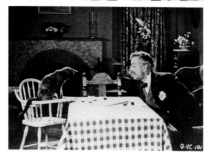

Pepper the Cat. 1920s

The gray cat climbed up through a broken floorboard and right into Mack Sennett's Hollywood studio, where she was immediately installed in the scene being shot. She performed beautifully. Sennett christened her Pepper and made her the feline star of many silents. Her curiosity made her a fast learner. She picked up checkers instantly to play with comedian Ben Turpin, and formed a lasting partnership with Teddy, the Sennett studio's Great Dane. In mourning for the departed dog, she ended her career just as she'd started it— by refusing to stay on the set.

MARLON BRANDO AT HOME. 1955
The brooding star of The Wild One *at home with his white cat,
a Domestic American Shorthair.*

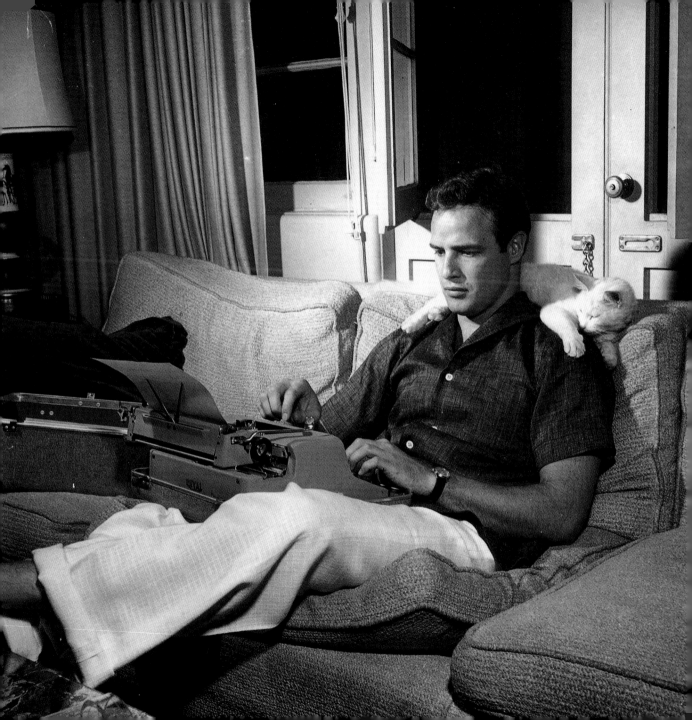

ROBIN SCHWARTZ
BALOO, NEW YORK, 1993

*Baloo was at the Madison Square Garden Cat Show in March. She's a Norwegian Forest Cat.
She was just hanging out on the chair, very laid back. I think it's remarkable for a cat
to act that way at a cat show. I'd be a wreck if I were a cat at a cat show.*

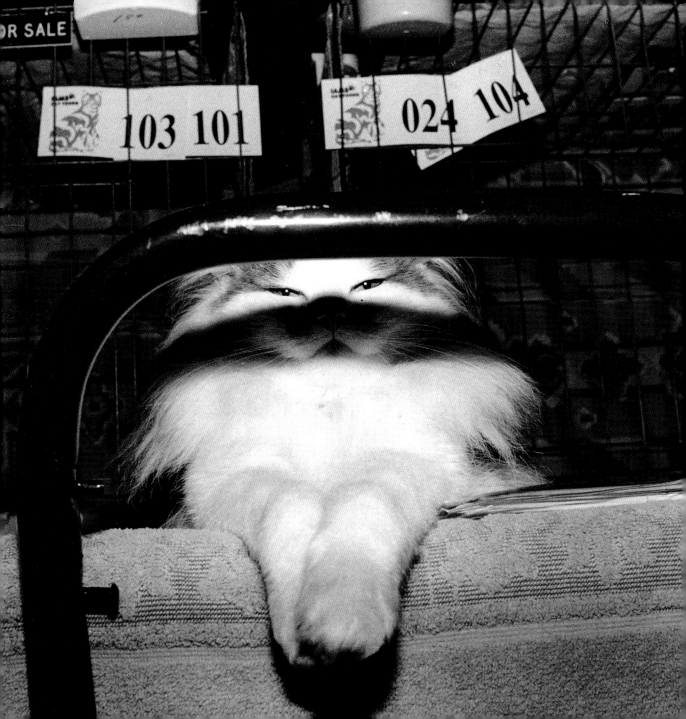

TWO OF A KIND

My friend who's extremely plump has a cat who out of sympathy became quite large as well, until the two of them were just enormous. The cat, though, is very proud of his bulk and carries it quite well, while his owner, on the other hand, seems quite embarrassed for himself.

VIVIEN GOLDMAN, MUSIC WRITER,
NEW YORK AND LONDON

RIGHT:
MARJORIE LUNDEN
I'M READY, STOCKHOLM, 1996
"When you point a camera at my cat, he poses. Cats are much more aware than we think they are. How else do you explain a cat who walks into a photographer's house and becomes her best model, always aware of the lens?"

OVERLEAF:
PALMER M. PEDERSEN
FOLLOW ME, MONTANA, 1955
Neighboring rancher and amateur photographer Palmer Pedersen caught this seven-member procession walking along the crest of a Montana hill. Like kittens following their mother, these cats stay close to their elderly owner.

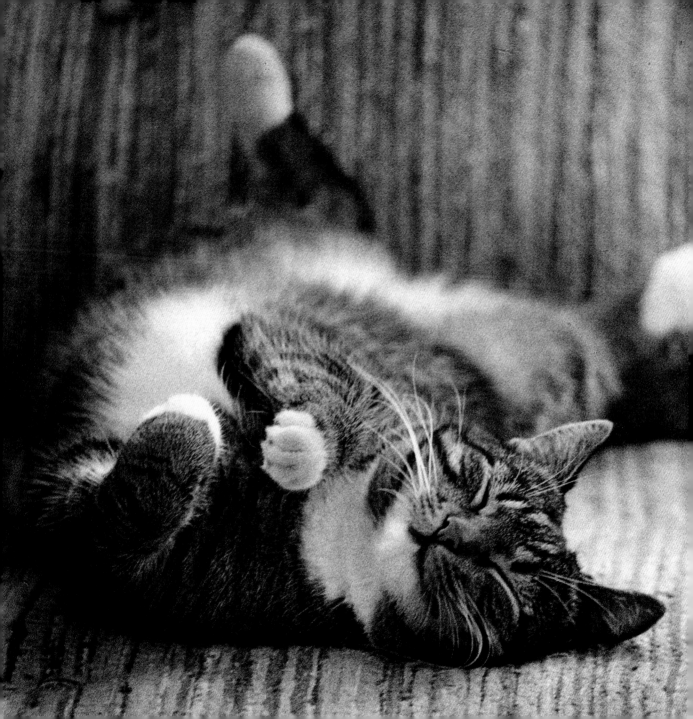

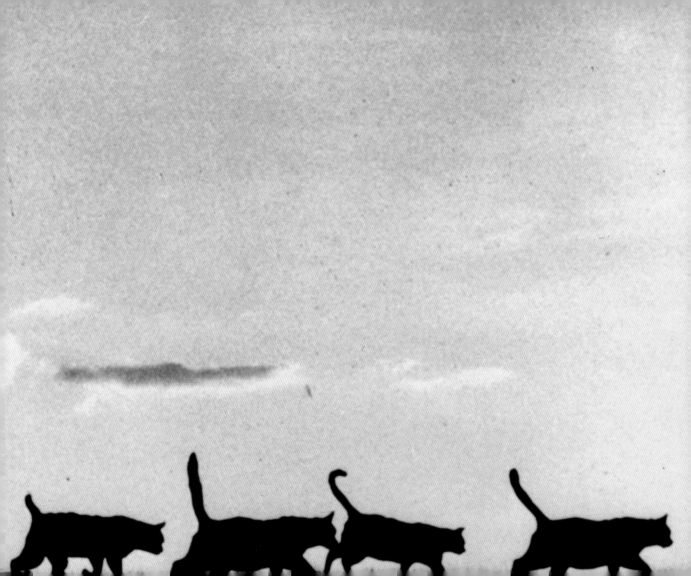

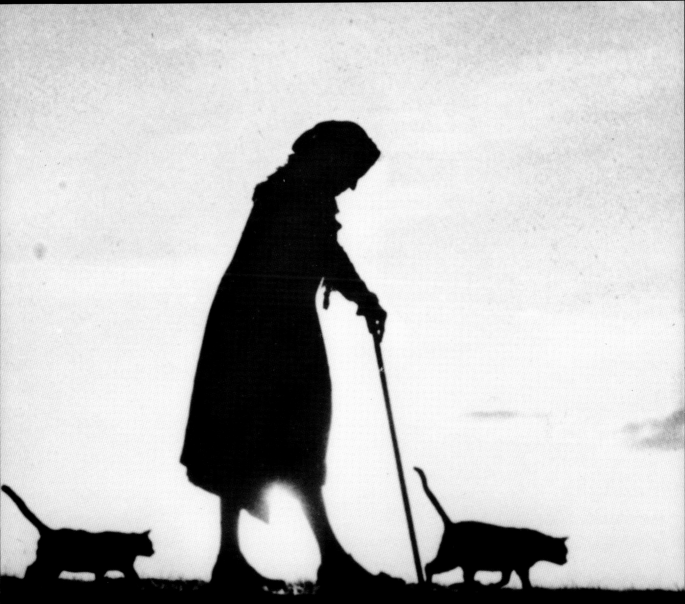

Page 1:
WALTER CHANDOHA
Toughie
Hunterdon County, New Jersey, 1969

Page 2:
WALTER CHANDOHA
Follow Me
Long Island, New York, 1967

Page 4:
JAN RIETZ
Looking for Food
Skane, Sweden, 1995

Pages 8-9:
DAVID MCENERY
Blackjack
Redondo Beach, California, 1994

PHOTOGRAPHY CREDITS

Walter Chandoha: Pages 1, 3, 17, 25, 26, 28-9, 36-7, 39, 43, 49, 55, 69, 75, 76-7, 80, 81, 83, 218-9, 221, 254-5, 269, 271, 317, 333
© Jan Rietz/Tiofoto AB: Pages 4, 21
© David McEnery: Pages 8-9,12-13, 31, 45, 65, 70-1, 105, 119, 156-7, 172, 195, 216-7, 223, 318-9, 336-7
© Claudia Gorman: Pages 11, 273, 315
© Studio Lemaire/Art Unlimited, Amsterdam: Page 15
© Marilaide Ghigliano: Page 18
© Guy le Querrec/Magnum Photos: Page 23
© Express Newspapers/Archive Photos: Page 27
© Donna Ruskin: Pages 32-3, 134, 143, 366, 367

Courtesy UPI/Corbis-Bettmann: Pages 34, 67, 99, 100-1, 203, 205, 302-3, 304-5, 380-1
© Johan Willner/Tiofoto AB: Page 35
Ylla, © Pryor Dodge: Pages 40, 127, 338-9, 352-3
© Lambert/Archive Photos: Pages 41, 73
Courtesy R. P. Kingston: Pages 42, 185
© Karl Baden: Pages 46-7, 120, 346-7, 349, 354, 365
© Nick Nichols/Magnum Photos: Page 51
Courtesy Express Newspapers/Archive Photos: Pages 52-3
© Thomas Wester: Pages 56, 60-1, 87, 95, 96-7, 102, 103, 116-7, 146-7, 155, 163, 175, 183, 199, 207, 235, 251, 266-7, 275, 283, 299, 312-3, 329, 330-1, 345
© Laura Straus: Page 59
© Andrea Mohin: Page 63
© Michael Nichols/Magnum Photos: Page 64
© Jayne Hinds Bidaut: Page 79
© Archive Photos: Pages 84-5
Courtesy Archive Photos: Pages 88, 89, 149, 151, 193, 196-7, 200, 201, 227, 229, 236-7, 297, 371
Courtesy Bettman/UPI: Pages 91, 132, 133, 220, 257, 287
© John Drysdale: Pages 92-3, 114-5, 179, 259, 265, 293, 321, 327
© Terry deRoy Gruber: Pages 106-7, 130-1, 176-7, 248-9, 253, 288-9, 362-3
© Per Wichmann: Pages 108-9, 110-1, 245
© Robin Schwartz: Pages 112, 113, 122, 123, 125, 136-7, 139, 145, 158-9, 160-1, 186-7, 191, 292, 335, 348, 355, 356-7
© Ann Finnell: Pages 121, 180-1, 230-1, 377
© Kritina Lee Knief: Pages 128-9, 144, 148, 165, 167, 171, 173, 277, 343
© Mikael Bertmar/Tiofoto AB: Page 135

DO CATS DREAM?

Published in the UK in 2004 by Scriptum Editions.
An imprint of Co & Bear Productions (UK) Ltd.
565 Fulham Road
London, SW6 1ES
www.scriptumeditions.com

Represented and distributed by Thames & Hudson Ltd.

Publishers Beatrice Vincenzini & Francesco Venturi
Executive Director David Shannon
Publishing Assistant Ruth Deary
Designer J.C. Suarès

First published in the USA by Welcome Books®
An imprint of Welcome Enterprises, Inc.

The publishers gratefully acknowledge the permission of the
following to reprinting the copyrighted material in this book:

Excerpt on pg. 20: Translated by Patrick and Justina Gregory,
in The Fables of Aesop, selected and illustrated by David Levine,
© 1975, David Levine.

Excerpt on pg. 22 from "the song of mehitabel" from archy and
mehitabel, by Don Marquis, © 1927 by Doubleday, a division of
Bantam Doubleday Dell Publishing Group, Inc. Reprinted by
permission of the publisher.

Excerpt on pg. 138 from "How the Cat Became," in How the
Whale Became and Other Stories, by Ted Hughes, © Ted Hughes,
1963, Faber and Faber Ltd., publishers.

Excerpts on pp. 151, 252: P.G. Wodehouse, "The Story of
Webster," permission given by A.P. Watt on behalf of the
Trustees of the Wodehouse Estate.

Excerpt on pg. 226: The Papers of Samuel Marchbanks, © 1986
by Robertson Davies. Used by permission of Viking Penguin, a
division of Penguin Books, USA, Inc.

Excerpt on pg. 250: The Indoor Cat, © 1981 by Patricia Curtis.
Reprinted by permission of Doubleday, a division of Bantam
Doubleday Dell Publishing Group, Inc.

Excerpt on pg. 274: Bring Me A Unicorn: Diaries and Letters of Anne
Morrow Lindbergh, 1922–1928, © 1972 by Anne Morrow Lindbergh.
Reprinted by permission of Harcourt, Brace & Company.

Every attempt has been made to obtain permission to reproduce
materials protected by copyright. Where omissions may have
occurred, the publisher will be happy to acknowledge this in
future printings.

ISBN 1–902686–44–6

Printed in Singapore

First Edition

10 9 8 7 6 5 4 3 2 1